PORTS
OF THE
WORLD

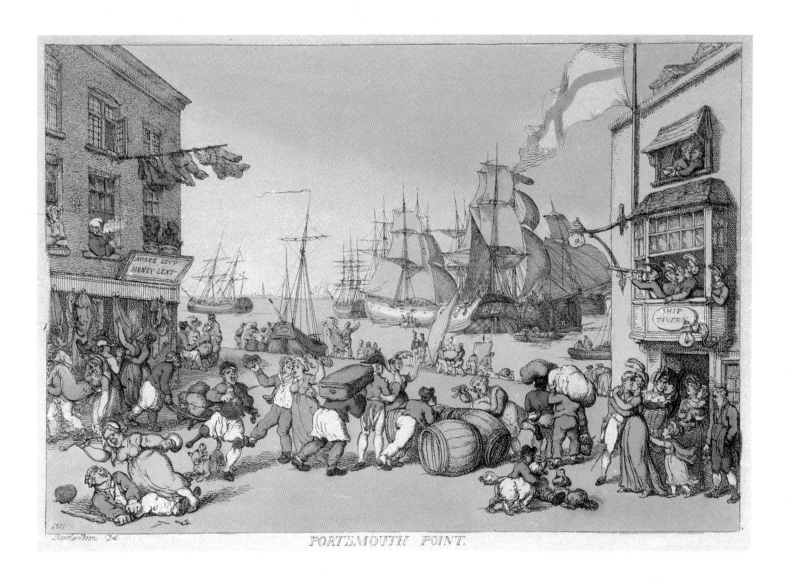

PORTSMOUTH POINT.

'PORTSMOUTH POINT'
Hand-coloured etching
Height 250 mm, width 350 mm
Drawn and engraved by Thomas Rowlandson;
published *c.*1811 (PAF 3841).

Engraved caricatures frequently provided
humorous views of British ports. Here Thomas
Rowlandson depicts a lively scene in Portsmouth,
home of a major naval base and one of Britain's
busiest ports in the eighteenth and nineteenth
centuries.

PORTS
OF THE
WORLD

Prints from the National Maritime Museum, Greenwich
c.1700–1870

Cindy McCreery

PHILIP WILSON PUBLISHERS

THE NATIONAL MARITIME MUSEUM
generously supported by
CGU plc

First published in 1999 by
Philip Wilson Publishers Ltd
143-149 Great Portland Street
London W1N 5FB

Distributed in the USA and Canada by
Antique Collectors' Club
91 Market Street Industrial Park
Wappingers' Falls
New York 12590

ISBN 0 85667 505 9

Designed by Peter Ling

Printed and bound in Italy by Editoriale Lloyd srl, Trieste

Jacket picture

'VÜE PANORAMIQUE DE LA VILLE DE RIGA PRIS DE
L'AUTRE COTÉ DU PONT DANS LA MAISON DU
DOUANIER...'
*Panoramic view of the town of Riga taken from the other
side of the bridge at the house of the customs officer...*
Coloured aquatint and etching
Height 199 mm, width 638 mm
Painted by F. Fielker and engraved by (?Johann
Friedrich) Frick; published *c.*1815 (PAI 7174).

Wide angled views, as in this aquatint of Riga in
Latvia, were a popular means of depicting ports in
the early nineteenth century. The logs visible in the
left foreground reveal Riga's involvement in the
Baltic timber trade.

Contents

Acknowledgements

This book would not have been possible without the assistance and enthusiasm of many people over several years.

First of all, I am delighted to acknowledge the support of the Trustees of the Caird Senior Fellowship at the National Maritime Museum. Their generous awards funded two years of research into prints of ports within the Museum's collection. I would also like to thank CGU plc for generously assisting the publication of this book.

Among the many current and former members of staff at the National Maritime Museum who helped me, I would like to thank in particular: Jane Ace, Susan Bax, Tina Chambers, Kathy Donoghue, Jacky Hayton, Roger Knight, Lindsey MacFarlane, Hélène Mitchell, Sarah Monks, Richard Ormond, Clive Powell, Rina Prentice, Roger Quarm, Sophia Robertson, Jane Samson, Catherine Sones, David Spence, James Taylor, Suzanne Testa, Ros Whitford and Fiona Wise.

I would also like to take this opportunity to thank Margarette Lincoln, Alasdair MacLeod, Debby Robson and Pieter van der Merwe, along with Anne Jackson, Peter Ling and Cangy Venables at Philip Wilson Publishers Ltd, for all their hard work in producing this book.

Finally, I am grateful for the support and interest of my family and friends: Don and Judy McCreery, Lisa and John Santoro, Thomas McCreery, Nicole Daly and, last but not least, Angus Gilchrist. Adventurous travellers all, I would like to thank them for accompanying me (literally as well as figuratively) on my journeys to the ports of the world.

Cindy McCreery
SYDNEY, AUSTRALIA
JUNE 1999

6

Foreword

The period from about 1700 to 1870 saw a golden age of print production, including the development of new forms of engraving such as aquatint and lithography. In this era, before the advent of commercial photography, engravings were often valued as accurate historical records as much as aesthetically appealing objects.

Ports of the World: Prints from the National Maritime Museum, Greenwich, c. 1700-1870 is the result of extensive study by Dr Cindy McCreery, NMM Caird Senior Research Fellow at the Museum from 1995-97, and presents some of the finest examples from the National Maritime Museum. It is the first extensive work on the Museum's superb collections since Michael Robinson's *A Pageant of the Sea: The Macpherson Collection of Maritime Prints and Drawings in the National Maritime Museum, Greenwich*, published in 1950.

The print collection reveals a firm link between art and commerce in the eighteenth and nineteenth centuries. Many record and illustrate the remarkable development of ports, from views of London, and particularly Greenwich, much favoured by engravers in the early part of the eighteenth century, to the visual record of commercial Australian ports from the mid-nineteenth century.

The National Maritime Museum is at the centre of the preservation and display of Britain's maritime heritage and this book does much to reveal the international nature of this fine collection to print enthusiasts as well as those with an interest in the commercial and maritime history of ports in this period.

Richard Ormond
DIRECTOR, NATIONAL MARITIME MUSEUM

Dedication

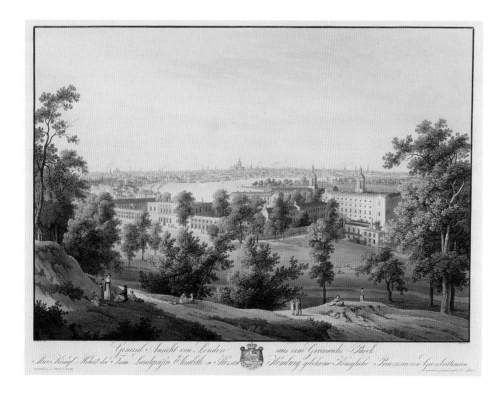

This book is dedicated to my two daring ancestors,
William Grant Broughton and Thomas McCreery,
who sailed to many ports of the world

Introduction

Views of world ports are among the many treasures of the prints and drawings collection of the National Maritime Museum, Greenwich. Since its foundation, the Museum has been at the centre of the preservation and display of world maritime heritage. In addition to wonderful collections of oil paintings, historic photographs and ship models, the museum possesses a magnificent collection of prints and drawings. Indeed, it was due in part to the necessity to find a permanent home for A. J. H. Macpherson's important collection of prints and drawings that the National Maritime Museum was established by act of parliament in 1934. The current collection of prints and drawings numbers over 60,000 items. These range from seventeenth-century Dutch pen-and-ink drawings to nineteenth-century French lithographs and twentieth-century British water-colours. They include ship portraits, prints of battles and other historical events, portraits of naval officers, atlases, caricatures and seascapes as well as views of ports. Despite the richness of this collection, the last major study was completed over 40 years ago – M. S. Robinson's *A Pageant of the Sea: The Macpherson Collection of Maritime Prints and Drawings in the National Maritime Museum, Greenwich.*[1]

As a general overview, *A Pageant of the Sea* describes only a few of the thousands of prints which are currently held by the Museum. Little attention could be given to the several hundred prints of ports in the collection. These port views are arguably some of the National Maritime Museum's most fascinating, yet understudied images.

Views of ports reveal not just what ports looked like at a certain point in history, but how the people of that time perceived them. Engravings, or prints, were a popular means of representing ports in the eighteenth and nineteenth centuries. Whereas paintings could reach only a few, generally wealthy clients, prints had a much wider audience. These prints show ports as valuable commercial hubs and military targets, as centres of civilisation and lonely colonial outposts. Ports appear as sophisticated capitals and primitive settlements – as places to meet friends or escape from enemies, to plan action or gather one's thoughts. Ports provide access to, and protection from, the sea. In short, they symbolise man's desire for exploration, trade, war and contemplation. Prints are thus valuable tools for investigating the complex history of man's relationship with the sea.

This book seeks to further the National Maritime Museum's commitment to international maritime heritage by providing an introduction to its prints of world ports. It takes a selective, rather than comprehensive approach to the Museum's vast holdings. Prints are chosen as useful historical illustrations as well as beautiful works of art. The majority of these port views take the form of engravings published between *c.*1700 and 1870. There are, however, a number of exceptions to this rule. Some attention has been given to sketches and watercolours, which were created as works of art in their own right as well as preliminary drawings for engravings. Oil paintings, on the other hand, are considered only in terms of their engraved versions. A few engravings published before 1700 or after 1870 have also been considered, including some of the earliest prints ever made. Fifteenth-century views of Lübeck and other Hanseatic towns demonstrate these German ports' importance as commercial centres during the Middle Ages. Yet the vast majority of ports reached their commercial and strategic peak in the eighteenth and nineteenth centuries, and the book focuses on the years from *c.*1700 to 1870. This period saw enormous political and economic changes occurring in Europe, which had implications for ports around the world. Prints of ports helped record these momentous developments for posterity.

Political and Economic Development and the Growth of Ports, c.1700-1870

From the European invention of printing in the mid-1400s up until *c.*1700, Portuguese, Spanish and Dutch ports dominated world trade. In the late fifteenth

and sixteenth centuries, the kingdoms of Portugal and Spain sponsored pioneering voyages of exploration and discovery to Asia, America and the Caribbean which led to the development of important maritime trade routes. Major ports were established at Havana, Rio de Janeiro and Lima to export valuable cargoes of gold, silver, tobacco and hardwood back to Europe. In the seventeenth century the Netherlands developed an extensive trading network stretching from Europe to Asia and America. Dutch East Indiamen transported spices, porcelain and tobacco through ports such as Batavia (Jakarta), Malacca and Cape Town. Paintings and, increasingly, engravings, were commissioned to record these voyages and illustrate the newly discovered or established ports.

By the beginning of the eighteenth century (*c.*1700), however, this pattern was changing. The traditional maritime powers in Europe were in decline, and new nations took charge of international trade. Britain's early industrialisation and long isolation from a series of crippling continental wars had paid off by the late eighteenth century. It was able to develop overseas colonies to supply cheap raw materials and new markets for British manufactures. France joined Britain in the hunt for overseas colonies, and by the end of the eighteenth century the British and French navies dominated the world. As well as obtaining territory through warfare, including political revolutions in North America, France, and South America, the navies of Britain, France and, to a lesser extent, Spain, explored the Pacific. This led to the discovery of Tahiti, Hawaii, Australia and New Zealand and, eventually, the establishment of port facilities and European settlements there.

By 1815 Britain's victory over France in the Napoleonic Wars confirmed its position as the world's largest and most important naval power. The nineteenth century saw the escalation of European maritime rivalry over far-flung colonies from Africa to the Pacific, as well as mass seaborne emigration from Europe to the New World. This expanding population strengthened the United States's development as an industrial and commercial power, and was reflected in the rapid growth of its ports. By the late nineteenth century there were more ports than ever before. While many ports remained small and locally orientated, other ports boomed as members of an international trade network.

This economic and political development spurred improvements in communications, such as the development of the postal service, the invention of the telegraph and advances in engraving techniques. Indeed, the period spanning the

eighteenth and nineteenth centuries is known as the golden age of popular print production in Europe and America, and was only eclipsed by the development of photography in the mid-nineteenth century. It was through engravings that ports were most frequently represented in this period. Prints introduced ports to viewers on the other side of the world.

The Print Market

As with its navy, Britain's print industry was a secondary force before the eighteenth century. Up until this point Dutch, French and German prints dominated the world market. Yet over the course of the eighteenth century Britain moved from being a net importer to a net exporter of prints. By the late eigteenth century, London was the centre of the printselling world.[2]

While the majority of British engravers and printsellers were located in London, prints were frequently prepared from sketches or paintings made elsewhere. Views were often sketched or painted by visiting amateur artists, including military and naval officers and female tourists. Some prints offer accurate and detailed views of ports, while others give only rough impressions. Other designs were made by professional artists who may or may not have visited the ports depicted. The Museum's collection includes views engraved after some of the most famous painters of the day, including members of Britain's Royal Academy. They include painters who specialised in maritime art, such as John Cleveley the younger, Dominic Serres and his son John Thomas Serres, as well as painters whose work spanned several genres, such as: Antonio Canal (Canaletto), Joseph Farington, Joseph Mallord William Turner and Claude-Joseph Vernet. These men produced their work with an eye to commercial sale and, indeed, publication rather than as a leisure activity. Patrons also commissioned views of ports from artists, or subscribed to limited editions of high-quality engravings.

The finished sketch or painting was then usually engraved by a professional engraver in a workshop. Up until the mid-nineteenth century this was most likely to take place in a European city such as London or Paris, but by the mid-1800s engravings (especially lithographs) were produced in North American and other towns around the world. Engravers ranged from anonymous hack workers, who reproduced others' designs in a quick and often careless manner, to talented

artists in their own right such as the Dutch engraver Romeyn de Hooghe and the British engravers Nathaniel and Samuel Buck, Joseph Constantine Stadler, Elisha Kirkhall and Francis Vivares. The finished engraving was then sold by one or more printsellers, who often acted as publisher as well. A number of the most prominent London printsellers sold views of ports, including: Rudolph Ackermann, John, Thomas and later Carington Bowles, John and Josiah Boydell, Colnaghi & Co. and Robert Sayer. Some engravers, for example William Daniell, also published their own work.

The major London printsellers had large and impressive shops where customers could examine engravings on a range of topics in different sizes and prices. Many engravings were available in both uncoloured and hand-coloured versions. In addition to printsellers' shops, engravings were distributed through printsellers' catalogues and by the artists themselves. Private patrons might also send engravings as gifts to friends and colleagues. Many British prints were exported to continental Europe, America and the new colonies of the Empire. In turn, Dutch, French and German artists produced views of ports which crisscrossed the globe. Indeed, many nineteenth-century views of American and Australian ports were produced by travelling British, French and German artists. Like ships' cargoes, prints of ports were the products of long journeys and the hard work and skill of many individuals.

As the print market expanded, a greater variety of prints was produced. This enabled a broader range of customers to purchase prints than ever before. Prints varied enormously in quality and price, according to their intended function and market. Many prints in this period were single-sheet images, published on their own or in thematic sets – for example John Thomas Serres's five aquatint views of Liverpool and Merseyside. Other, cheaper prints such as etchings and woodcuts were produced as illustrations for books and magazines. Illustrated travel guides became increasingly popular in this period for prospective and armchair travellers alike. British prints ranged widely in price. An eighteenth-century caricature sold for as little as sixpence plain/one shilling coloured, while a hand-coloured aquatint might cost several guineas. In nineteenth-century America, lithographs were sold for as little as a few dollars. Expensive prints were framed or stored in collectors' albums, while cheaper prints were simply tacked onto walls or stored loose in drawers. Many prints would have been shown by their

owners to friends and colleagues – perhaps as after-dinner entertainment – in homes, workplaces and taverns.

As prints varied enormously, so did their customers. Customers included the traditional print collectors – namely wealthy, often aristocratic individuals who collected high-quality, expensive prints as works of art. Such collectors were often more interested in the artistic quality of prints than their subject matter, and concentrated on purchasing works by specific artists or engravers. In turn, artists often dedicated prints to an individual – the patron who commissioned or sub-sidised the production of their print, the officer they had served under in the army or navy, or a politician they were trying to gain favour with.

Other buyers chose prints specifically for the ports depicted. Such purchasers spanned a wide range of social groups – from prosperous merchants to poor sailors. These customers might buy prints only occasionally, perhaps only once in their life. Views were bought as souvenirs of recent visits, reminders of profits made, battles won, and adventures enjoyed and anticipated. Many prints were dedicated to groups as well as individuals – members of the town corporation, regiments and ships' crews – who commissioned the print directly or would be expected to subscribe to several copies.

Subjects

Eighteenth- and nineteenth-century prints touch on some of the major developments of the period, namely exploration and settlement of new lands, trade, war, and tourism. Views of ports provided a means of recording and publi-cising developments which contemporaries judged to be important. Visual representations complemented the information which was provided in written accounts, and gave the viewer the feeling of experiencing the port first-hand. These prints are thus a useful source for understanding the social and political history of the age.

The voyages of European explorers inspired many prints of the ports they visited. Places as diverse as Kamchatka and the Society Islands are recorded in scenes from the voyages of Captain Cook. Such prints presented these expeditions in a favourable light and emphasised the exotic nature of the ports visited. They also served as Europeans' first visual encounter with many parts of the Pacific.

Prints were an excellent means of advertising ports' commercial function. Views of ports as different as Liverpool, Ancona, Canton and Marseilles all accentuate their involvement in trade. Trading voyages inspired the production of views of ports such as Cape Town and Rio de Janeiro, where ships stopped for fresh food and water during their long journeys between Europe and Asia or the Pacific. Views of British, French and American ports often express considerable civic pride, and serve as advertisements for the ports' commercial, naval or leisure resources. Such views were designed to draw trade and settlers to these ports. Potential immigrants may have been attracted to a particular port because of a print view they had seen. In the case of a view of 'Progress' in the United States, the engraving advertises a town which would remain a land developer's dream!

Prints also documented battles and the occupation of ports during wartime. Because of their commercial value, ports such as Cartagena, Havana and Honduras were often the target of naval attacks. Ports with strategic positions such as Gibraltar, Malta and Minorca featured in prints commemorating local battles and wars. Many prints depicted ports in the Iberian peninsula and southwest France involved in the Peninsular War, such as Corunna (La Coruña). Often such prints were commissioned by military officers and dedicated to their superior officers, as is the case in a view of Port Louis, Mauritius. Other views, including a set of four views of Alexandria, were sketched by officers as a way to pass the time during their long tours of duty abroad. Ports were often valued for several reasons: an engraving of the island of St Helena commemorates both Napoleon Bonaparte's final place of exile and a strategic location in the Atlantic Ocean.

Many early nineteenth-century prints document Britain's network of colonial ports. New additions to the British Empire such as Penang, Rangoon and Sydney are recorded with interest. Older colonial networks are also depicted in prints, including Spanish colonial ports in South and Central America such as Acapulco, Lima and Matanzas.

Other prints seem to have been intended as introductory guides for would-be tourists as well as souvenirs for seasoned travellers. Engravings evoked the balmy atmosphere of Antibes and Bermuda, as well as chillier holiday spots like Ramsgate and Scarborough. Another type of print which provided insight into British ports was the cartoon, or caricature. Caricatures captured the lively atmosphere of contemporary British ports and the humorous aspects of life in the Royal Navy.

Ports feature in many prints of the British Navy, especially royal dockyards such as Chatham and Portsmouth.

Watercolour and Engraving Techniques

Several of the port views discussed in this book were first made in watercolour.[3] Watercolour is a type of painting which employs water soluble paints and produces a watery, translucent appearance. Watercolour painting is a quick and portable medium, and a box of watercolour paints was often preferred by amateur artists and travellers to cumbersome and expensive oils. Gouache involves painting in opaque watercolours, which gives the image a chalky appearance. It produces effects similar to oil painting.

The oldest engravings mentioned in this book take the form of woodcut engravings. Woodcut is a type of print made from a block of wood of medium hardness and cut along the grain. Parts of the surface are cut away and appear white, while the protruding section receives the ink and appears as black. Woodcuts are durable and can be coloured by hand.

Most of the views discussed in this book involve one or more intaglio engraving techniques. Intaglio ('cut into' in Italian) engraving encompasses a variety of methods of incising a design onto a metal plate, which is then covered with ink. The surface is wiped clean, and the ink remains only on the incised lines. When paper is pressed onto the plate the ink is transferred to it, leaving an impression or print. The oldest and probably most difficult form of intaglio technique is line-engraving, which will be referred to here simply as engraving. The design is made directly with a steel tool known as a burin on a metal, usually copper plate. This creates burr in the metal which is removed, leaving a clean groove to hold the ink. Engraving is a time-consuming process which requires considerable skill, and was usually the work of professionals.

Etching was another engraving technique which was frequently used in prints of ports. In etching the plate is first covered with an acid-resistant coating such as wax. The design is scratched through the coating using a needle. The plate is then dipped in acid to reveal the lines of the design. The etching needle is both quicker and easier to use than the engraver's burin, and thus etching could often be mastered by amateurs more readily than engraving. For these reasons pure

etchings could be less expensive than engravings. Yet etching was employed in fine prints too, often in combination with engraving and/or aquatint.

Aquatint is a type of etching which employs a metal plate coated with a porous resin. This gives the resulting image a granulated effect. Aquatints have a watery tone which resembles watercolour painting, and were frequently employed to reproduce (or imitate) watercolour views of ports. Aquatint views of ports were often beautifully coloured by hand, and were relatively expensive items which were sold both individually and in sets.

Mezzotint is a time-consuming and thus fairly expensive engraving process which is suitable for reproducing the tonal qualities of oil paintings. To create a mezzotint, a metal plate is first covered with fine scratching by using a rocking tool called a cradle. When covered with ink this appears as a black background. The design is burnished onto it and appears as white. Mezzotints could also be coloured by hand in one or more colours. In the eighteenth century mezzotint was often used for reproducing portraits as well as some caricatures and port views, but it was largely superseded by photography in the nineteenth century.

Stipple engraving involves a combination of etching and engraving techniques, and consists of small dots applied to a metal plate with an etching needle or a wheel known as a roulette. It was most often used for portraits, and was frequently coloured, which resulted in a soft, even sentimental appearance.

Print runs of copper-plate engravings were usually fairly small, with up to a few hundred impressions printed per design before the plate wore down and had to be re-engraved. The limitations on production and the time involved in preparation meant that copper-plate engravings could be quite expensive. Steel engraving was invented in the second quarter of the nineteenth century and involves engraving onto a copper plate which has been faced with steel. As steel is harder than copper, more impressions can be printed from the plate before it deteriorates. Steel engraving is thus a cheaper and quicker method than copper-plate engraving, but its appearance is correspondingly harder and less tonal.

Lithography was invented at the end of the eighteenth century and became very popular in the mid-nineteenth century, particularly in the United States where it was used for many bird's eye views of sea and river ports. Currier & Ives is perhaps the most famous publishing firm associated with this technique.[4] Lithography is a surface rather than intaglio engraving technique, as it does not

involve cutting into a metal plate or surface. Instead the design is drawn with a greasy chalk or ink onto a porous limestone or zinc plate. The stone or plate is wetted and greasy ink is applied which adheres only to the drawn lines. Dampened paper is applied to the stone or plate and is rubbed over with a special press to make the print. Lithographs were often hand-coloured. Chromolithographs are multicoloured lithographs, made by using a separate stone or plate for each colour.

Chapter Synopsis

The book is divided into six thematic chapters. Each examines prints of ports from one or more geographical areas, beginning with Britain and ending with Australia. The prints cover a wide range of ports from around the world. While not all prints mentioned in the book are reproduced here, the text is complemented by a generous number of illustrations, many of them in colour. Chapter One explores prints of British and Irish ports, which form the most numerous group in the National Maritime Museum's collection. Views of London, which by the early nineteenth century was the most influential port in the world, are particularly abundant. British dockyards and regional ports are also well represented. Chapter Two crosses the English Channel and investigates prints of Northern European ports, including the mighty Western French ports and Amsterdam, the home of the Netherlands' great trading empire. Prints depicting the early nineteenth-century expansion of Scandinavian and Baltic ports are also discussed. Chapter Three moves south to the Mediterranean, the scene of numerous battles between European powers for control of strategic ports such as Gibraltar, and the gateway to the exotic ports of the East such as Constantinople. Chapter Four follows the path of European voyagers to Asia and Africa, and surveys trading centres such as Batavia (Jakarta), victualling ports such as Cape Town and new colonial centres such as Port Elizabeth. Chapter Five explores the ports of the New World. It moves from Canada to the United States, and considers images of seaports such as New York and river ports such as New Orleans. Views of South American ports from Rio de Janeiro to Acapulco are then considered. Chapter Six turns to the ports of the Caribbean, Pacific and Australia. Although very different in appearance from European ports, views of ports such as Antigua, Huaheine and Melbourne reveal the extension of European culture and politics around the globe.

In the late nineteenth century, the shift from sail to steam power and from engraving to photography brought fundamental changes to views of ports. While both sailing ships and engravings continued to be employed, the new technologies soon dominated their fields. The adoption of photography greatly increased the emphasis placed on the accuracy of views. Aesthetic concerns did not completely disappear, yet views of ports came to be valued more as providers of information than as works of art. In order to compete with photographs, engravings tended to concentrate on detail rather than atmosphere. While valuable historical tools in their own right, these later engravings and photographs often lack the artistry and romance of the earlier views. The following overview of eighteenth- and nineteenth-century prints of ports serves as a reminder of their visual appeal to generations of viewers. Looking anew at these wonderful views, we can recapture contemporaries' excitement at discovering the ports of the world through prints.

FURTHER READING

Timothy Clayton, *The English Print 1688–1802* (New Haven and London: Yale University Press, published for the Paul Mellon Centre for British Art, 1997).

Cedric Flower, *The Antipodes Observed: Prints and Print Makers of Australia, 1788–1850* (South Melbourne, Vic.: Macmillan, 1975).

Antony Griffiths, *The Print in Stuart Britain, 1603–1689*, with the collaboration of Robert A. Gerard (London: British Museum Press, 1998).

John Lowell Pratt, ed., *Currier & Ives: Chronicles of America*, with an introduction by A. K. Baragwanath (Maplewood, New Jersey: Hammond Incorporated, 1968).

Rina Prentice, *A Celebration of the Sea: the Decorative Arts Collection of the National Maritime Museum* (London: HMSO, 1994).

John W. Reps, *Bird's Eye Views: Historic Lithographs of North American Cities* (New York: Princeton Architectural Press, 1998).

John W. Reps, *Cities of the Mississippi: Nineteenth-Century Images of Urban Development with Modern Photographs from the Air by Alex MacLean* (Columbia, Missouri and London: University of Missouri Press, 1994).

M. S. Robinson, *A Pageant of the Sea: The Macpherson Collection of Maritime Prints and Drawings in the National Maritime Museum Greenwich* (London and New York: Halton & Company Ltd, 1950).

James Taylor, *Marine Painting: Images of Sail, Sea and Shore* (London: Studio Editions, published in association with the National Maritime Museum, Greenwich, 1995).

Martin Terry, *Maritime Paintings of Early Australia, 1788–1900* (Melbourne: The Miegunyah Press, Melbourne University Press, 1998).

NOTES

1 M. S. Robinson, *A Pageant of the Sea: The Macpherson Collection of Maritime Prints and Drawings in the National Maritime Museum Greenwich* (London and New York: Halton & Company Ltd, 1950).

2 For further information about the British print market see Timothy Clayton, *The English Print 1688–1802* (New Haven and London: Yale University Press, published for the Paul Mellon Centre for British Art, 1997).

3 The following discussion of watercolour and engraving techniques is drawn primarily from Edward Lucie-Smith, *The Thames and Hudson Dictionary of Art Terms* (London: Thames and Hudson, 1984) with additional information from Peter and Linda Murray, *The Penguin Dictionary of Art and Artists* (London: Penguin Books, sixth ed., 1989).

5 John Lowell Pratt, ed., *Currier & Ives: Chronicles of America*, with an introduction by A. K. Baragwanath (Maplewood, New Jersey: Hammond Incorporated, 1968), p. 13.

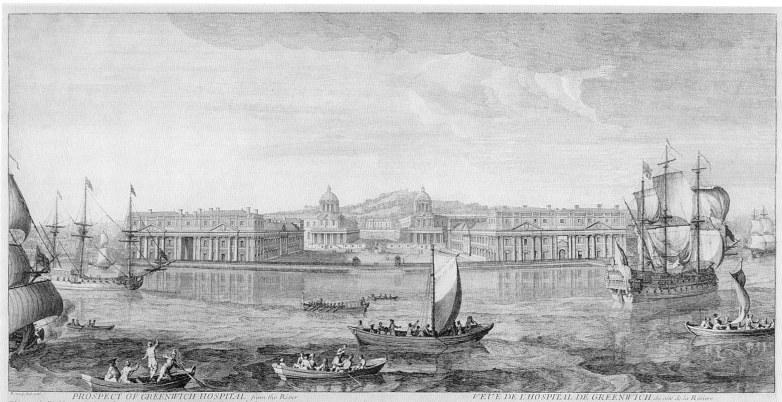

PROSPECT OF GREENWICH HOSPITAL _from the River_

This stately Building intended at first by King Charles II for a Royal Palace, was afterwards converted to the use of disabled sea-men, but part of the Left Wing Lyes still unfinished. The old Royal House Where the Governour resides stands at the farther end of it at the entrance in la Greenwich Park.

VEUE DE L'HOSPITAL DE GREENWICH _du cote de la Riviere_

Ce magnifique Edifice scitué au bord de la Tamise fut destiné par Charles II pour la residence des Roys; mais par la suite il a été converti pour la retraite des Marins Invalides. Il reste une partie de l'aile gauche qui n'est pas encore achevée la vieille maison Royalle ou le gouverneur demeure paroit dans le fond et fait l'entrée du Parc de Greenwich.

'PROSPECT OF GREENWICH HOSPITAL
FROM THE RIVER...'
Title also in French
Engraving
Height 497 mm, width 840 mm
Designed and engraved by Jacques Rigaud;
published in Paris in 1736 (PAI 7092).

Engravings of the former royal palace at
Greenwich from the River Thames were among the
most popular views of eighteenth-century London.
A variety of ships and boats dot the river in the
foreground of this design.

Chapter One

From London to Falmouth

British and Irish Ports

London

While London had long served as the political, administrative and commercial centre of Britain, its international significance increased markedly with the rapid expansion of its port in the eighteenth and nineteenth centuries. During this period London boomed as a centre of both national and international trade, and the River Thames became a focal point for the export and import of the products of the new industrial revolution. As trade elevated London's commercial status, artists and engravers drew greater attention to the city's maritime dimension. Images of docks, warehouses and bridges were added to the well-established repertoire of palace, Parliament and church views. A variety of prints was produced, encompassing old techniques such as woodcut and line engraving and new techniques such as aquatint, lithography, and eventually photography.

Prominent among engraved views of London were views of Greenwich. As the site of a former royal palace, current naval hospital and a long-established royal observatory, Greenwich symbolised the nexus of London's glorious royal, naval and scientific traditions. Greenwich Hospital was a favourite subject for engravers, and the captions to the designs, for example the French artist Jacques Rigaud's 'Prospect of Greenwich Hospital from the River...' (1736) often stressed the historical significance of the buildings (see left and page 8). The Venetian artist Giovanni Antonio Canal, known as 'Canaletto', painted several views of London and the Thames in the mid-eighteenth century, including Greenwich and Westminster

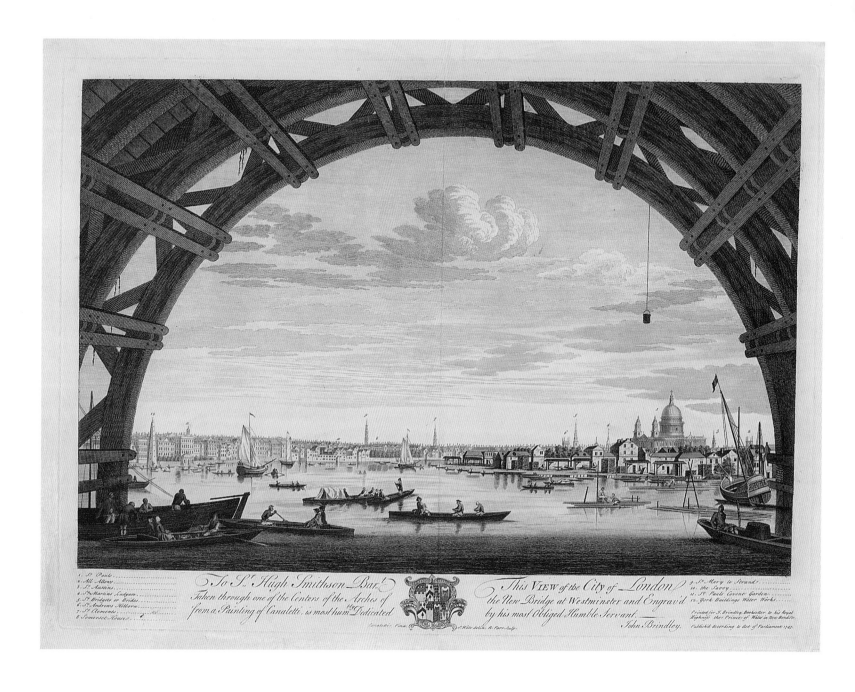

To Sr. Hugh Smithson Bart. Taken through one of the Centers of the Arches of from a Painting of Canaletti, is most humbly Dedicated

This VIEW of the City of London the New Bridge at Westminster and Engrav'd by his most Obliged Humble Servant.

John Brindley.

Canaleti. Pinx. J. Wale delin. R. Parr Sculp.

Printed for J. Brindley, Bookseller to his Royal Highness the Prince of Wales in New Bond St. Publish'd according to Act of Parliament 1747.

Bridge. Canaletto's paintings typically included an elegant sweep of river, fine detail and beautiful colouring, and greatly influenced subsequent views, both in oil painting and engraving (see above). Westminster Bridge was also a favourite subject of artists and engravers like J. W. Edy, who catered to the growing domestic and international market for engravings of London and the Thames. Views framed through the arches of bridges continued to be popular in the nineteenth century.

In 1804–05 the acclaimed topographical artist and engraver William Daniell published a series of six colour aquatint views of London. The series included views of the river, the Tower of London, St Paul's Cathedral, London Bridge, Somerset House and Westminster Abbey. Sites of royal, ecclesiastical and noble power continued to dominate views of London, and remained ideal souvenirs for local people and tourists alike.

The River Thames itself was frequently celebrated in engravings as a conduit of Britain's trade. A pair of prints entitled 'The Thames', designed by John Thomas Serres, includes a poem which celebrates the river for the wealth and glory it brings Britain. The Thames was Britain's life-blood, connecting London with the global market for Britain's goods and influence. Images of London and the Thames were also included in contemporary periodicals. Views of Deptford were published in *Harrison's History of London* and the *Modern Universal Traveller*, while in 1782 the *London Magazine* published 'A Perspective View of the River Thames &c. taken from the Kings Arms at Blackwall' which included Shooter's Hill, Woolwich and the 'East India Dock Yard'. The circulation and number of periodicals increased markedly in the nineteenth century as the introduction of rolling presses and steel engraving reduced the cost and increased the size of print runs. The invention of lithography also helped to supply the periodical market with relatively inexpensive prints, as seen in such famous nineteenth-century periodicals as the *Illustrated London News* and *Punch*.

Several artists, including Thomas Rowlandson, produced engraved series of views of London's naval and commercial buildings, including the Board Room of the Admiralty, Long Room Custom House, India House Sale Room, South Sea House Dividend Hall, Trinity House, West India Docks and Lloyd's Subscription Room. These rooms and buildings were important as symbols both of the organisations they housed and, taken together, of London's vast commercial wealth.

Pride in ports' technological capacities was expressed through many early nineteenth-century prints depicting new commercial dock projects, such as William Daniell's 1802 view of the construction of the new West India docks on the Isle of Dogs in east London (see page 26). Several other engravers produced less obviously scripted views of new projects, suggesting that interest in new dock projects extended beyond individual proprietors. Thus a small engraving was produced of 'Mr Perry's Dock at Blackwall'. Other unprepossessing prints also

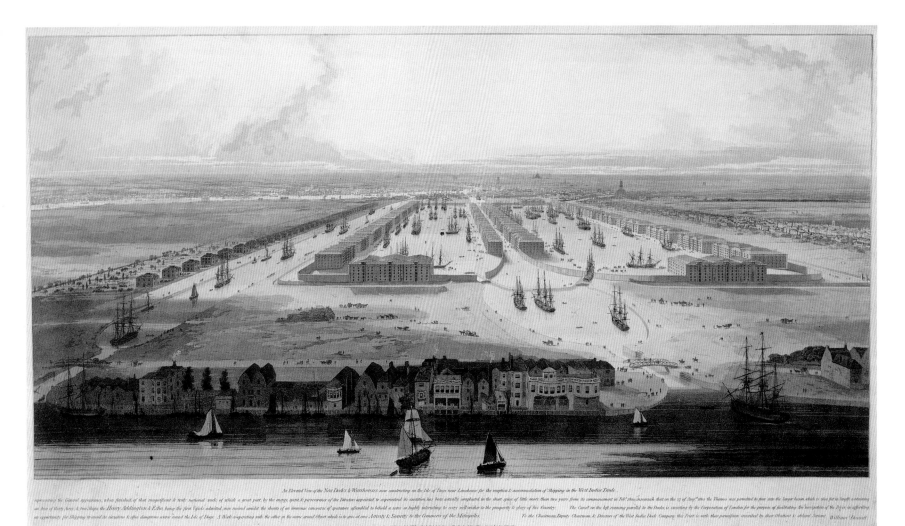

An Elevated View of the New Docks & Warehouses now constructing on the Isle of Dogs near Limehouse for the reception & accommodation of Shipping in the West India Trade.

depicted individual enterprises, such as F. C. Turner's 'View on the Thames. Shewing Goding's New Lion Ale Brewery, The Wharfs, Shot Factories, and the Lambeth end of Waterloo Bridge' (see right). The practice of commemorating historic openings of port and river facilities became more popular during the nineteenth century. London's continuing progress in completing improvements to its port infrastructure was marked by the publication of lavish images such as William John Huggins's view 'representing the Opening of St Katharine Docks, on Saturday the 25th of October, 1828.' Viewers could expect such prints to recreate the details as well as the atmosphere of the event.

'AN ELEVATED VIEW OF THE NEW DOCKS & WAREHOUSES NOW CONSTRUCTING ON THE ISLE OF DOGS NEAR LIMEHOUSE FOR THE RECEPTION & ACCOMMODATION OF SHIPPING IN THE WEST INDIA TRADE...'
Colour aquatint and etching
Height 403 mm, width 775 mm
Designed, engraved and published by William Daniell in London on 15 October 1802 (PAI 7124).

This bird's eye view provides a detailed description of an early nineteenth-century dock project in east London, close to the modern-day Canary Wharf development.

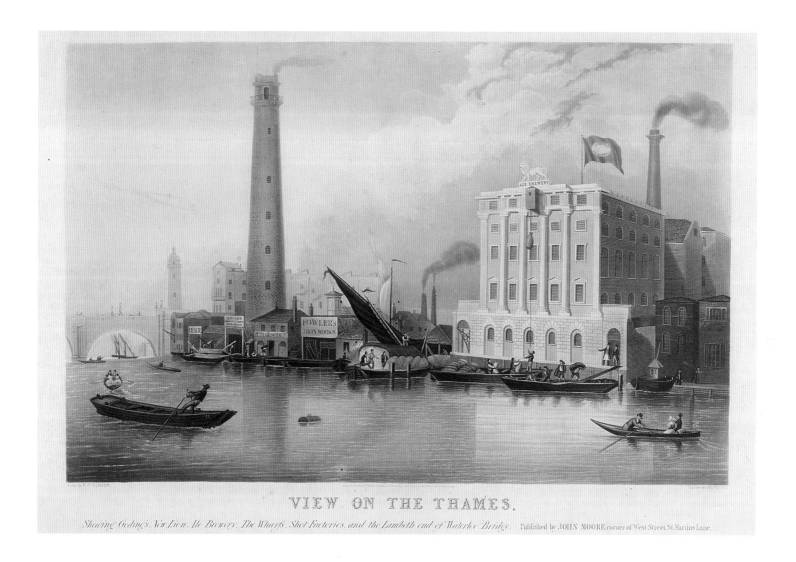

VIEW ON THE THAMES.

Shewing Goding's New Lion Ale Brewery, The Wharfs, Shot Factories, and the Lambeth end of Waterloo Bridge. Published by JOHN MOORE, corner of West Street, St Martins Lane.

'View on the Thames. Shewing Goding's New Lion Ale Brewery, The Wharfs, Shot Factories, and the Lambeth end of Waterloo Bridge' Proof, hand-coloured aquatint Height 481 mm, width 675 mm Designed by F. C. Turner and engraved by G. (?George) Hunt; published by John Moore in London on 30 December 1836 (PAH 9896).

Mid-nineteenth-century images of the Thames often drew attention to the river's role in servicing London's new industrial concerns, such as the brewery and factories visible in this design.

Even views of small projects convey a sense of their historical significance. The printselling firm Laurie & Whittle, which catered to the cheaper end of the print market, published 'A View of the First Bridge at Paddington, and the Accommodation Barge going down the Grand Junction Canal to Uxbridge' in 1801, and a 'View of the Vauxhall Iron Bridge' in 1806. In 1843 the Rotherhithe Tunnel under the Thames opened, inspiring detailed engravings which explained the engineering behind its remarkable design. By the late eighteenth century London was leading the way in port development, and the city's success as a commercial port only declined after World War One.

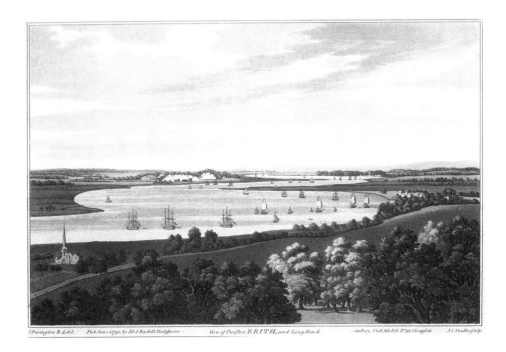

'VIEW OF PURFLEET, ERITH AND LONG-REACH'
Hand-coloured aquatint and etching
Height 306 mm, width 410 mm
Designed by Joseph Farington, R. A. and engraved
by Joseph Constantine Stadler; published by John &
Josiah Boydell in London on 1 June 1795
(PAH 1993).

This beautiful view of shipping on the Thames
downstream from London reminds us that
maritime engravings were intended as works of
art as well as sources of information.

While most views of the Thames focused on the old and new landmarks of
central London – buildings, bridges and docks – other engravings looked down-
stream towards the sea. Images such as Joseph Constantine Stadler's colour
aquatint of Joseph Farington's 'View of Purfleet, Erith and Long-Reach', published
by John and Josiah Boydell in 1795, may not depict a commercially or politically
significant stretch of the Thames (see above). Yet the artistic care taken with the
print, which was designed, engraved and published by four of the most prominent
men in their fields, indicates that the subject-matter was considered both
important and commercially appealing – and also that such prints would have been
expensive, and thus restricted to wealthy print customers.

Views of London often included one of the Royal dockyards located in the
Thames Estuary or on the Medway in Kent, such as the engraving of Chatham
discussed below. Dockyards had great symbolic as well as practical importance as
the origin of Britain's mighty navy, and in the late eighteenth century dockyards
grew in both size and significance as Britain once again prepared to go to war with
her old enemy France. The entrepreneurial London printseller John Boydell and
his nephew Josiah published several views of Royal dockyards painted and

engraved by the equally ambitious Robert Dodd in the late 1780s and early 1790s. Each of the dockyards had distinctive features which distinguished it from others in the series, and the captions below the designs underline both the unique characteristics of the individual dockyard and its links with other dockyards.

Other British and Irish Ports

While London, as the centre of Britain's commercial world, continued to feature prominently, other British ports also appeared regularly in eighteenth- and nineteenth-century prints. Many of the major ports were linked with particular functions and trades: Portsmouth and Plymouth with the Royal Navy, Newcastle with the coal trade and new industrial development, Liverpool with trade to North America, including emigration, and Hull with the fishing industry. Smaller ports, such as Scarborough and Aberystwyth, developed new roles as holiday resorts in this period. Other areas, such as Western Scotland and Ireland, while largely unaffected by the commercial boom affecting other ports, nevertheless drew artists' attention to the natural beauty of their coastlines. This interest in the topography of the British and Irish coasts predated the eighteenth century, but the sheer number of engraved views of coastal scenes in this period, including series by William Daniell and John Thomas Serres, indicates growing interest in defining the boundaries of Britain, and analysing its national as well as regional character.

Despite numerous differences, certain continuities linked the representation of London and other British ports. Indeed, several engravings depict London as merely the biggest link in the British chain of ports. The design of one early eighteenth-century engraving points out the connection between domestic, land-based trade and international, seaborne trade. Vignettes of some of the nation's most important ports – London, Chester, Bristol, Yarmouth, Southampton, Newcastle-upon-Tyne, Hull, Portsmouth, Harwich, Plymouth, Dartmouth, Falmouth, 'Dover Castle' and 'Leverpool' – surround a table of cities and market towns in England and Wales (see page 30).

Eighteenth- and nineteenth-century prints of British ports employed many of the conventions of earlier designs. Drawings or sketches 'done on the spot', with their promise of accurate topographical information, continued to form the basis of many engraved views of ports. Concern for accuracy was combined with

LONDON

CHESTER

BRISTOL

YARMOUTH

SOUTHAMPTON

NEW CASTLE upon TYNE

HULL

PORTSMOUTH

HARWICH

PLYMOUTH

DARTMOUTH

FALMOUTH

DOVER CASTLE

LEVERPOOL

An Alphabetical Table of all the CITIES and Market TOWNS in ENGLAND and WALES

An Alphabetical Table of all the CITIES and Market TOWNS in ENGLAND and WALES

'The Chart of Kingsale [sic] Harbour...'
Hand-coloured etching
Height 456 mm, width 578 mm
Designed by Captain Greenvile Collins and etched
by F. Harris; published *c.* 1693 (PAH 9868).

This beautiful chart of Kinsale Harbour in Cork,
Ireland was one of many designed by Greenvile
Collins to aid navigation of Britain and Ireland's
ports and harbours.

'An Alphabetical Table of all the Cities and
Market Towns in England and Wales'
Etching
Height 495 mm, width 590 mm
Etched by Sutton Nicholls; published *c.*1724
(PAH 2064).

Many of Britain's most important trading centres
were also ports, as this early eighteenth-century
table points out.

demand for aesthetically pleasing images. Captain Greenvile Collins's *Great Britain's Coasting Pilot* (1693), with its detailed plans of British and Irish harbours and coastlines, continued to be used for navigation and as a model for maps and plans of ports throughout the eighteenth century. A beautiful example of Collins's harbour plans is '...This Chart of Kingsale [sic] Harbour...' in Cork, Ireland (see above).

Another important influence on images of British ports was the prospect view, i.e. a view taken from an elevation. Engraved after the French artist Menageot, and published in 1740, 'A Prospect of Portsmouth' depicts a view of the town from a distant hill (see page 32). The design emphasises the viewer's position, and incorporates several figures, including an artist sketching in the lower right-hand corner, which lends authority to the print's claim to be a 'true' record.

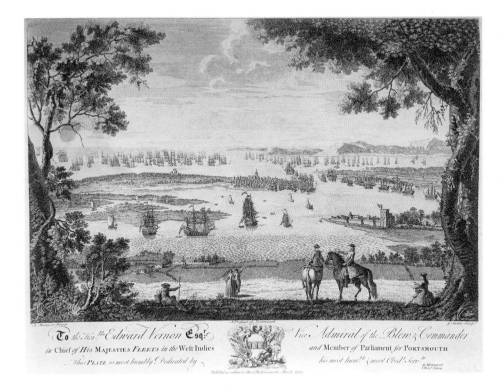

'A PROSPECT OF PORTSMOUTH'
Etching
Height 354 mm, width 461 mm
Designed by A. Menageot and etched by
G.(?Gérard) Scotin; published by A. Menageot on
16 March 1740 (PAH 2006).

As well as providing an elegant view of the harbour and town, this print draws attention to Portsmouth's dependence on the Royal Navy. Ships dominate the design, including a massive fleet standing guard between Portsmouth and the Isle of Wight in the background.

The inclusion of a fashionable couple on horseback admiring the view draws attention to the port's status as a sight that is worthy of artistic representation. The prominence given to the fort and the fleet is less an accurate representation of their size than an indication of their symbolic importance to the town, and, by extension, the nation. The print's dedication to 'The Hon:ble Edward Vernon Esqr: Vice Admiral of the Blew & Commander in Chief of His Majesties Fleets in the West Indies and Member of Parliament for Portsmouth' and recent victor against the Spanish at Portobello draws further attention to local links with the Royal Navy.

Many engravings were made of royal dockyards such as Portsmouth and Chatham in the eighteenth and nineteenth centuries. 'A View of His Majesty's Dock Yard at Chatham in the County of Kent, on the River Medway', by John Cleveley the younger, is one of many similar prints of royal dockyards published by the Bowles family of printsellers, often hand-coloured in lurid shades and sold from one to several shillings (see right). Chatham dockyard is shown from across the water and at roughly eye-level. The simple design, reasonable price and French and English captions meant such prints sold quite well both in Britain and abroad.

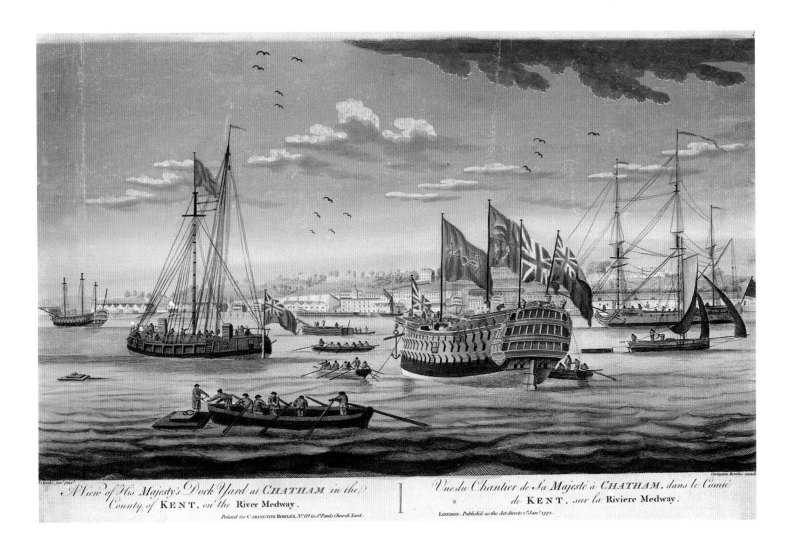

A View of His Majesty's Dock Yard at CHATHAM in the
County of KENT, on the River Medway.
Printed for Carington Bowles, No 69 in St Pauls Church Yard.

Vue du Chantier de Sa Majesté à CHATHAM, dans le Comté
de KENT, sur la Riviere Medway.
LONDON. Published as the Act directs 1st Jan 1772.

'A VIEW OF HIS MAJESTY'S DOCK YARD AT CHATHAM
IN THE COUNTY OF KENT, ON THE RIVER MEDWAY'
Title also in French
Hand-coloured engraving
Height 277 mm, width 411 mm
Designed by John Cleveley the younger; engraved
and published by Carington Bowles in London on
1 January 1772 (PAD 1035).

This brightly coloured engraving provides a close-
up look at one of the royal dockyards. A newly
launched warship decorated with flags awaits its
new mast, which will be loaded from the ship
on the left.

Many eighteenth- and nineteenth-century designs focus on the aesthetic as
well as practical features of commercial ports. In 1798 the marine artist John
Thomas Serres, son of the eminent marine painter and Royal Academician Dominic
Serres, produced a series of five elegant and expensive etched colour views of
Liverpool and Merseyside. The designs, crowded with ships and men, operate as
effective advertisements for Liverpool's role as a major port. Serres includes his
name on a plank of wood within one of the designs. Moreover, the inclusion of his
official title 'Marine Painter to his Majesty & His H.R.H. the Duke of Clarence',
and the dedication to an aristocratic patron, the Earl of Derby, indicate how promi-
nent names were used to promote the commercial success of prints (see page 34).

33

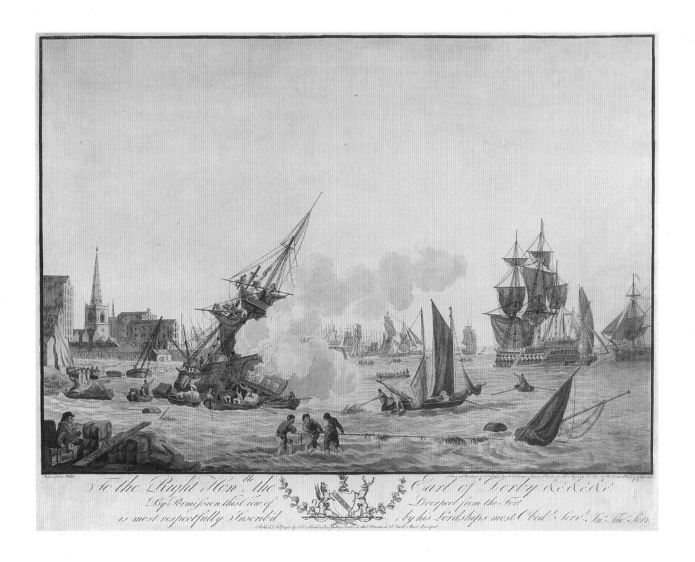

In the nineteenth century Liverpool developed as one of the major embarkation points for Britons, Irish and Scandinavians emigrating to America and Australia. Several contemporary prints depict emigrants boarding ships, and we will see a view of emigrants arriving in Sydney Harbour in Chapter Six. While such prints would have been too expensive for all but the wealthiest emigrants, interested local and national customers would have purchased them. Indeed, such images may have been promoted by shipping companies and local authorities who were trying to encourage emigration.

The civic pride evident in eighteenth- and nineteenth-century views of Liverpool can also be seen in contemporary prints of Newcastle, which grew

'...VIEW OF LIVERPOOL FROM THE FORT...'
Hand-coloured etching
Height 430 mm, width 558 mm
Designed and engraved by John Thomas Serres; published by Thomas Macklin in London and Robert Preston & Co. in Liverpool in February 1798 (PAH 9787).

In the left foreground of this view of Liverpool, the artist sketches the scene, which includes a ship listing to one side and on fire. Ships were often careened (tilted to one side) to clean their bottoms, but the frantic activity on and around this ship suggests an emergency.

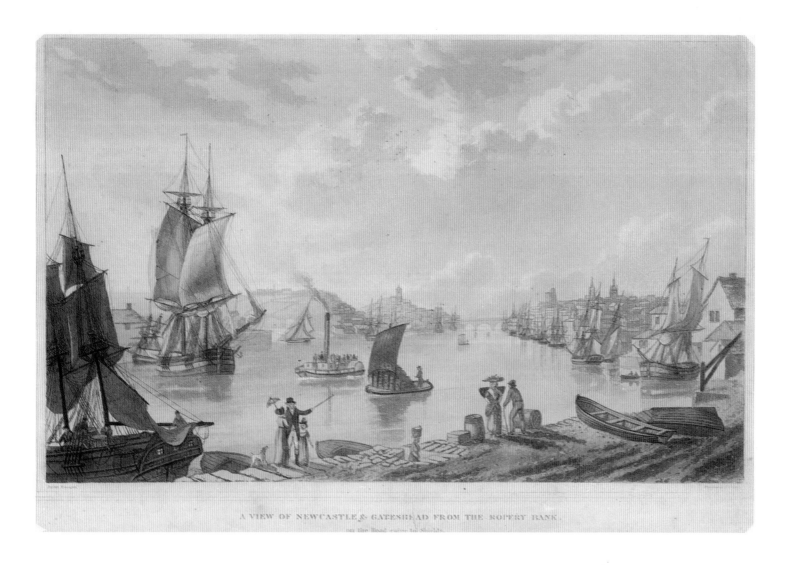

A VIEW OF NEWCASTLE & GATESHEAD FROM THE ROPERY BANK.
on the Road going to Shields.

'A VIEW OF NEWCASTLE & GATESHEAD FROM THE ROPERY BANK, ON THE ROAD GOING TO SHIELDS [SIC]'
Coloured aquatint
Height 264 mm, width 391 mm
Designed by (?Henry Perle) Parker and engraved by W. H. Timms; published in the early nineteenth century (PAD 1254).

This charming scene reflects the pride of local artists such as Henry Perle Parker, who worked to promote the arts in Newcastle. Spectators and a fishwife with a basket on her head stand on the riverbank, while behind them a variety of vessels, including a steamboat, ply the river.

substantially during this period to serve the expanding coal trade and new industrial development. Numerous engravings record the completion of local landmarks such as the cast-iron bridge spanning the River Wear. Early nineteenth-century prints such as 'A View of Newcastle & Gateshead from the Ropery Bank, on the Road going to Shields [sic]' by (?Henry Perle) Parker, engraved by W. H. Timms, depict the port as a scene of beauty as well as industry (see above). Ships, wharves and goods are all given prominence in the scene. Yet the careful arrangement of the expanse of water leading to the arched bridge in the distance, the steam tug and the family admiring the view convey the beautiful side of Newcastle. The atmosphere is of quiet prosperity rather than frenetic activity. Such a pleasant

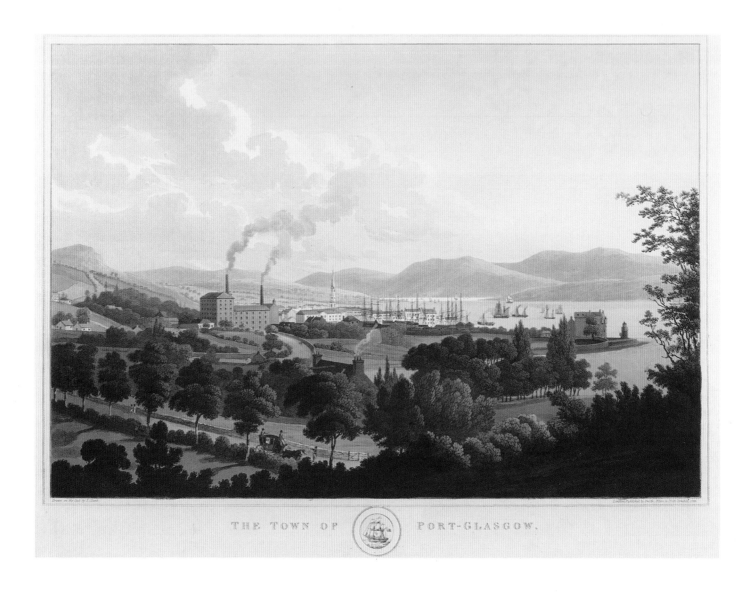

THE TOWN OF PORT-GLASGOW.

scene differs radically from later depictions of Newcastle as a bleak jumble of heavy industry. This design evinces local pride in Newcastle's manufacturing and trade network, and in its role as a northern metropolis. Such prints also boosted pride in regional ports and helped publicise officials' sense of civic pride and duty.

Early nineteenth-century views of Scottish ports, such as an 1825 colour aquatint view of Port Glasgow, part of a series by I. Clark, provide images of sleepy coastal towns that had only recently begun the transformation to major international ports (see above). More remote ports, such as Oban, gateway to the Scottish Highlands, were also represented in engravings. Lieutenant John Pierie, Royal

'THE TOWN OF PORT-GLASGOW'
Hand-coloured aquatint
Height 477 mm, width 624 mm
Designed and engraved by I. (?John) Clark; published by Smith, Elder & Co. in London in 1825 (PAH 9818).

Although soon to become a busy industrial port, in the early nineteenth century Glasgow was still a relatively small town. In this design, factory buildings with smokestacks share the landscape with houses, trees and ships on the river beyond.

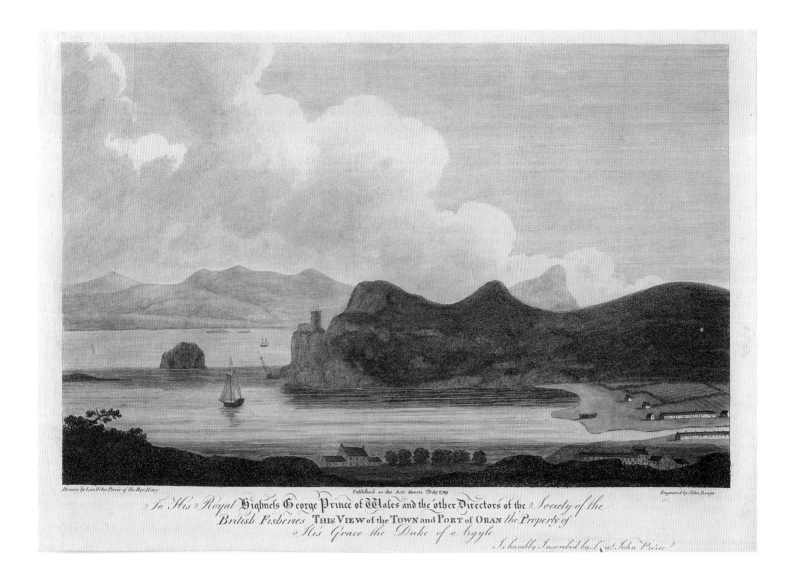

Drawn by Lieut John Pierie of the Roy Navy *Published as the Act directs 1 July 1789* *Engraved by John Beugo*

To His Royal Highness George Prince of Wales and the other Directors of the Society of the British Fisheries THIS VIEW of the TOWN and PORT of OBAN the Property of His Grace the Duke of Argyle Is humbly Inscribed by Lieut John Pierie

'…VIEW OF THE TOWN AND PORT OF OBAN …
Hand-coloured etching
Height 291 mm, width 399 mm
Designed by Lieutenant John Pierie, Royal Navy
and engraved by John Beugo; published on 1 July
1789 (PAH 2096).

This beautiful image of the small Scottish port of
Oban was probably intended to promote the local
fishing industry. Engravings were frequently used
to draw attention to commercial projects and
their sponsors.

Navy, evidently believed that a tranquil view of this modest port would appeal to patrons such as 'His Royal Highness George Prince of Wales and the other Directors of the Society of British Fisheries…' (see above). Irish ports were also usually represented as quiet havens rather than bustling port communities. Still, pride in Belfast's and Dublin's new port facilities was conveyed in contemporary prints. One of a series of colour prints of Dublin's riverfront emphasises the beauty as well as commercial success of its central quays (see page 38).

As home of the East Coat herring fleet, Hull featured in several eighteenth- and nineteenth-century prints. Many engravings of Hull combine reverence for

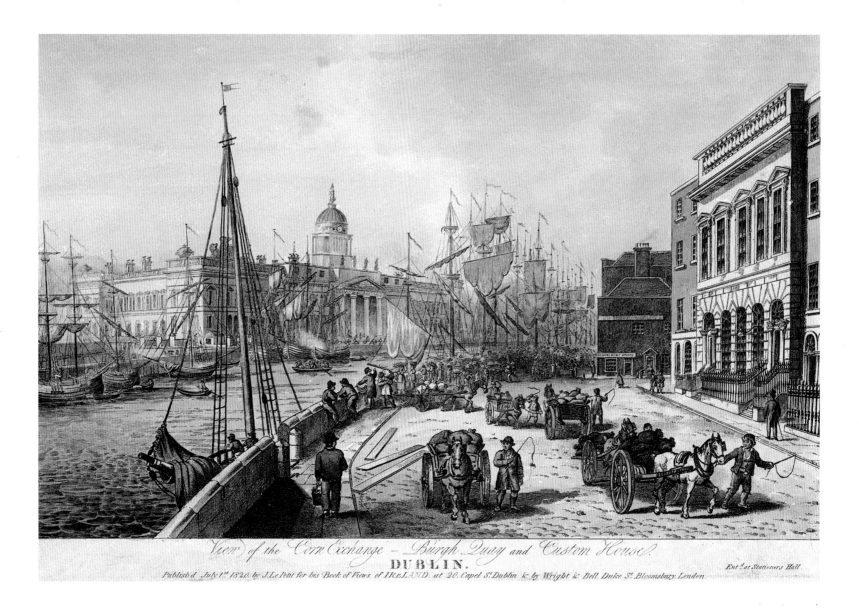

View of the Corn Exchange – Burgh Quay and Custom House.
DUBLIN.

Publish'd July 1st 1820 by J.Le Petit for his Book of Views of IRELAND, at 20. Capel St Dublin & by Wright & Bell. Duke St Bloomsbury London. *Entd at Stationers Hall.*

the practical details of new port facilities – bridges and docks – with appreciation of their aesthetic elements. In addition to British artists, European artists such as Balthasar-Friedrich Leizelt produced views of Hull, demonstrating its international reputation (see page 39).

Prints of British ports often fulfill a variety of functions, including entertainment, civic pride and interest in new technology. Ramsgate, a Kent coastal town better known as a holiday resort than a commercial port, was the subject of prints

'VIEW OF THE CORN EXCHANGE – BURGH QUAY AND CUSTOM HOUSE. DUBLIN'
Coloured etching
Height 234 mm, width 340 mm
Published by J. Le Petit for his *Book of Views of Ireland* and by Wright & Bell on 1 July 1820
(PAD 1467).

Dublin was a bustling port in the early nineteenth century, as this print reveals. In the city centre, horses draw wagons loaded with goods on a road by the river, where many ships are berthed.

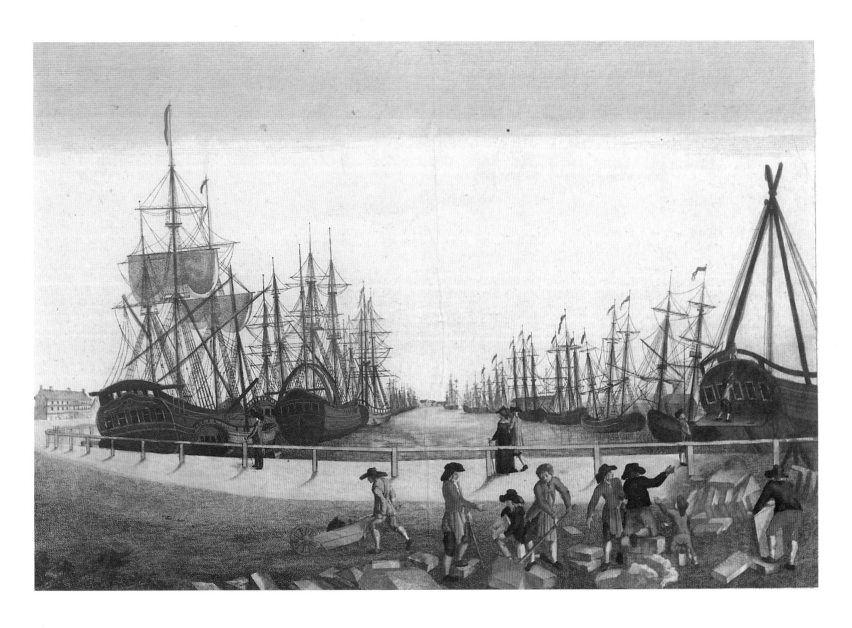

'Vuë de l'Ouest du Nouvel-Arsenal de
Kingiston [sic] sur l'Hull'
View from the West of the New Arsenal of
Kingston on Hull
Hand-coloured etching and engraving
Height 313 mm, width 403 mm
Designed and engraved by Balthasar-Friedrich
Leizelt; published by Georg Balthasar Probst,
c.1780 (PAH 2090).

Hull, on Britain's northeast coast, was famous
throughout Europe for its fishing fleet, which
featured in many prints like this one.

which included details of the harbour's technical features as well as its aesthetic
delights. Francis Jukes's aquatint and etching of 1787 provides a delightful and
informative souvenir of the town for affluent visitors (see page 40). The eighteenth
and nineteenth centuries saw the massive increase in popularity of south coast
resorts such as Ramsgate, Weymouth and Margate. Seaside resorts sprang up in
sleepy villages as well as established ports, and both attracted the eye of artists and
engravers eager to supply the growing demand for views of British ports. Artists

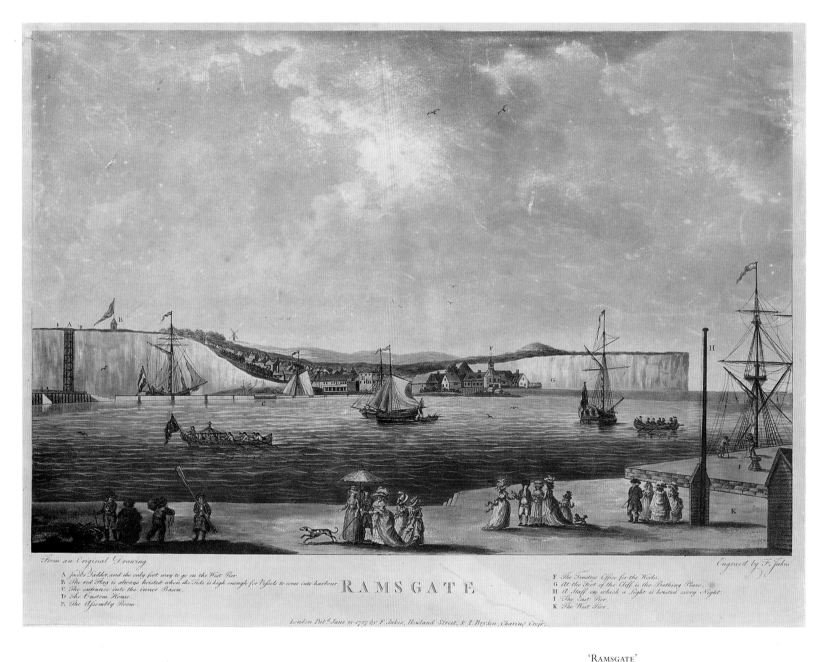

From an Original Drawing

Engraved by F. Jukes

A *Jacob's Ladder, and the only foot way to go on the West Pier.*
B *The red Flag is always hoisted when the Tide is high enough for Vessels to come into harbour.*
C *The entrance into the inner Basin.*
D *The Custom House.*
E *The Assembly Room.*

F *The Trustees Office for the Works.*
G *At the Foot of the Cliff is the Bathing Place.*
H *A Staff on which a Light is hoisted every Night.*
I *The East Pier.*
K *The West Pier.*

RAMSGATE

London Pub.d June 21 1787 by F.Jukes, Howland Street, & I.Brydon, Charing Cross.

were quick to turn the British royal family's interest in the seaside to their advantage by creating beautiful views of seaside towns; thus John Thomas Serres dedicated an elegant aquatint view of Weymouth to his patron King George III in 1803. While initially a royal and primarily aristocratic pastime, visits to seaside resorts soon broadened to include ordinary folk. By the mid-nineteenth century

'RAMSGATE'
Aquatint and etching
Height 319 mm, width 426 mm
Engraved by Francis Jukes from an original drawing; published by Francis Jukes and I.(?John) Brydon in London on 21 June 1787 (PAH 1955).

This lively view of Ramsgate includes a key below the design which describes the Kent port's facilities for both shipping and tourists.

'A TRIP TO MARGATE PL 2D BY PAUL PRY ESQR'
Hand-coloured etching
Height 286 mm, width 425 mm
Bound in a pamphlet published by Thomas McLean
in London in the early nineteenth century
(PAF 3869).

Londoners' expeditions to Margate and other
nearby coastal resorts were a popular subject of
eighteenth- and nineteenth-century caricatures.
This group of nine vignettes includes, in the
lower left-hand corner, a view of a bathing machine
in use.

41

ports close to London such as Margate catered primarily for working-class patrons. Margate's reputation as a rough-and-ready resort was furthered by the creation of humorous caricature series such as 'A Trip to Margate Pl 2d by Paul Pry Esqr' (see page 41). Such designs record the central role of seaside resorts in expanding the leisure opportunities for all classes in Britain over the course of the eighteenth and nineteenth centuries.

While most were clustered along the south coast, seaside resorts did appear on other parts of the British coastline. An early example of a northern resort is depicted in Samuel and Nathaniel Buck's engraving 'The South Prospect of Scarborough in the County of York', published in 1745 (see above). Scarborough was a well-established market town, but in the mid-eighteenth century it developed facilities for sea bathing, including the wagons known as 'bathing machines' visible in the Bucks' design. Likewise several seaside towns in Wales developed facilities for tourists which were recorded in contemporary prints. Elegant and aesthetically pleasing designs such as a '…View of the Town of Aberistwith [sic]…' depict ambitious holiday spots. Like Scarborough, Aberystwyth boasts bathing machines and a row of buildings on a hill. Such engravings demonstrate how a

'THE SOUTH PROSPECT OF SCARBOROUGH IN THE COUNTY OF YORK'
Etching
Height 313 mm, width 811 mm
Designed and etched by Samuel and Nathaniel Buck; published in London on 15 April 1745 (PAH 9811).

Scarborough's early development as a bathing resort is described here. The view of wagons on the beach is one of the first recorded depictions of 'bathing machines' at a British resort.

'…VIEW OF THE TOWN OF ABERISTWITH [SIC]…'
Coloured aquatint
Height 270 mm, width 339 mm
Engraved by J.(?John) Hassell; published by T. Jones and by J.(?John) Hassell in London on 1 January 1796 (PAD 1181).

This quaint view advertises Aberystwyth's modest pretensions as a seaside resort. The reluctant horse in the foreground suggests that not everyone was convinced of the Welsh resort's charms!

Drawn & Engrav'd by J.Hassell.

TO THE Rt HON. LORD VISCt BATEMAN

This View of the Town of Aberistwith, is by permission humbly inscribed

by His Lordship's Most obt & devoted Servt.

T. Jones & J.Hassell.

London, Publish'd Jan.r 1st 1796, by T.Jones, No.23, Clarges Street & J.Hassell, at Mrs Walkers, Printseller, Cornhill.

range of small and hitherto obscure coastal settlements came to national attention in the eighteenth century (see page 43).

Ports are often represented as havens – for both men and vessels – from the physical dangers of the sea. An engraving of lifeboats going to the assistance of storm-tossed ships near Lowestoft, Suffolk, combines civic pride in the local humanitarian society with excitement at the awesome majesty of the storm; spectators gather on the beach to watch the struggle between man and nature. Similarly, a late eighteenth-century view of Plymouth acknowledges the death and devastation caused by a recent storm.

Ports also appear as refuges from the loneliness of life at sea. Caricatures frequently represent ports not as specific locations but as atmospheres of warmth and security. In 'Men of War, Bound for the Port of Pleasure', for example, British sailors, or 'Men of War', relax in the company of prostitutes, who literally embody their 'port of pleasure' (see right). While the depiction of women picking the sailors' pockets indicates that there are dangers as well as pleasures in this port, the overall tone of the design is comical rather than critical. This design is one of many eighteenth- and nineteenth-century engravings showing British sailors relaxing in the company of prostitutes in port. These prints suggest that the role of the port as a centre for sexual services as well as a psychological refuge from the stresses of shipboard life is both inevitable and beneficial.

The strong links between both port and local community and port and national community are evident in an early nineteenth-century engraving entitled 'A View of Falmouth and Places Adjacent' (see pages 46-47). This image is both local and national in its focus. It is local in the sense that it depicts a specific port, Falmouth in Cornwall, and the topographical and physical details of the surrounding area. Moreover, this design was published in Falmouth itself rather than London, which suggests that it was intended for a local audience. But the design is national in the sense that it incorporates elements that link Falmouth with other British ports, and with British priorities and values. Falmouth's small size and rural atmosphere were features shared by most British ports before the mid-nineteenth century. Specifically, the presence of the fort with the Union Jack on top of the hill, the docks and port buildings, and above all the ships passing to and fro highlight Falmouth's role as a link in a national chain of naval and commercial ports.

'Men of War, Bound for the Port of Pleasure'
Hand-coloured mezzotint'
Height 347 mm, width 250 mm
Published by Carington Bowles in London on 25 April 1791 (PAF 4036).

This is one of many eighteenth-century caricatures which humorously record sailors' adventures in British ports. A poster on the wall advertising a coach service indicates that the scene takes place in either Gravesend or Chatham, near London.

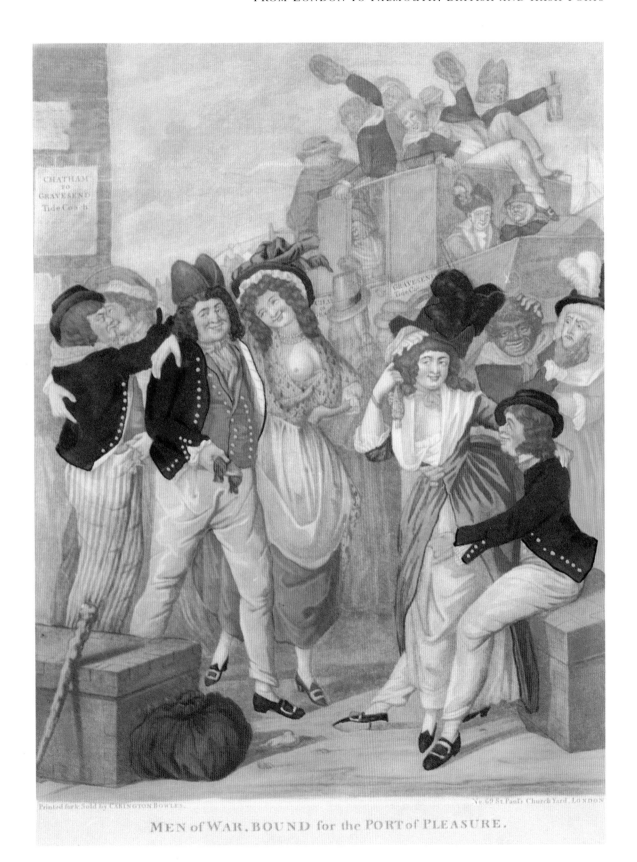

MEN of WAR, BOUND for the PORT of PLEASURE.

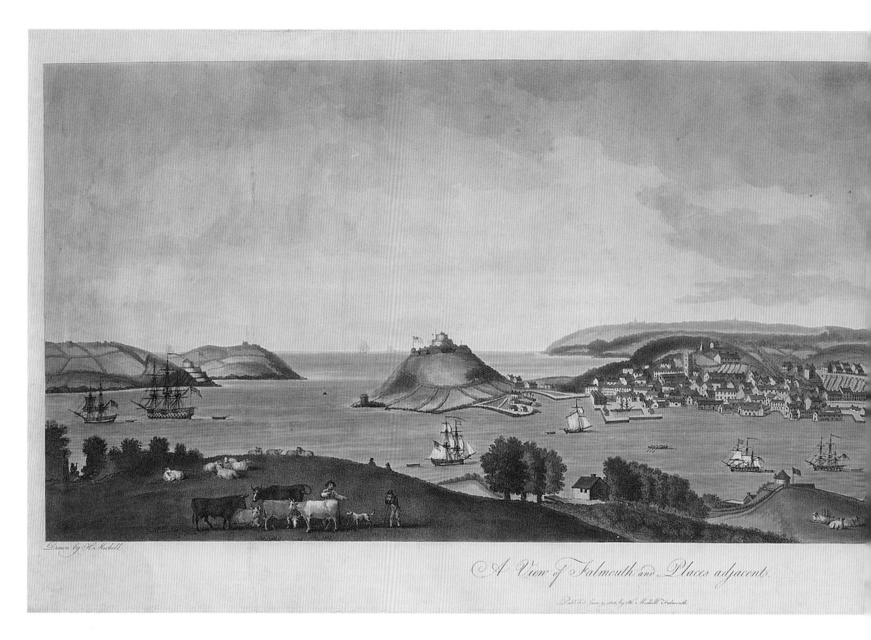

Drawn by H. Michell

A View of Falmouth and Places adjacent.

Publish'd June 9, 1806 by H. Michell, Falmouth

'A VIEW OF FALMOUTH AND PLACES ADJACENT'
Hand-coloured aquatint and etching
Height 306 mm, width 752 mm
Designed by H. Michell and engraved by Robert
Pollard; published by H. Michell in Falmouth on
9 June 1806 (PAI 7111).

The small port of Falmouth, in Cornwall, is
affectionately represented here by a local artist.
Falmouth's harmonious combination of land,
ocean, people and ships is a microcosm of Britain's
own close relationship with the sea.

Conclusion

Political and commercial developments brought important changes to British and Irish ports in the eighteenth and nineteenth centuries. Small coastal settlements developed into some of the world's largest and most important trading ports, and the home of the world's most powerful navy. These developments are well represented in the many contemporary prints produced for consumption at home and export abroad. Pride, industry, humour and fear are all expressed in these images, which make them such a valuable tool for understanding contemporary society. Yet other ports also beckoned to the British and Irish people. Many of the professional artists, military and naval officers, emigrants and tourists who produced views of ports around the world came from Britain and Ireland. Their views of foreign ports were often shaped by their knowledge of, and familiarity with, British and Irish ports. Closest to home were the ports of Northern Europe. These ports were attracting the attention of both foreign and local artists and engravers in this period, and will be considered in the next chapter.

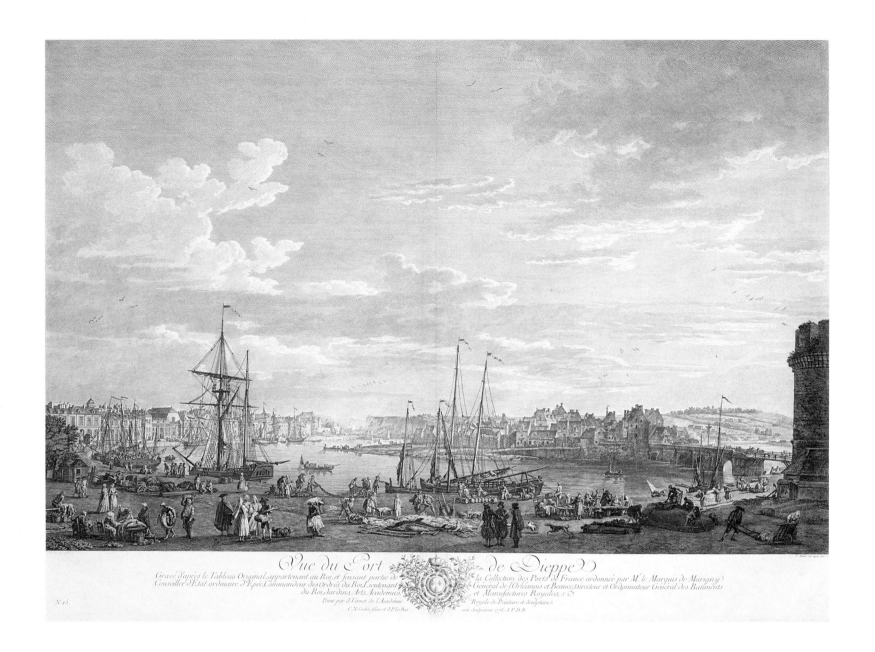

Vue du Port de Dieppe

Gravé d'après le Tableau Original, appartenant au Roi, et faisant partie de ... la Collection des Ports de France ordonnée par M.^r le Marquis de Marigny, Conseiller d'Etat ordinaire d'Epée, Commandeur des Ordres du Roi, Lieutenant ... Général de l'Orléanois et Beauce, Directeur et Ordonnateur Général des Batiments du Roi, Jardins, Arts, Académies, ... et Manufactures Royalles.

N. 15.

Peint par J. Vernet de l'Academie

C.N. Cochin filius et J.P. Le Bas

Royalle de Peinture et Sculpture.

cum Sculpserunt 1776. A.P.D.R.

'Vue du Port de Dieppe...Plate No. 15'

View of the Port of Dieppe...

Engraving and etching

Height 547 mm, width 757 mm

Painted by Claude-Joseph Vernet in 1765, engraved by Pietro Antonio Martini in 1775, engraved by Charles-Nicolas Cochin (the younger) and Jacques-Philippe Le Bas; published *c*.1778 (PAI 7135).

This magnificent view of Dieppe expresses French pride in their port system, and demonstrates how ports could be the subject of grand paintings. Vernet's series of views influenced the representation of many other ports.

48

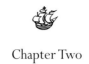

Chapter Two

Beyond the Channel

Northern European Ports

Beyond Britain and Ireland, French, Dutch, German and a host of other northern European ports were explored in eighteenth- and nineteenth-century prints. Styles varied enormously, from Claude-Joseph Vernet's elegant series of the Royal Ports of France to quaint views of Scandinavian ports. Despite considerable aesthetic differences, most engravings worked to enhance a nation's prestige by depicting its ports in a glorious manner. In addition to local engravers, many British artists produced views of northern European ports. Such prints indicate the close relationships developing between Britain and its European neighbours – as commercial partners, naval allies and, inevitably, rivals. As Britain's commercial and naval dominance increased over the course of the eighteenth and nineteenth centuries, British engravings tended to be less concerned with the commercial and naval capacities of European ports and more with their picturesque appearance.

French Ports

Given France's contemporary political might and its venerable naval tradition, it is not surprising that French ports appear frequently in eighteenth- and nineteenth-century engravings. While many prints of French ports were produced, the crowning achievement was undoubtedly Claude-Joseph Vernet's mid-eighteenth-century series of the Royal Ports of France. Engraved after his huge oil paintings, Vernet's views of ports such as Bordeaux, Cette, Dieppe, Marseilles, Toulon and La

Rochelle demonstrate the magnificence of Louis XV's absolutist French state. France's commercial and naval strength is acknowledged through detailed images of wharves, cargoes and ships. Yet the emphasis of the engravings is on the majesty of the French King and his 'Ministre de la Marine'. Rather than accurate scenes of everyday life in French ports, Vernet's designs display a theatrical quality. Aristocrats are placed near labourers in the central foreground of the designs as if on a stage, and Vernet gives as much attention to their dress as to the work going on in the ports. Such grand views of ports were an innovation, promoting French pride in their national ports and inspiring many other artists to emulate Vernet (see page 48).

One particularly notable contemporary of Vernet was Nicolas-Marie Ozanne, who, with the assistance of members of his talented family, including his brother-in-law Yves-Marie Le Gouaz, made several engravings of French ports among a host of other maritime subjects. These prints lack the grand scale and aristocratic tone of Vernet's engravings, and would have been sold in a greater variety of sizes and price levels to a wider range of customers. Ozanne's designs nevertheless constitute an impressive statement of national pride in French ports, as his detailed view of people and ships in Nantes harbour demonstrates (see right). Neither Vernet's nor Ozanne's series had any real counterpart in Britain, which may explain why British printsellers such as John Boydell chose to publish inexpensive versions of Vernet's series for sale in Britain. Government support for marine artists remained less generous in Britain than in France. Early nineteenth-century artists and engravers such as William Daniell, Robert Havell and Joseph Mallord William Turner turned to public subscriptions and private patrons to finance their series of engravings of British ports. Despite Britain's growing naval and commercial superiority, in terms of grand engravings of ports, mid-eighteenth-century France led the world.

In addition to views that accentuated the grandeur of the French port network, many engravings focussed on the commercial and strategic advantages of individual ports. Artists drew particular attention to the role of the Atlantic ports as commercial gateways to France, and as launching pads for, and buttresses against, invasion attempts. A colour map (1693) of the coast and islands near St Malo with cartouche and insets by the acclaimed Dutch engraver Romeyn de Hooghe provides a beautiful yet practical image of the seaport, useful for Dutch

Nt Ozanne del.

Y le Gouax sculp.

LE PORT DE NANTES

Vu du Chantier de Construction de la Fosse

Réduit de la Collection des Ports de France dessinés pour le Roi en 1776.

Par le St. Ozanne Ingénieur de la Marine Pensionnaire de Sa Majesté.

A Paris chez le Gouaz Graveur rue St Hyacinte la 1re Porte cochere à gauche par la Place St Michel. 15.

'LE PORT DE NANTES…'

The Port of Nantes…

Etching and engraving

Height 291 mm, width 757 mm

Designed by Nicolas-Marie Ozanne and engraved

by Yves-Marie Le Gouaz; published in Paris,

c.1776 (**PAD** 1513).

Nantes featured in several eighteenth-century French engravings, including this one which records the various activities in the harbour. People gather and sell fish, navigate boats and repair ships, and admire the view.

'LA CARTE IV. CARTE NOUVELLE DES COSTES DE
BRETAGNE, DEPUIS ST MALO JUSQUES À L'EM-
BOUCHEURE DE LA RIVIÈRE DE LOIRE...'
*Map 4. New Map of the Coasts of Brittany, from St Malo
to the mouth of the Loire River...*
Hand-coloured etching
Height 602 mm, width 948 mm
Etched by Romeyn de Hooghe; published by Pierre
(Pieter) Mortier in 1693 (PAI 9969).

Detailed and expensive maps such as this one of
the coast of Brittany demonstrate the importance
of accurate navigational tools and the high status of
engraving in early modern Europe.

and English mariners and merchants as well as print collectors (see left). Likewise an engraved map of Bordeaux, an important port in the wine trade, combines accurate detail with aesthetic elegance. Many prints focused on specific historical events, such as the laying of a cone in the road (channel) to Cherbourg in 1785. While the French Revolution was rarely mentioned directly, the age-old rivalry between France and Britain continued to feature prominently in views of French ports. Patriotism flavoured many prints of ports, including a plan of Dunkirk as it looked prior to its demolition by the British in 1714. Similarly, a pair of coloured proofs depict Napoleon's fleet in harbour *c*.1800, preparing for an attempted invasion of Britain.

While these prints combine aesthetic appeal with practical detail, other views of Atlantic French ports celebrate the beauties of the local landscape. The British marine artist Nicholas Pocock, highly regarded for his accurate detail and elegant use of colour, produced many watercolour and oil harbour views which were reproduced as aquatints. They include a delightful image of the Isles of St Marçou, off France's west coast, published in 1798. Twenty or so years later another acclaimed British artist, Richard Parkes Bonington, produced a lively view of Rouen. Pocock and Bonington were as interested in these areas' aesthetic qualities as much as their status as seaports. As the nineteenth century proceeded, views of French seaports continued to stress their visual as well as their commercial appeal. Thus, while a view of Boulogne of 1834 was dedicated by the artist to the local

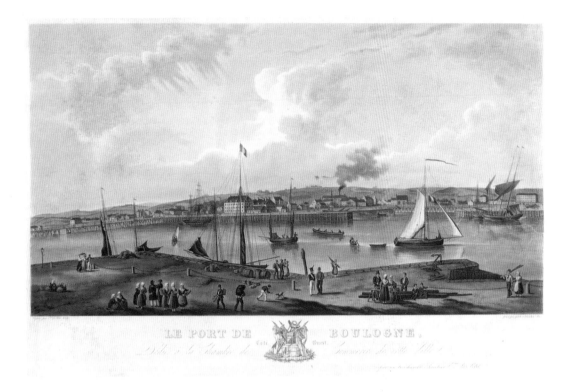

'LE PORT DE BOULOGNE. CÔTÉ OUEST'
The Port of Boulogne. West Side
Hand-coloured aquatint
Height 347 mm, width 527 mm
Designed by Etne Le Petit in 1834 and engraved by
(?Johann N.) Gibèle and (?Jules-Gabriel) Douchin;
published in Paris c.1834 (PAH 9965).

Boulogne's position on the English Channel
boosted its commercial development, which in
turn inspired engravings like this one celebrating
the port's success in trade.

chamber of commerce, indicating the influence of local commercial interests
(see above), a mid-nineteenth-century view of a storm at St Malo focussed on the
dramatic atmosphere of the forces of nature rather than on its disruption of the
town's trade.

Dutch Ports

Engraved images of Dutch ports are also plentiful. Many date from the seven-
teenth and eighteenth centuries, the apogee of Dutch commerce and culture. If
Britain was the up-and-coming maritime nation in the eighteenth century and the
clear leader in the nineteenth century, the Netherlands occupied that position in
the seventeenth and at least part of the eighteenth century. As a centre of
European trade and the original gateway to the East Indies and Africa, the
Netherlands long remained the world's premier trading nation. Among many
other proofs of their success, high-quality engravings demonstrate Dutch
commercial and cultural supremacy.

'AMSTELODAMUM VETUS ET NOVISSIMUM…'
Map of Amsterdam with inset view
Hand-coloured engraving and etching
Height 500 mm, width 589 mm
Engraved by Carel Allardt; published in 1675
(PAH 9933).
The many canals and ships on this vividly-coloured
map of Amsterdam emphasise the Dutch capital's
close links with the sea.

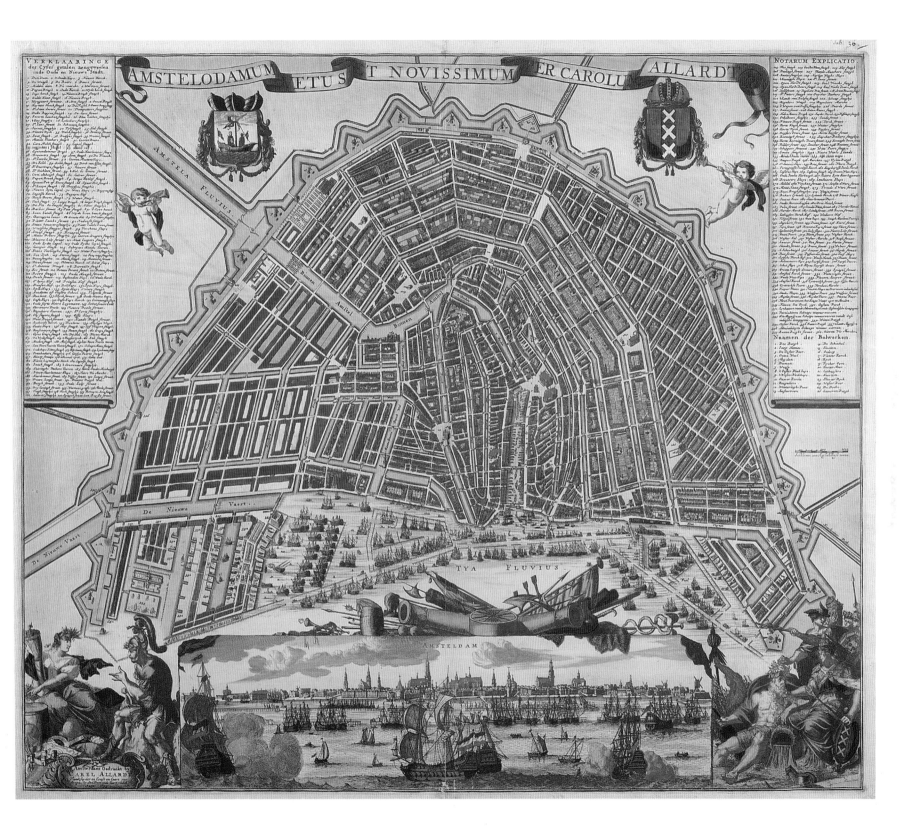

Views of Amsterdam – London's predecessor as the centre of world trade and long the home of the world's most powerful navy – are particularly abundant. A 1675 colour city plan with insets of ships fully demonstrates Amsterdam's dependence on the sea for its wealth and power (see page 55). As with views of the port of London, buildings associated with trade are featured prominently in engravings. Thus 'A Perspective View of the Admiralty Office, Dock-Yard, Storehouses &c at Amsterdam' was 'engraved for Middleton's Complete System of Geography'. Views of the Dutch East India Company (VOC) building were also popular, as were maps of Amsterdam's extensive canal network. Other prints depict the launch of new ships, as for example a beautiful colour etching which depicts spectators watching the launch of three VOC ships in Amsterdam harbour in 1783 (see below). Interest in views of Dutch ports was not confined to Britain or the Netherlands, indeed many prints have titles in French as well as English or Dutch, indicating that they were designed for foreign as well as domestic viewers. Thus

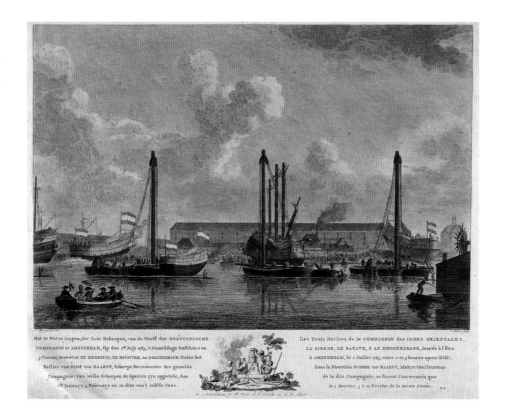

'Les Trois Navires de la Compagnie des Indes Orientales, La Sirene, Le Batave & Le Doggersbank lances à l'Eau à Amsterdam, le 2 Juillet 1783'

The Launch of Three Ships of the Dutch East India Company, La Sirene, Le Batave & Le Doggersbank, at Amsterdam, 2 July 1783 …

Hand-coloured etching

Height 433 mm, width 508 mm

Designed by J.(?Jurriaan) Andriesson and engraved by C.(?Cornelis) Brouwer; published by P.(?Pierre) Yver, F. W. Greebe and J. W. Smit (PAH 2224).

The ships of the Dutch East India Company were a symbol of the republic's trading might and a source of great pride. Ship launches drew sizable crowds and were occasions for public celebration.

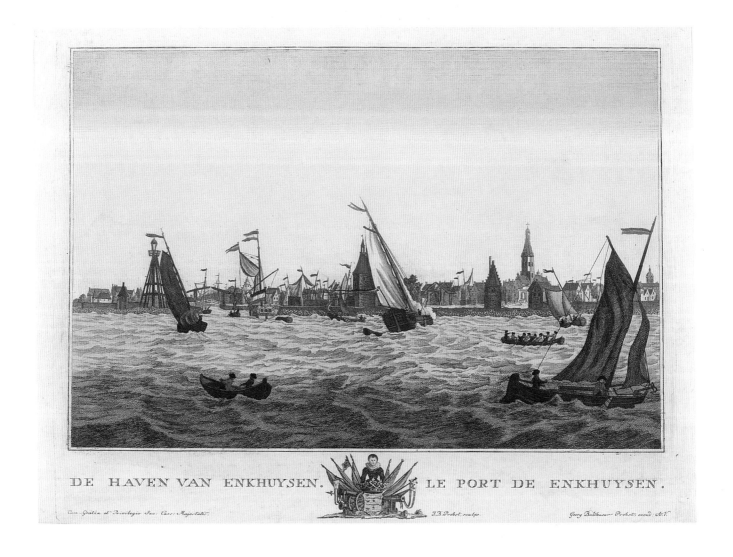

DE HAVEN VAN ENKHUYSEN. LE PORT DE ENKHUYSEN.

'DE HAVEN VAN ENKHUYSEN. LE PORT DE
ENKHUYSEN'
The Port of Enkhuizen
Hand-coloured etching
Height 317 mm, width 419 mm
Etched by F. B. Probst; published by Georg
Balthasar Probst in the late eighteenth century
(PAH 2215).

This view of ships off Enkhuizen in a brisk wind
was one of several prints of Dutch ports designed
for foreign as well as local viewers.

Georg Balthasar Probst published a series of colour etchings of Dutch ports such as Enkhuysen (Enkhuizen) and Edam with titles in both Dutch and French (see above).

Other major Dutch and Belgian ports such as Rotterdam, Zien, Ostend, Bruges and Antwerp, as well as many smaller ports, featured in contemporary engravings. Commerce is emphasised in the pair of eighteenth-century aquatint views of 'the Island of Texel in Holland' (see page 58) and 'the Port of Helvoetsluys in Holland'. This pair is noteworthy because it combines the authority of someone involved in Anglo-Dutch trade – 'Drawn by S. Hutchinson Esqr. Agent &c, &c, to His Majesty's Packet Boats at the Brielle in Holland' – with dedications to two

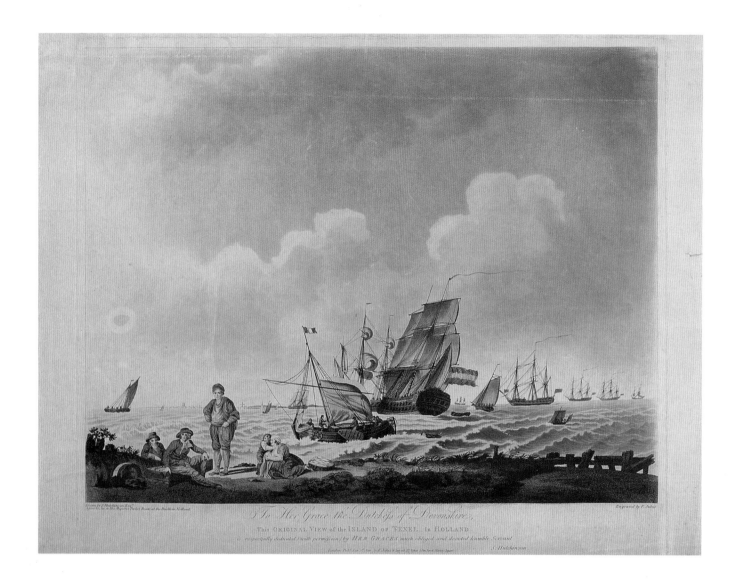

To Her Grace the Dutchess of Devonshire,

This ORIGINAL VIEW of the ISLAND of TEXEL in HOLLAND

is respectfully dedicated with permission by HER GRACES much obliged and devoted humble Servant.

S. Hutchinson.

British aristocratic women, 'Her Grace the Dutchess [sic] of Devonshire' and 'the Right Honble. the Countess of Bessborough'. Such lofty patrons for these engravings may indicate that the artist had special connections with these families, but it also suggests that views of Dutch ports were considered worthy artistic subjects, graceful enough for a duchess and a countess to support publicly. At the more humble end of the spectrum were engravings such as 'Going into the Port of Flushing' which was included in 'A New Book of Shipping', sold cheaply at one shilling by the London printseller Robert Sayer. At such a low price, this set of

'...ORIGINAL VIEW OF THE ISLAND OF TEXEL – IN HOLLAND...'
Aquatint and engraving
Height 433 mm, width 508 mm
Drawn by S.(?Samuel) Hutchinson and engraved by Francis Jukes; published by Francis Jukes and Sarjent in London on 1 January 1810 (PAH 9927).

Places such as the island of Texel became familiar through engravings which celebrated the many trading links between Britain and Holland. This design gives less attention to the island itself than to the shipping off its coast.

engravings would have been affordable to middle and even some lower middle-class customers. In addition to being commercially important, the lands today known as Belgium and the Netherlands were famous as the site of bitter struggles with European powers such as the Spanish Habsburgs. Historical events were recorded in visual as well as written form, thus 'Newport a Strong Sea-Port Town in Flanders, restore[d] to the Empire by ye Treaty of Utrecht. For Mr. Tindale's Continuation of Mr. Rapin's History of England'.

Although today it is evident that the Netherlands' trading empire and naval strength were declining steadily in the eighteenth century, this was not obvious to contemporaries. Continuing faith in Dutch commercial acumen explains the large number of British engravings of Dutch ports. It was not until the dramatic events of the 1790s, when the Dutch state surrendered to the invading army of Revolutionary France, that the Netherlands' demise as a world power was made both certain and clear. By the early nineteenth century, views of Dutch ports tended to emphasise their aesthetic appeal rather than their commercial capacity. Thus a view of the harbour of Medenblik depicts ships in a town canal with spectators in the foreground. Such quiet, beautiful scenes focus on the local rather than international dimensions of these ports. Whereas prints of British ports increase in the nineteenth century, prints of Dutch and Flemish ports become less frequent, mirroring the Netherlands' decline in trade during and after the Napoleonic Wars. In engravings as in so much else, the seventeenth and eighteenth centuries were the Netherlands' 'golden age'.

German Ports

While German ports were fewer in number and generally of a smaller size than British, French and Dutch ports, their frequent representation in engravings indicates considerable pride in their commercial facilities and aesthetic qualities. From the middle ages German ports developed as important centres of European trade, many as members of the powerful Hanseatic League, a group of north German towns linked to promote and protect their mutual trade interests. The Hanseatic port of Lübeck appeared in one of the earliest series of engravings, a set of hand-coloured woodcut views from the Nuremburg Chronicle, published in 1493 (see page 60, top). Another engraving from the same series depicts Lübeck

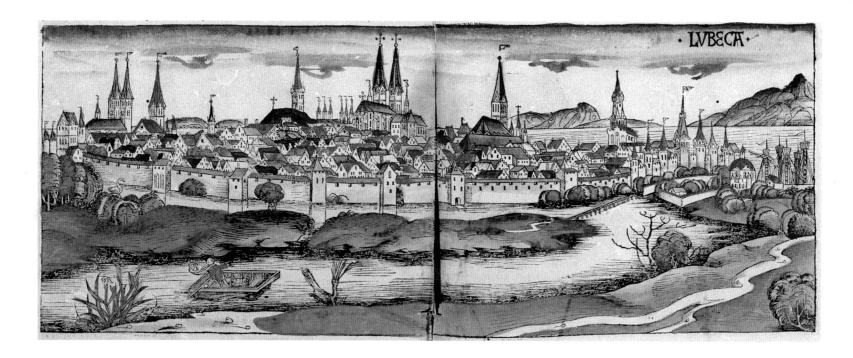

VIEW OF LÜBECK, CRACOW AND NISSA
from The Nuremberg Chronicle *by Hartmann Schedel*
Hand-coloured woodcut
Height 450 mm, width 610 mm
Designed and engraved by Michael Wolgemut and
Wilhelm Pleydenwurff; published by Anton
Koberger in 1493 (PAD 8329).

As early as the fifteenth century engravings were
made to accompany written accounts of Baltic
ports. The cluster of ships' masts visible on the
right-hand side of this design draws attention to
Lübeck's role as a trading centre.

VIEW OF THE HANSEATIC PORTS
from The Nuremburg Chronicle *by*
Hartmann Schedel
Hand-coloured woodcut with text in Latin
Height 450 mm, width 617 mm
Designed and engraved by Michael Wolgemut and
Wilhelm Pleydenwurff; published by Anton
Koberger in 1493 (PAD 8324).

The Hanseatic League of north German ports
was one of the most successful commercial
organisations in medieval Europe, and
contemporary engravings such as this one
advertised its trading might.

as one of a chain of Hanseatic ports (see above). Lübeck's continuing importance
as a centre of maritime trade was demonstrated by an etching published *c.*1580,
whose Latin title describes Lübeck as an imperial city and Free House town.
Likewise, a *c.*1580 plan of Bremen describes the city in terms of its membership
in the Hanseatic League. Long after the Hanseatic League had lost its influence,

'PLAN DER REICHSSTADT BREMEN. PROSPECT DER
STADT BREMEN'

Plan and View of the City of Bremen, Plate No. 116
Engraving
Height 227 mm, width 378 mm
Published in (?)1764 (PAD 1740).

Unlike many former members of the Hanseatic
League, the north German port of Bremen
continued to prosper, as this print published in
the mid-eighteenth century demonstrates.

however, German ports remained popular subjects of engravings. Thus Bremen
appeared in a chart, published in the mid-eighteenth century, which underlines
the importance of its geographical position (see above). Kiel was another major
German port, seen in an etching as early as c. 1600. But it was the Crimean War
that prompted engravers to focus on Kiel. A series of vivid hand-coloured
lithographs depicted the French and British fleets at Kiel Harbour in May 1854,
including 'The French Squadron at Bellevue Kiel harbour, 20th of May
1854' (see page 62). Later still the versatile British artist William Lionel Wyllie
produced several fine watercolour views of shipping in Kiel harbour.

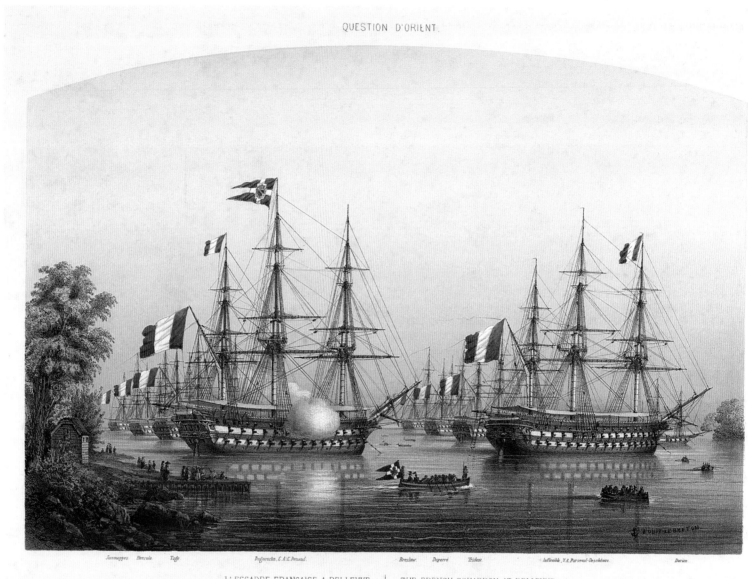

QUESTION D'ORIENT.

L'ESCADRE FRANÇAISE A BELLEVUE † THE FRENCH SQUADRON AT BELLEVUE

Rade de Kiel, 20 Mai 1854 . 1 Kiel harbour, 20ᵗʰ of May 1854 .

'QUESTION D'ORIENT. L'ESCADRE FRANÇAISE A
BELLEVUE RADE DE KIEL, 20 MAI 1854'
The French Squadron at Bellevue Kiel harbour,
20th of May 1854
Hand-coloured lithograph
Height 448 mm, width 630 mm
Designed by Louis Le Breton; published by
François Delarue and E. Gambart & Co. *c.*1854
(PAH 8239).

War frequently inspired prints of ports. This
lithograph depicts French warships with brightly
coloured tricolour flags in the German port of Kiel
during the Crimean War.

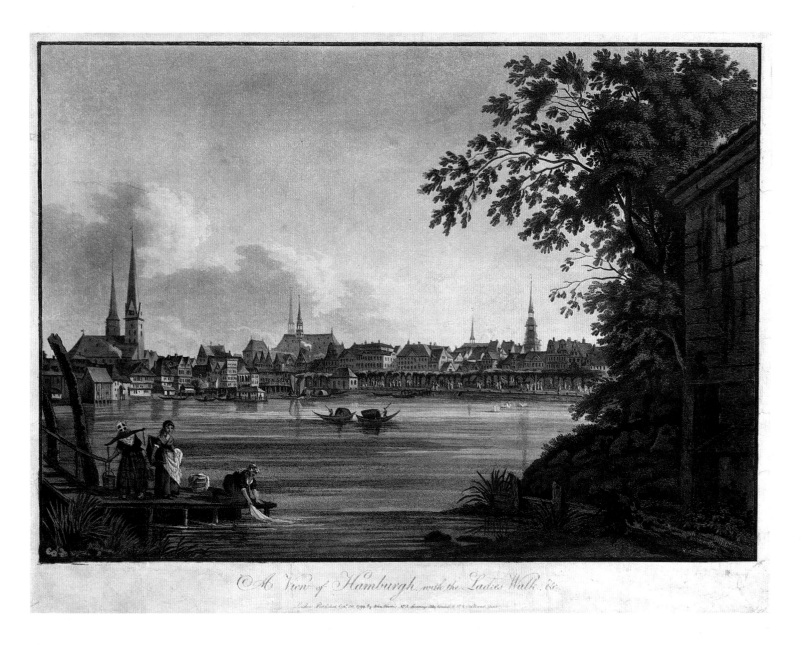

A View of Hamburgh, with the Ladies Walk. &c.

'A VIEW OF HAMBURGH, WITH THE LADIES
WALK, &c'
Hand-coloured aquatint
Height 517 mm, width 619 mm
Published by John Harris in London on 30 October
1799 (PAI 0114).

Hamburg grew into one of the busiest ports in
Germany, but this late eighteenth-century view
depicts its tranquil side. Women wash clothes in the
foreground, while small boats are visible in the
quiet harbour beyond.

While most images emphasised German ports' trade and naval links, other
engravings demonstrated their aesthetic features. The colour aquatint 'A View of
Hamburgh, with the Ladies Walk, &c' published by John Harris in London in
1799, masterfully evokes a quiet scene (see above). As well as representing the
main buildings of the city and the harbour, the artist has included a foreground
view of women washing clothes in the river, a detail that nicely captures

'HAMBURG VOM ALSTERUFER GESEHEN...'
View of Hamburg from the River Alster...
Hand-coloured lithograph
Height 420 mm, width 845 mm
Designed and engraved by W.(?Wilhelm) Heuer;
published by C.(?Charles) Fuchs in Hamburg in
the mid-nineteenth century (PAI 7166).

This sweeping view celebrates the industry of mid-
nineteenth-century Hamburg. In the foreground
smart carriages travel along a road parallel to the
river. Across a large bridge impressive buildings
line the opposite bank.

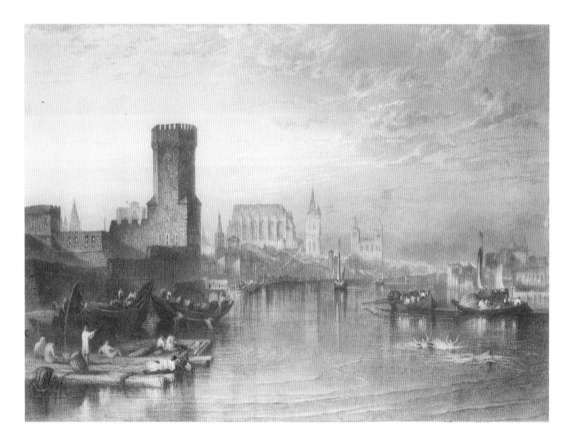

'COLOGNE FROM THE RIVER...'
Steel engraving
Height 195 mm, width 259 mm
Designed by Joseph Mallord William Turner,
engraved by Arthur Willmore; published *c.*1849
(PAD 1741).

Famous for his many images of British ports,
Turner also drew European ports, such as
this romantic view of the German port
of Cologne, on the Rhine river.

Hamburg's air of cosy industriousness. Half a century later a large colour litho-graph, 'Hamburg vom Alsterufer Gesehen...' provides an insider's view of the port city (see left). This print, which according to its publication line was drawn on the spot, and published in Hamburg, provides a panoramic view of the port. Yet churches and bridges are also identified, revealing pride in the individual details as well as the overall majesty of the city. The river port of Cologne also featured in numerous engravings, including an atmospheric steel engraving designed by Joseph Mallord William Turner (see above).

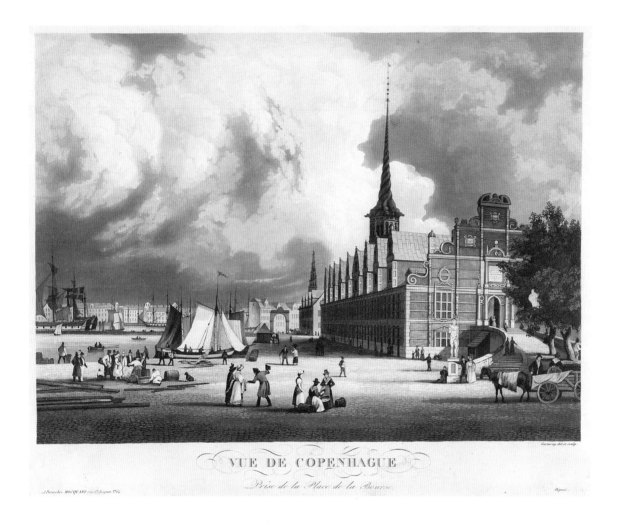

VUE DE COPENHAGUE

Prise de la Place de la Bourse

Scandinavian Ports

Scandinavian ports also featured in engravings, particularly in the early nineteenth century when industrialisation, the continuing importance of the Baltic trade and the threat of Napoleonic conquest all drew increased international attention to their strategic significance. Captain Fyers of Britain drew a view of Copenhagen not long before Admiral Nelson's bombardment of the port in 1801. Of the same period is Ambroise Louis Garneray's more detailed aquatint of Copenhagen's impressive waterfront and a superb colour aquatint of the Danish castle of Cronembourg on the sound separating Denmark and Sweden (see above and right). The Swedish artist Elias Martin produced a panoramic view of Stockholm,

'VUE DE COPENHAGUE PRISE DE LA PLACE DE LA BOURSE'
View of Copenhagen Taken from Stock Exchange Square
Aquatint
Height 414 mm, width 527 mm
Designed and engraved by Ambroise Louis Garneray; published by (?Edouard) Hocquart in the early nineteenth century (PAI 0125).

Copenhagen was one of several Scandinavian ports whose growth attracted the attention of artists in the early nineteenth century. This view depicts a central quay in the Danish capital filled with ships, boats and townspeople.

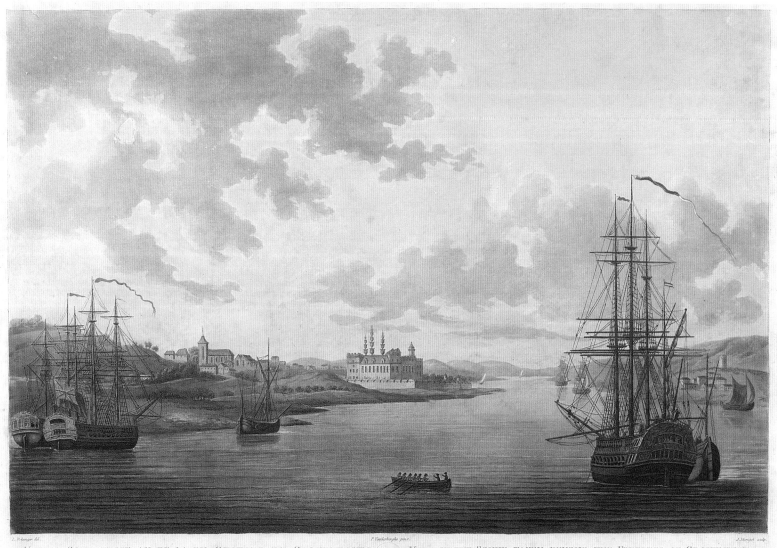

L. Belanger del. P. Vanterberghe pinx. J. Merigot sculp.

VUE DU SOND PRISE AU DE LA DU CHATEAU DU CRONEMBOURG. VIEW OF THE SOUND TAKEN BEYOND THE FORTRESS OF CRONEMBOURG.

Cette Forteresse est sur la gauche plus près l'on voit une partie de la ville d'Elseneur, et This Fortress is on the left, nearer to the eye is a part of the town of Helsingör and on the
sur le rivage oppose Helsembourg ville de Suede et une tour ruinée qui a autrefois fait partie opposite shore the Swedish town of Helsembourg with a ruined tower which belonged formerly
d'une Forteresse. La largeur du détroit est d'environ 3. Milles Anglois. to a Fort. The distance from one shore to the other is about 3 English Miles

Published April 1. 1801 for the Author by McN.rs G.&J. Nicol, Pall Mall. J. White Fleet Street & Colnaghi & C.o Cockspur Street.

'VIEW OF THE SOUND TAKEN BEYOND THE FORTRESS
OF CRONEMBOURG...'
Title also in French
Hand-coloured aquatint
Height 456 mm, width 597 mm
Designed by L.(?Louis) Belanger after
P. Vanterberghe and engraved by J. Merigot;
published by G. & J. Nicol, J. White and Colnaghi
& Co. in London on 1 April 1801 (PAI 0135).

This view of the sound separating Denmark and
Sweden emphasises its romantic setting as well as its
strategic significance. Scandinavian ports attracted
the attention of both the British and French navies
during the Napoleonic Wars.

67

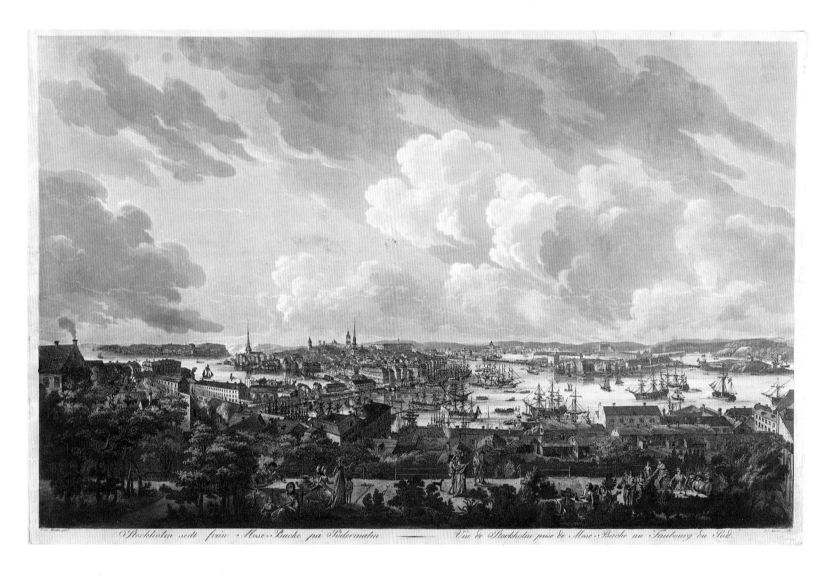

Stockholm sedt från Mose-Backe på Södermalm —— *Vue de Stockholm prise de Mose-Backe au Faubourg du Sud.*

engraved by his compatriot John Frederick Martin in 1805, with titles in Swedish and French, which reflects the city's increased size and commercial and political self-confidence (see above). Similarly, a French print depicting the Royal Palace, bridges and water highlights Stockholm's grand waterfront. Johan Jakob George Haas, a member of the Royal Academies of Fine Arts of both Copenhagen and Paris, engraved elegant views of the Norwegian ports of Bergen (see right) and Christiania (see page 70).

'STOCKHOLM SEDT FRAN MOSE-BACKE PA SODERMALM...'
View of Stockholm taken from Mose-Backe in Sodermalm
Title also in French
Hand-coloured aquatint and engraving
Height 473 mm, width 722 mm
Designed by Elias Martin and engraved by John Frederick Martin; published *c.*1805 (PAI 0121).

This grand view of Stockholm in Sweden was designed by a former pupil of Claude-Joseph Vernet. The dramatic sky and details such as the elegantly-dressed party on the terrace in the foreground recall Vernet's views of French ports.

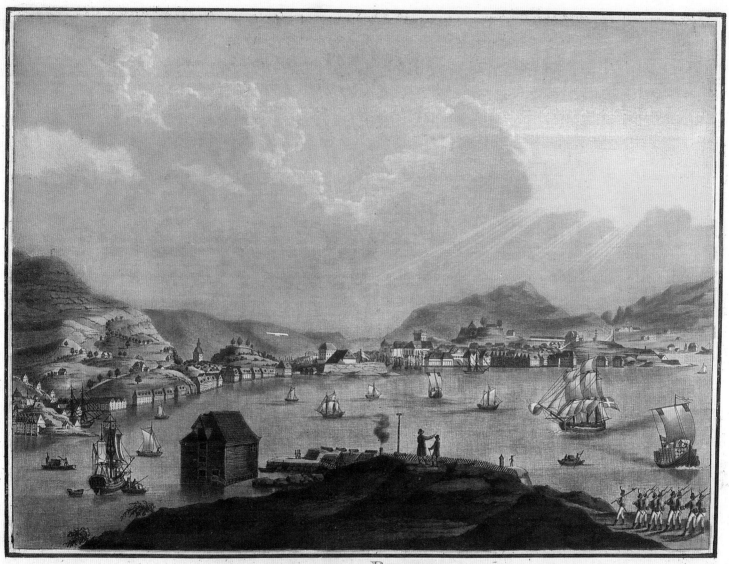

LA VILLE DE BERGEN
prise d'une Batterie nommé Hæggrénsset

Gravé par J. George Haas.

'LA VILLE DE BERGEN PRISE D'UNE BATTERIE
NOMMÉ HOEGGRÉNSSET'
*The Town of Bergen taken from a Battery
named Hoeggrénsset*
Hand-coloured etching and mezzotint
Height 371 mm, width 480 mm
Engraved by Johan Jakob George Haas; published
in the early nineteenth century (PAI 0130).

Like many other early nineteenth-century
engravings of Scandinavian ports, this view of
Bergen in Norway reflects both the engraver's
training in France and his pride in his subject.
Spectators in the foreground watch the ships in
the harbour, while troops march towards them
from the right.

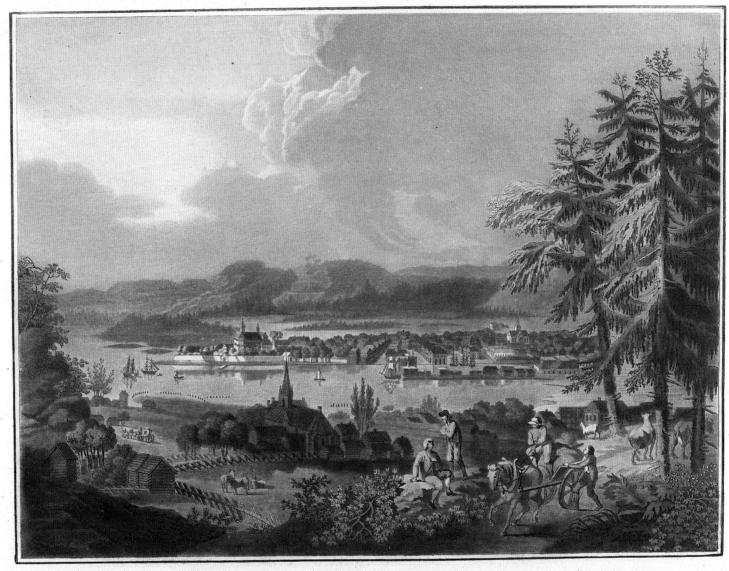

VUE DE LA VILLE DE CHRISTIANIA

Peint par le Professeur Lorentzen Peinter du Roi, & Gravé par J.J.G. Haas Graveur du Roi Membre des Academies Royales des Beaux Arts de Copenhague & de Paris &c

'Vue de la Ville de Christiania'
View of the Town of Christiania
Hand-coloured etching and mezzotint
Height 403 mm, width 504 mm
Painted by Christian August Lorentzen and
engraved by Johan Jakob George Haas; published
in the early nineteenth century (PAI 0128).

Small Norwegian ports such as Christiania also
drew artists' attention. This charming view depicts
the alpine setting, with forests and mountains
framing the town.

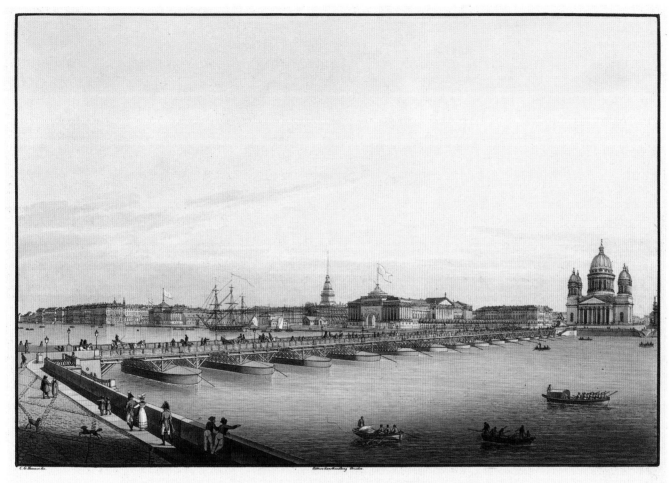

Vue du Pont d'Isaac, du Palais d'Hiver, de l'Admiralité etc. à St: Petersbourg.

VUE DU PONT D'ISAAC, DU PALAIS D'HIVER, DE L'ADMIRALITÉ ETC: À ST: PETERSBOURG
View of Isaac's Bridge, the Winter Palace, Admiralty etc. in St Petersburg
Hand-coloured aquatint and etching
Height 435 mm, width 555 mm
Published by Christian Gottlieb Hammer and Rittners Kunsthandlung in the early nineteenth century (PAI 0140).

This beautiful view of the Russian port of St Petersburg records its architectural splendour and commercial ambitions. An elegant bridge links the foreground with the stately buildings on the far side of the River Neva.

Russian ports, too, were on display. Many prints record the splendid new buildings and facilities for trade in St Petersburg. One early nineteenth-century Russian engraving, with titles in French and Russian, was dedicated to Tsar Alexander I. Another print depicts a bridge, ships and an impressive array of public buildings along the River Neva (see above). Several prints reveal ongoing international rivalry for control of Baltic and Russian ports, and their access to the valuable timber trade. Thus Cronstadt (Kronshtadt), a seaport on an island strategically located west of St Petersburg in the Gulf of Finland, featured in a colour chart published as early as *c.*1720. This etching includes descriptions of the

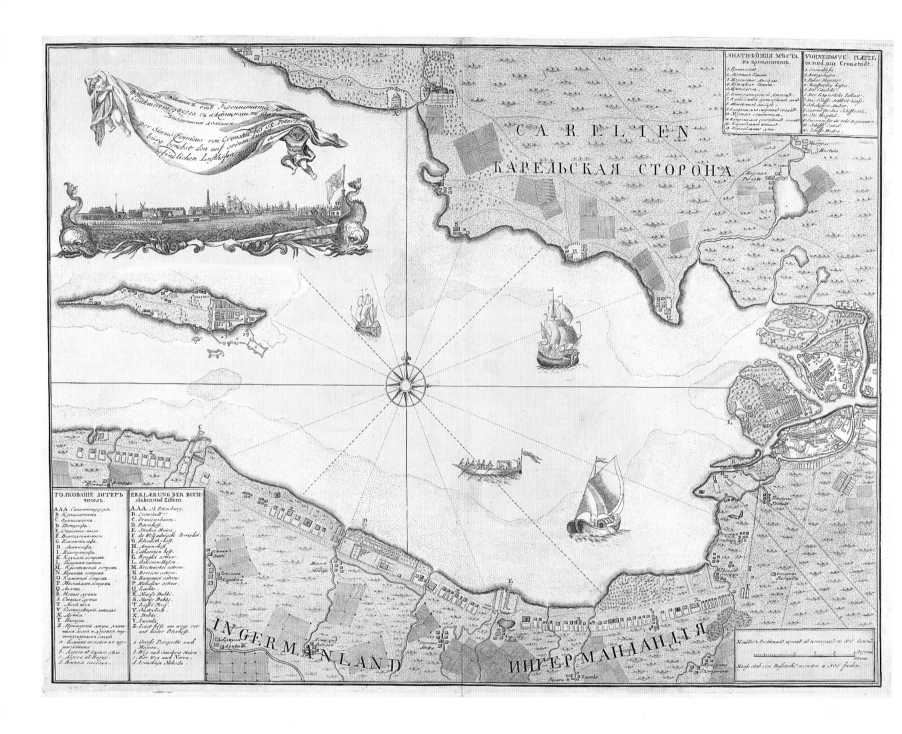

CARELIEN
КАРЕЛЬСКАЯ СТОРОНА

INGERMANLAND
ИНГЕРМАНЛАНДIЯ

town and surrounding region in both German and Russian, along with a cartouche view of the port (see page 72). A detailed panoramic view of Riga, the chief seaport of Latvia, was published *c.*1815 with a French title (see jacket illustration).

Conclusion

In the eighteenth and nineteenth centuries, then, northern European ports underwent a process of transformation in response to unprecedented political and social developments. The ports of old trading empires such as the Netherlands and Germany were supplanted by those of new powers, in particular Britain, and, for two decades, Revolutionary and Napoleonic France. These rapid and far-reaching changes were reflected in the diversity of engravings of European ports in this period. Many historic ports came to be depicted more for their aesthetic than their commercial qualities, yet ports in newly expanding areas such as the Baltic and Western France were represented as symbols of the internationalisation of trade. While, broadly speaking, prints of European ports enhanced the prestige of their state (sometimes blatantly expressing national ambition), many prints reflect a sense of curiosity about other cultures. This is particularly true of engravings of southern European and Mediterranean ports, the subject of the next chapter.

CHART OF CRONSTADT
Hand-coloured etching
Height 469 mm, width 637 mm,
Published *c.*1720 (PAI 0144).

This delicately coloured chart of the port of Cronstadt (Kronshtadt) highlights its strategic position. Like many ports in the Baltic region, it was known through both its German and Russian names.

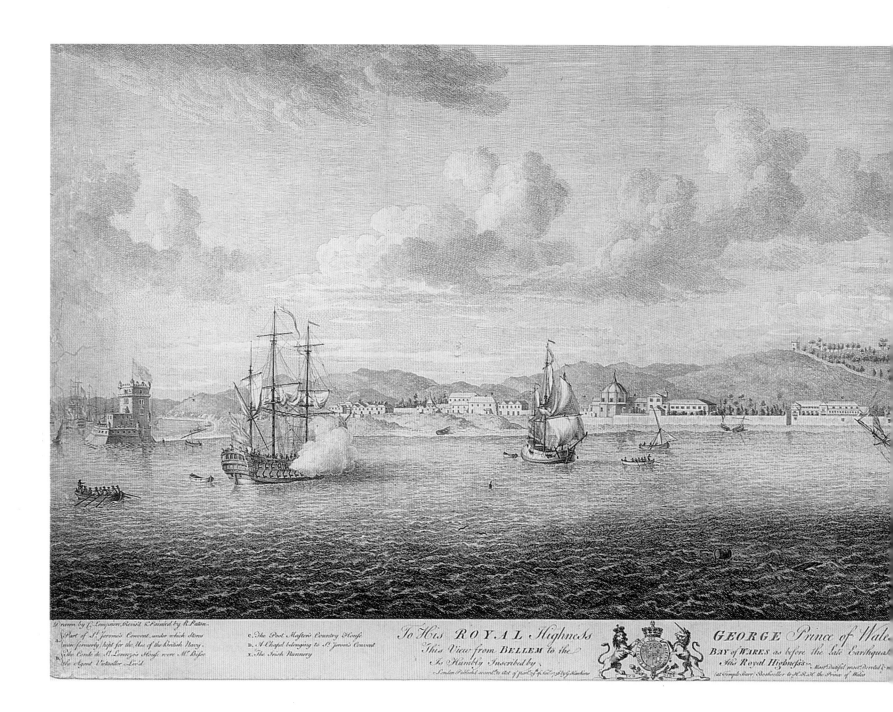

Within the image (engraving inscriptions):

Drawn by C. Lempriere, Revis'd & Painted by R. Paton.

Part of S.t Jerome's Convent under which Stores
were formerly kept for the Use of the British Navy.
The Conde de S.t Lorenzo's House near Mr. Bifse
the Agent Victualler Liv'd.

c. The Post Master's Country House.
d. A Chapel belonging to S.t Jerom's Convent
x. The Irish Nunnery.

To His ROYAL Highness
This View from BELLEM to the
Is Humbly Inscribed by.
London Publish'd according to Act of parl.t 9 Oct. 1756 by G. Hawkins

GEORGE Prince of Wales
BAY of WARES as before the Late Earthquake
His Royal Highness's Most Dutiful most Devoted & m
at Temple Barr, Bookseller to H.R.H. the Prince of Wales

'...VIEW FROM BELLEM [SIC] TO THE BAY OF WARES
AS BEFORE THE LATE EARTHQUAKE...'
Engraving and etching
Height 389 mm, width 757 mm
Drawn by C. Lempriere, revised and painted by R.
(?Richard) Paton and engraved by J.(?James)
Mason; published by George Hawkins in London
on 29 November 1756 (PAI 7154).

This view of the approach to Lisbon from the
water includes several ships in the foreground.
The Portuguese capital's importance as a port
was severely affected by the devastating earthquake
of 1755.

74

1. St Joseph
2. St Catharine
3. Bellem Castle
4. Ships in the Bay of Wars.

Bellem Castle-house Engrav'd by J. Mason.

Sailing South

Southern European and Mediterranean Ports

B eyond northern Europe, the ports of southern Europe and the Mediterranean attracted considerable attention from engravers in the eighteenth and nine-teenth centuries. Southern European ports appeared as more relaxed, scenic spots than their northern cousins, while those of the eastern Mediterranean appealed as both exotic and, indeed, strategically important locales. Many views reveal European imperial ambitions in the region. Excitement at the possibilities for European political expansion and commercial development is evident in many engravings. Naval and military campaigns, particularly during the early nine-teenth-century Napoleonic Wars, inspired numerous depictions of battle sites and new areas of conquest. Other views seem to have been intended merely as pleasantly exotic scenes for would-be travellers to admire from the convenience and comfort of home.

Portuguese and Spanish Ports

In contrast to many views of northern European ports, images of Portuguese and Spanish ports are usually associated with military action rather than trade. Some exceptions were made, however, for instance a pair of views depicting the Lisbon area before the earthquake of 1755. These were intended as historical records of the city's appearance and importance as a trade centre before its virtual destruc-tion (see left). Views of Oporto on the River Douro, famous as the home of the

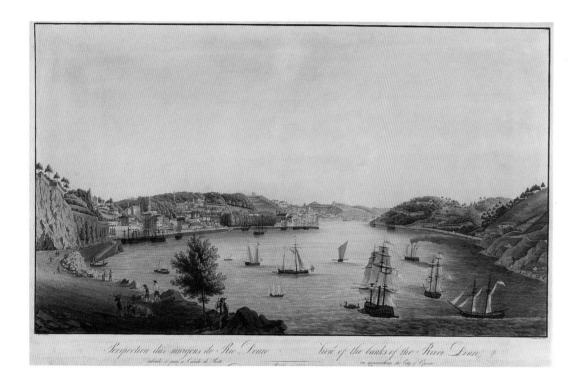

Perspectiva das margens do Rio Douro View of the banks of the River Douro
entrando se para a Cidade do Porto on approaching the City of Oporto

'VIEW OF THE BANKS OF THE RIVER DOURO ON
APPROACHING THE CITY OF OPORTO'
Title also in Portuguese
Hand-coloured aquatint and etching
Height 541 mm, width 740 mm
Designed by G. Köpke in Porto in 1827 and
engraved by C. G. (?Christian Gottlieb) Hammer
in Dresden; published *c.* 1827 (?1857) (PAI 7156).

This tranquil view of ships and boats on the
river near Oporto would have appealed to print
collectors, and port drinkers, both in and
beyond Portugal.

'WEST VIEW OF THE MOLE OF MALAGA SEEN FROM
ONE OF THE TOWERS OF THE CATHEDRAL AND
DRAWN BY FRANCIS CARTER 1772'
Engraving and etching
Height 205 mm, width 740 mm
Drawn by Francis Carter and engraved by James
Basire; published on 1 January 1777 (PAD 1648).

Sketching Mediterranean ports was a popular
pastime in the late eighteenth century. Francis
Carter's elegant view of the Spanish port of Malaga
draws attention to its architecture, including the
large 'mole' or breakwater visible on the right-
hand side of the design.

port wine trade, also feature commercial rather than strategic details, as a German
design of 1827 with English and Portuguese titles demonstrates (see above).
Similarly, a pair of views of Malaga drawn by Francis Carter in 1772 and 1773 and
engraved by James Basire, engraver to the Society of Antiquaries, stress the tran-
quil beauty of this Spanish port rather than its strategic significance (see below).

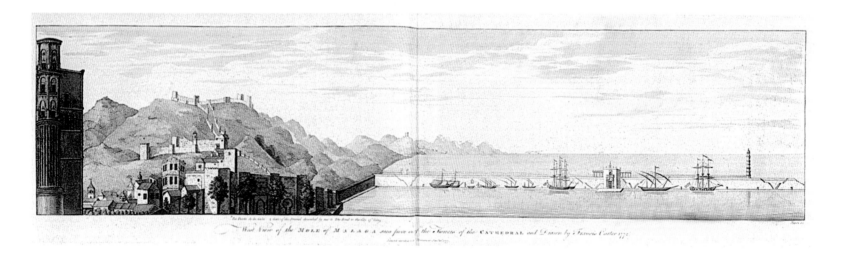

West View of the MOLE of MALAGA seen from one of the Towers of the CATHEDRAL and Drawn by Francis Carter 1772

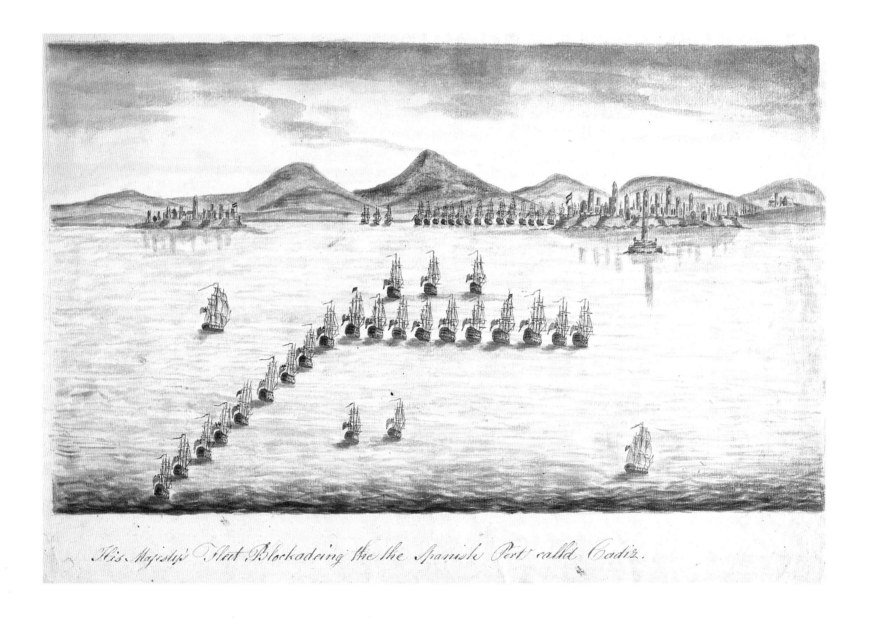

His Majesty's Fleet Blockadeing the the Spanish Port calld Cadiz.

'His Majesty's Fleet Blockadeing the the [sic] Spanish Port calld [sic] Cadiz'
Watercolour
Height 285 mm, width 430 mm
Painted in the late eighteenth century (PAD 1663).

An amateur artist such as a naval officer most likely painted this watercolour of British warships blocking the entrance of Cádiz in Spain. Naval blockades were commonly used in Europe to confine the enemy to port, most notably during the Napoleonic Wars.

But war dominates many late eighteenth- and early nineteenth-century images, including a watercolour view of the British fleet blockading the Spanish port of Cádiz (see above). Prominent among contemporary engravings are views of ports involved in territorial struggles between European powers, such as Port Mahon on the island of Minorca, and Gibraltar. Minorca was the site of the British Admiral John Byng's inconclusive battle against the French fleet in 1757, which returned Port Mahon to French hands and resulted in Byng's court-martial and

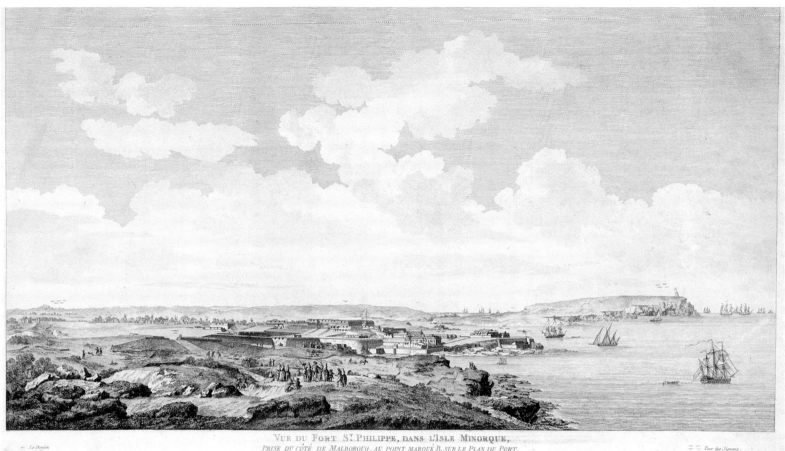

VUE DU FORT S.ᵗ PHILIPPE, DANS L'ISLE MINORQUE,
PRISE DU CÔTÉ DE MALBOROUG, AU POINT MARQUÉ B. SUR LE PLAN DU PORT.

Dédié à Son Excellence Dᵉ Pierre Paul Abarca de Bolea Ximénès de Urrea, Comte d'Aranda, &ᵃ Grᵈ d'Espagⁿᵉ de la 1ʳᵉ Classe, Chevalier de la Toison d'Or et du
S.ᵗ Esprit, Gentilhomme de Sa Majesté Catholique, Capⁱᵗ. Général de Ses Armées, et son Ambassadeur extraordʳᵉ auprès de Sa Majesté très Chretienne

Se vend à Paris chez Berthault éditeur, rue S.ᵗ Louis près la Place Royale, Mᵉᵈ du Serrurier. Et chez Delafosse Place du Carrousel. Prix 8ᵗ. Par son très Humble et très Obéissant Serviteur, Berthault.

execution for failure to do his duty. The fiasco inspired numerous political cartoons of Byng's ineffectual battle, and later views of Minorca by both French and British artists (see above). Even more potent as a source of European rivalry was the steep rocky peninsula of Gibraltar, which juts out from the Spanish mainland. Numerous engravings were produced of this gateway to the Mediterranean, most commonly following successful British efforts to reinforce or relieve it. Many small prints of Gibraltar appeared in British magazines, designed to give readers a glimpse of the rock that was such an important part of contemporary British diplomacy. But there were many grander and more expensive views, which combined elegant visual representation with fulsome patriotism, including:

'VUE DU FORT ST. PHILIPPE, DANS L'ISLE MINORQUE, PRISE DU CÔTÉ DE MALBOROUG, AU POINT MARQUÉ B. SUR LE PLAN DU PORT...'
View of Fort St. Philip in the island of Minorca, taken from the side of Malboroug, at the point marked 'B' on the map of the Port
Etching
Height 313 mm, width 494 mm
Engraved and published by (?Jean-Pierre) Berthault and Delafosse in the early to mid-nineteenth century (PAI 0037).

This French view of Minorca was one of several engravings made of the strategically located Mediterranean island in the eighteenth and nineteenth centuries.

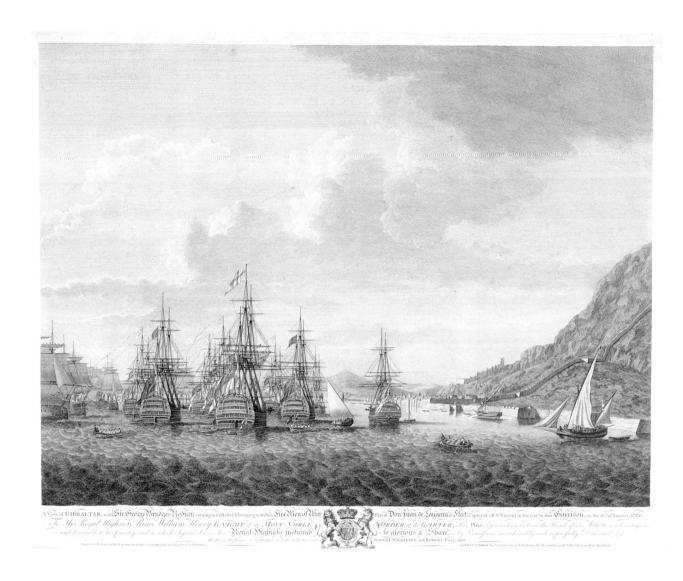

'A VIEW OF GIBRALTAR, WITH SIR GEORGE
BRYDGES RODNEY COMING TO ITS RELIEF...'
Engraving and etching
Height 485 mm, width 615 mm
Painted by Dominic Serres and engraved by Robert
Pollard; published by Robert Wilkinson and
Robert Pollard in London on 1 June 1782
(PAI 0012).

This magnificent view depicts a great moment in
British naval history – Admiral Rodney's heroic
relief of the besieged naval base at Gibraltar during
the American War of Independence.

A View of Gibraltar, with Sir George Brydges Rodney
coming to its Relief, & bringing with him Five Men of War
Part of Juan de Langara's Fleet, Captured off St. Vincent
on his way to that Garrison, on the 16th. of January 1780.

This 1782 view was painted by the esteemed marine artist Dominic Serres,
'Marine Painter to his Majesty', engraved by the well-known engraver Robert
Pollard and dedicated to Prince William Henry, who had taken part in the naval
action (see above). Such a panoply of prestigious figures associated with this
engraving indicates Gibraltar's central place in the contemporary British imagination.

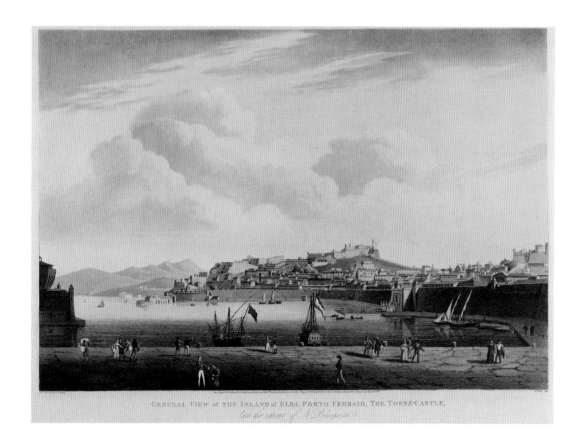

GENERAL VIEW of THE ISLAND of ELBA, PORTO FERRAIO, THE TOWN & CASTLE,
late the retreat of N. Bonaparte

'GENERAL VIEW OF THE ISLAND OF ELBA, PORTO FERRAIO, THE TOWN & CASTLE, LATE THE RETREAT OF N. BONAPARTE'
Hand-coloured aquatint
Height 496 mm, width 675 mm
Drawn on the spot by A. S. Terreni and engraved by M. Dubourg; published by Edward Orme in London on 1 June 1814 (PAH 9984).

This view of Elba is one of many engravings of Mediterranean ports associated with the Napoleonic Wars. People in brightly coloured clothes gather near ships in the harbour, while in the background an impressive castle stands guard over the town. Both the ships and the castle fly the French tricolour flag.

Prints after Sketches by Military and Naval officers

Many views of Mediterranean ports were drawn by amateurs, in particular military and naval officers, and later engraved and sold by professionals. Engravings after sketches of scenes from the Napoleonic Wars, including the early nineteenth-century Peninsular War, were especially popular. Professional artists also painted views which would appeal to military audiences. Considerable emphasis was placed on the fact that the design was made at the scene, rather than in an artist's studio. Thus a 'General View of the Island of Elba, Porto Ferraio, the Town & Castle…' was 'Taken on the Spot by A. S. Terreni' (see above). Porto Ferraio was the capital of Elba, an island in the Mediterranean located between Corsica and Italy, and the residence of Napoleon Bonaparte after his abdication, 1814–15. Elba was thus a place of considerable interest to foreign viewers. So too was Malta, an island strategically located between Sicily and Africa, which was captured by the British from the French in 1799. A spectacular view was engraved by Thomas

'MALTA, TAKEN FROM THE MOUTH OF THE HARBOUR'
Hand-coloured aquatint
Height 495 mm, width 694 mm
Drawn by Major Pierrepont and engraved by Thomas Sutherland; published by Rudolph Ackermann in London on 1 February 1812 (PAI 0105).

Images of strategic spots in the Mediterranean were often engraved from drawings made by military and naval officers. The skilful delineation of the harbour wall, ships and people fishing distinguishes this view of the island of Malta from most other amateur designs.

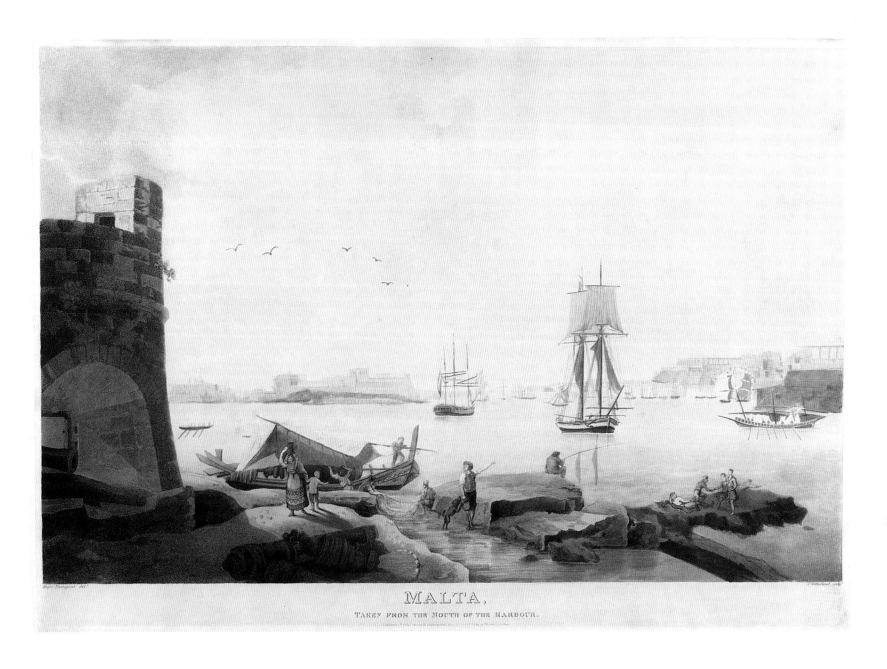

MALTA,
TAKEN FROM THE MOUTH OF THE HARBOUR.

Sutherland after a drawing by 'Major Pierrepont' and published in 1812 (see above). Perhaps most moving is a panoramic view of the northern Spanish port of Corunna (La Coruña), dedicated to the memory of army officer Sir John Moore after the 1809 Battle of Corunna (see page 82). The southwestern French Atlantic seaport of Bayonne merely provides the backdrop for British military and political

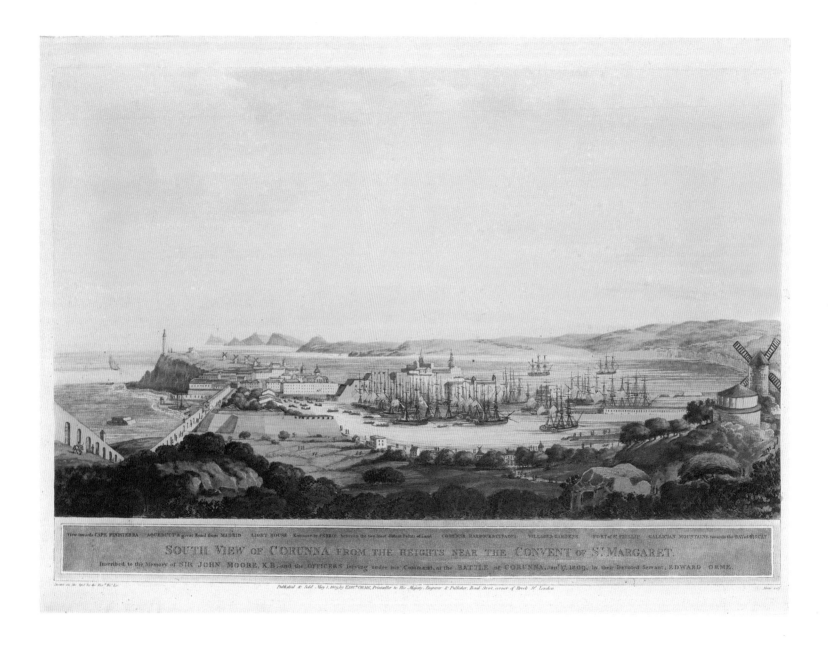

View towards CAPE FINISTERRA AQUEDUCT & great Road from MADRID LIGHT HOUSE Entrance by FERROL between the two most distant Points of Land CORUNNA HARBOUR & CITADEL VILLAGES & GARDENS FORT of S⁖ PHILIP GALLICIAN MOUNTAINS towards the BAY of BISCAY

SOUTH VIEW OF CORUNNA FROM THE HEIGHTS NEAR THE CONVENT OF S⁖ MARGARET.

Inscribed to the Memory of SIR JOHN MOORE, K.B., and the OFFICERS serving under his Command, at the BATTLE of CORUNNA, Jan⁖ 17 1809, by their Devoted Servant, EDWARD ORME.

Published & Sold May 1, 1809, by EDW⁖ ORME, Printseller to His Majesty, Engraver & Publisher, Bond Street, corner of Brook S⁖ London.

success in an engraving commemorating the Duke of Wellington's victory of 1814 against the Napoleonic forces (see page 83). The caption below the print reads:

> *View of Bayonne, taken from the Sand Hills on the left of the*
> *Adour, when occupied by the British Forces on the 12 of March*
> *1814, by Lieutenant George B Willis, of the Royal Artillery.*
> *Dedicated with permission to the Rt. Hon:ble Earl Musgrave,*

'VIEW OF BAYONNE, TAKEN FROM THE SAND HILLS
ON THE LEFT OF THE ADOUR…'
Hand-coloured aquatint
Height 507 mm, width 642 mm
Designed by Lieutenant George Brander Willis,
R.A. and engraved by (?John) Clark and (?M.)
Dubourg; published by Edward Orme in London
on 24 June 1814 (PAH 9985).

Ports such as Bayonne in France were the site of
important battles during the Peninsular War, and
engravings recorded the moment for posterity.
Small groups of red-coated soldiers march and
build a campfire in front of the practically
deserted port.

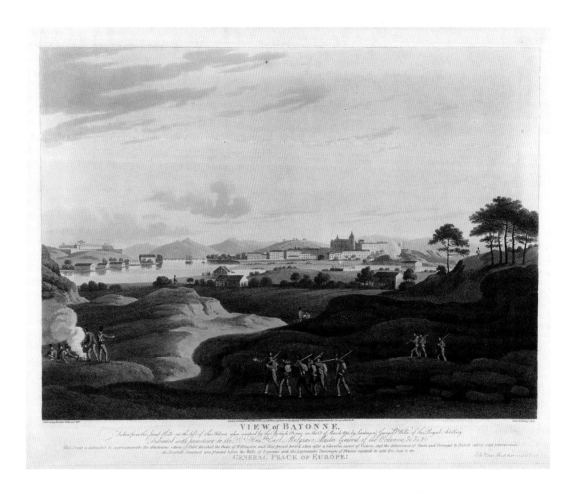

VIEW of BAYONNE.

'SOUTH VIEW OF CORUNNA FROM THE HEIGHTS
NEAR THE CONVENT OF ST. MARGARET…'
Hand-coloured aquatint
Height 504 mm, width 706 mm
Designed by (?Reverend Francis Lee) and engraved
by (?H.) Merke; published by Edward Orme in
London on 1 May 1809 (PAI 0007).

While this view of the Spanish port of Corunna
(La Coruña) was intended primarily to chronicle
the events of the Peninsular War, it also provides
a glimpse of the workings of the port. Blue and red
flags draw attention to the numerous British ships
in the harbour.

*Master General of the Ordnance, &c. &c. &c. This Print
is intended to commemorate the illustrious return of Field
Marshal the Duke of Wellington, and that proud period, when
after a Glorious career of Victory, and the deliverance of Spain
and Portugal by British valour and perseverance, the English
Standard was planted before the Walls of Bayonne, and the
Legitimate Sovereign of France recalled to add His Seal to the
General Peace of Europe!*

While this print reveals little about Bayonne itself or its commerce, it does
indicate that southwestern French ports could be considered as strategically
important as northern ports. Moreover, this engraving demonstrates that Bayonne
and other French seaports had links with southern, Mediterranean cultures as well
as northern, Atlantic cultures.

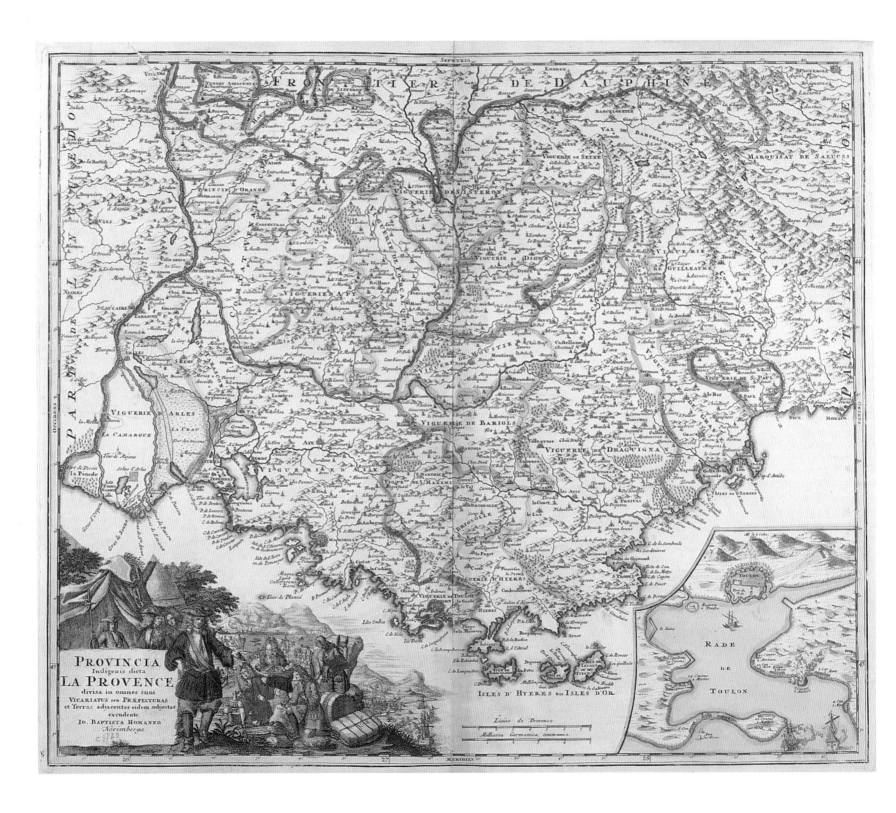

PROVINCIA
Indigenis dicta
LA PROVENCE
divisa in omnes suas
VICARIATUS seu PRÆFECTURAS
et Terras adjacentes eidem subjectas
excudente
Io. BAPTISTA HOMANNO
Norimbergæ

Isles d' Hyeres ou Isles d'Or

Licuee de Provence

Milliaria Germanica communia

RADE
DE
TOULON

SAILING SOUTH: SOUTHERN EUROPEAN AND MEDITERRANEAN PORTS

French Mediterranean ports

'Provincia Indigenis dicta La Provence...'
Map of Provence with cartouche and inset
Hand-coloured etching
Designed by (?Johann-Baptista Homann); published
*c.*1740 (PAH 9989).

This detailed map of the Provence region of France
emphasises the area's strategic significance. A plan
inset in the lower right-hand corner of the design
depicts the entrance to Toulon, the home of a
major French naval base.

French Mediterranean ports were also frequently represented in engravings.
Vernet produced famous views of Toulon and Marseilles in his series of the Royal
Ports of France which emphasised their naval and commercial importance. A map
of Provence *c.*1740 with cartouche and inset reveals the commercial and strategic
importance of the port of Toulon to the surrounding area (see left). Beyond these
two ports, however, French Mediterranean ports were often represented quite
differently from French Atlantic ports. Existing cultural variations were widened
in the nineteenth century by the growing industrialisation of northern France. The
Mediterranean coast lagged behind, and its ports accordingly appear sleepier than
Atlantic ports, and more geared to pleasure than commerce. As attitudes to the sea
became more positive and the benefits of sea air and bathing were promoted by
doctors, southern coastal towns began to be depicted in engravings as pleasant hol-
iday spots. Even more than their British counterparts, southern French ports such
as Antibes were represented as beautiful, restful places (see below). Amateurs,
including women, produced views of the southern coast which were later

'Harbour of Antibes'
Coloured aquatint
Height 266 mm, width 317 mm
Designed by 'AB' and engraved by Cornelis
Apostool; published by A. Beaumont in London on
1 January 1794 (PAD 1620).

This lovely view of Antibes reflects growing
interest in ports as places of relaxation and
contemplation. For those who could not travel
to the South of France, this engraving skilfully
evokes its peaceful atmosphere.

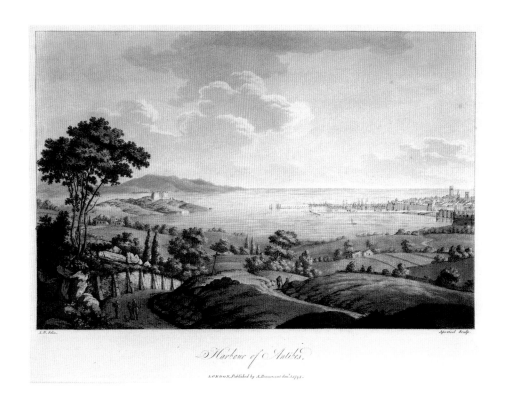

Harbour of Antibes.
LONDON, Published by A. Beaumont Jan.1.1794.

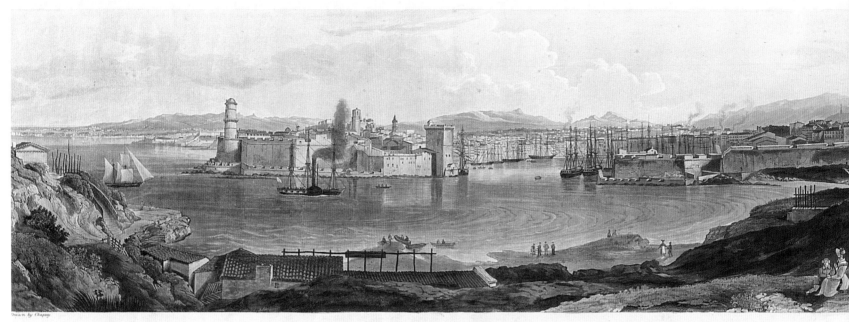

PANORAMIC VIEW OF THE TOWN AND HARBOUR OF MARSEILLE.

London, Published 1838 by Robt. Havell, 77, Oxford Street

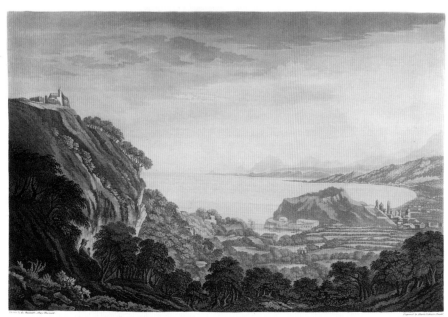

A VIEW OF THE TOWN OF NICE AND ITS ENVIRONS TAKEN FROM THE ROAD TO VILLA FRANCA.

'PANORAMIC VIEW OF THE TOWN AND HARBOUR OF MARSEILLE'
Coloured stipple
Height 225 mm, width 805 mm
Designed by (?Nicolas or by ?Marie-Joseph) Chapuy; engraved and published by Robert Havell in London in 1838 (PAI 7149).

Although Marseilles remained an important French centre of commerce, in this wide-angle view it appears as a tranquil beauty spot. As in many prints of ports, spectators in the right foreground admire the view.

'A VIEW OF THE TOWN OF NICE AND ITS ENVIRONS TAKEN FROM THE ROAD TO VILLA FRANCA'
Aquatint
Height 415 mm, width 590 mm
Designed by the Honorable Mary Harcourt and engraved by Maria Catherine Prestel; published in the (?)late eighteenth century (PAH 9987).

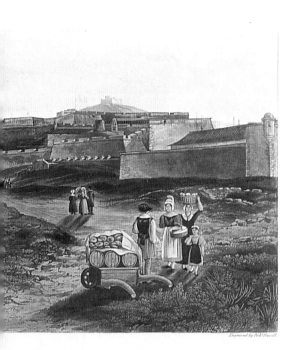

engraved for sale. Thus 'the Honorable Mary Harcourt' drew two views of the coast near Nice which were engraved by another woman, the professional engraver Maria Catherine Prestel (see bottom left). Even Marseilles, which remained more important as a commercial centre and naval base than as a resort, appeared sunny and serene in a print of 1838 (see top left).

Italian ports

Among the most popular views of the Mediterranean were Italian ports, celebrated for their commercial and political heritage and their beautiful scenery. Leghorn (Livorno) was often depicted in engravings, including an 1803 harbour view by a member of the Royal Navy depicting a British warship and an Italian galley with distinctive checkerboard sails (see below). Many other prints portray the historical and aesthetic significance of Italian ports. Paul Sandby produced several exquisite views of Naples, including a colour aquatint of the 'Castello dell' Ovo at Naples' whose golden tones evoke the warmth of the Mediterranean sun.

Not all prints of ports were made by men. This view of the Mediterranean port of Nice was drawn by a British gentlewoman, one of many female amateur artists. Professional female engravers, such as the German woman who engraved the design, were more unusual.

'VIEW REPRESENTING THE CITY AND PORT OF LEGHORN IN TUSCANY, H. M. SHIP QUEEN CHARLOTTE, AND ONE OF H. R. H. THE GRAND DUKE'S GALLEYS...'
Title also in French
Hand-coloured aquatint
Height 446 mm, width 620 mm
Designed by John Chessell, Royal Navy and engraved by J. B. Harraden; published by John Chessell on 20 April 1803 (PAI 0063).

This print may be intended to commemorate HMS Queen Charlotte, the British warship which was accidentally blown up off Leghorn (Livorno) in 1800. The warship, Italian galley and lighthouse dominate this striking harbour view.

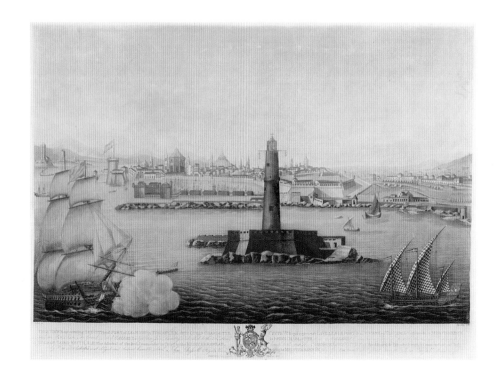

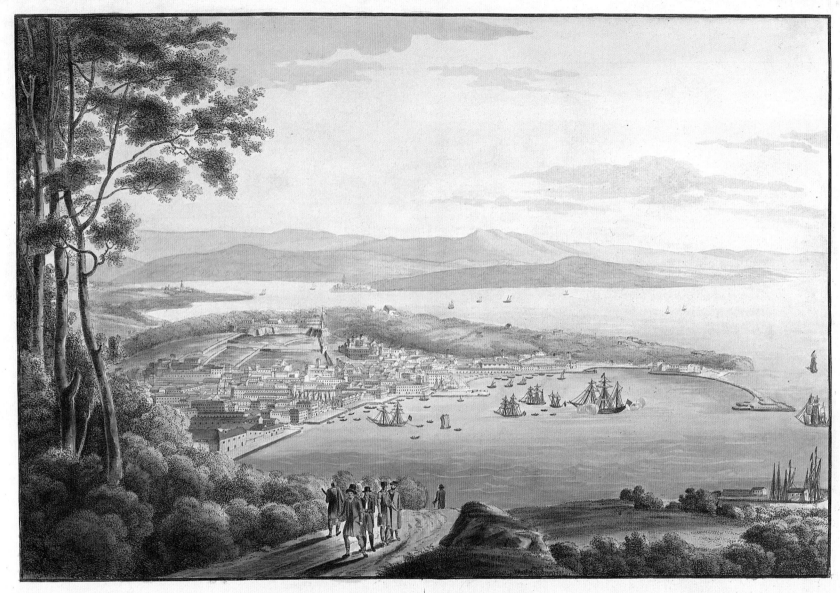

Ansicht von **TRIEST** *auf der Anhöhe von Optschina aufgenommen* | *Veduta di* **TRIESTE** *presa dalla Strada d'Optschina*

Wien *bey* Artaria *und* Comp. *C.P.S.C.M.* Milano *presso* Ferdinando Artaria *ed altri Negozianti di Stampe deposta alla Biblioteca Reale.*

*First View of the Harbour of Ancona, showing the Arch
of Trajan…*
Etching
Height 438 mm, width 580 mm
Designed by P. (?Philip) Hackert in 1784 and
engraved by Balthasar-Anton Dunker and Mathias-
Gottfried Eichler; published by Giorgio Hackert
in Naples c. 1784 (PAI 0065).

This view of the harbour at Ancona reveals the
Italian port's commercial and cultural links with
the Near East. In addition to people and goods
filling the quay in the foreground, the forest of
masts in the left background signifies Ancona's
importance as a trade centre.

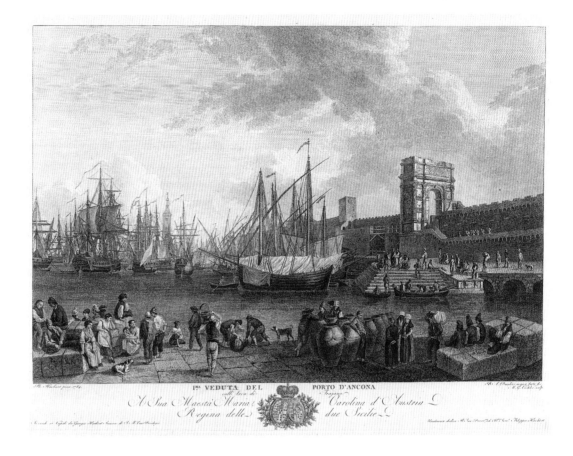

'…VEDUTA DI TRIESTE PRESA DALLA STRADA
D'OPTSCHINA'
View of Trieste from the Optschina Road
Title also in German
Hand-coloured etching
Height 320 mm, width 440 mm
Published by Ferdinando Artaria in Vienna in the
early to mid-nineteenth century (PAI 0064).

Like many Mediterranean ports, Trieste had a
mixed cultural heritage. Trieste's position as an
Italian port under Austrian control is reflected in
the Italian and German captions to this brightly
coloured engraving.

Sandby was just one of several eminent artists who produced engraved views of
Italian ports. Two views of Venice drawn by Antonio Canal, known as Canaletto,
were published in Britain in 1794 and 1818 respectively – at least half a century
after Canaletto had drawn them. Republication of such old designs testifies to the
ongoing British love affair with Canaletto's panoramic views of ports and with
views of Venice generally.

Images of other Italian ports acknowledge their links with different European
and Mediterranean cultures. A nineteenth-century view of Trieste with both
German and Italian titles published in Vienna testifies to the Austrian empire's
strong presence in the Adriatic region (see left). In contrast to this, a view of
Ancona of 1784 emphasises this port's eastern orientation through the depiction
of men in long robes and turbans surrounded by bales and large jars on the quay-
side (see above).

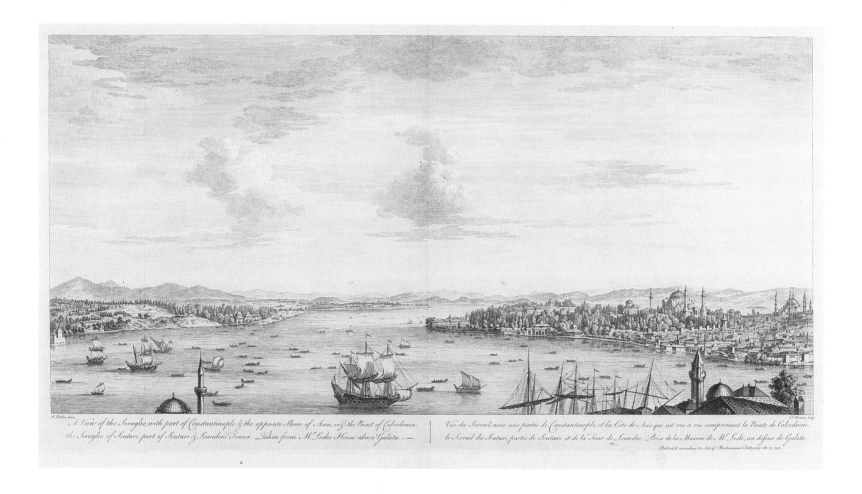

A View of the Seraglio, with part of Constantinople & the opposite Shore of Asia, viz the Point of Calcedonia, the Seraglio of Scutari, part of Scutari & Leander's Tower. Taken from Mr Lisles House above Galata.

Vüe du Serrail, avec une partie de Constantinople, et la Côte de Asie qui est vis a vis comprenant la Pointe de Calcedoine, le Serrail du Scutari, partie de Scutari et de la Tour de Leandre. Prise de la Maison de Mr Lisle, au dessus de Galata.

Published according to Act of Parliament February the 15 1752.

Eastern Mediterranean ports

The exotic theme is even more pronounced in engravings of eastern Mediterranean ports. Perhaps the most familiar and in many ways the most European of these ports was Constantinople (Istanbul). Long the nexus of European and Asian trade, Constantinople featured in many prints, including engravings made for atlases and books of geography. An early eighteenth-century European view of Constantinople is provided in Richard Dalton's design engraved by Francis Vivares (see above). Much less familiar to European viewers were ports such as Beirut and Tripoli, the subjects of superb separate colour aquatints published by Thomas McLean in 1819 (see right). The emphasis in these prints, and in similar views of Algiers, Tunis and Rosetta (Rashid), is on foreign customs and the exotic atmosphere. Veiled women, camels and minarets abound, as well as local

'A VIEW OF THE SERAGLIO, WITH PART OF
CONSTANTINOPLE & THE OPPOSITE SHORE OF
ASIA…'
Title also in French
Engraving and etching
Height 380 mm, width 718 mm
Designed by R. [Richard] Dalton and engraved
by Francis Vivares; published in London on
15 February 1752 (PAI 0156).

This delicate view of Constantinople in Turkey
includes 'the Point of Calcedonia, the Seraglio of
Scutari, part of Scutari & Leander's Tower' and was
'Taken from Mr Lisles House above Galata'. The
buildings of Constantinople appear on the right,
while shipping in the harbour and the top of a
minaret are visible on the left.

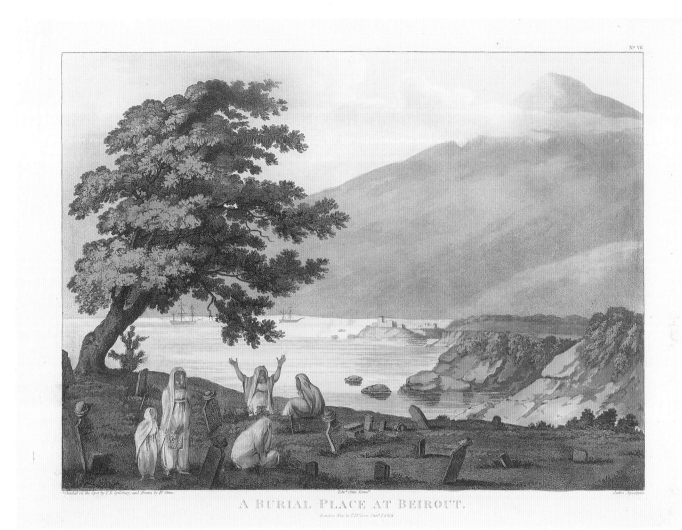

A BURIAL PLACE AT BEIROUT.

'A BURIAL PLACE AT BEIROUT'

Plate No. VII

Hand-coloured aquatint

Height 307 mm, width 397 mm

Designed by Daniel Orme after F. B. Spilsbury and engraved by (?Joseph) Jeakes and Edward Orme; published by Thomas McLean in London on 1 January 1819 (PAH 2644).

This view of veiled women at a burial site near Beirut in Lebanon was one of a series of engravings which revealed the customs of Eastern ports to Western viewers. Across the water to the right the buildings of the town are visible.

craft such as feluccas and dhows (see page 92). Commerce is depicted more to reveal these ports' eastern flavour than to display their trading might.

Several eastern Mediterranean ports were linked with military and naval campaigns. Indeed it was through engravings of the Napoleonic Wars and the Greek independence movement that the British became acquainted with contemporary views of ports such as Alexandria and Athens. It is nevertheless striking how many of these harbour views depict peace rather than war, portraying scenes of relaxation rather than battle. A colour aquatint view of Athens published in 1821 gives less attention to Athens's seaport than to its classical ruins, including the

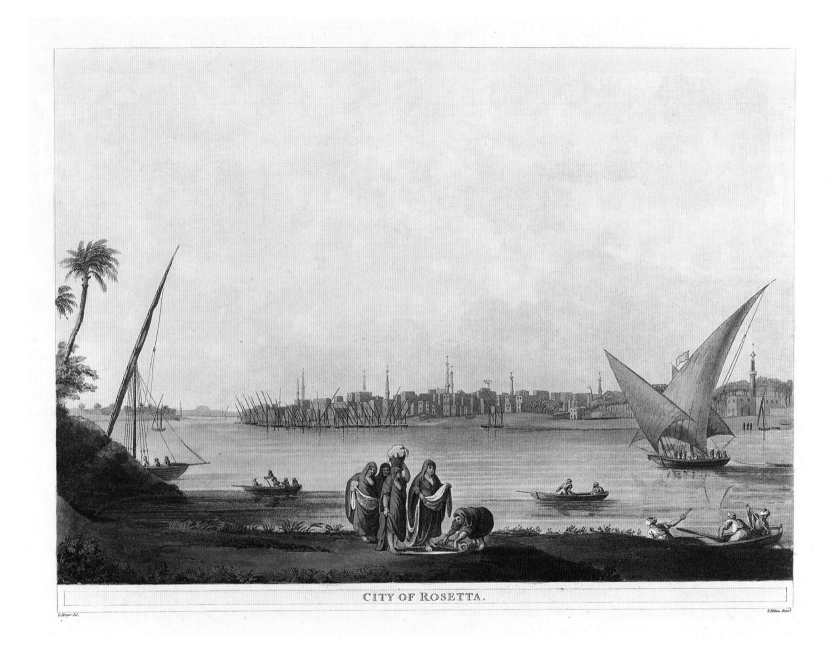

CITY OF ROSETTA.

Acropolis, and local people dressed in colourful Greek costumes (see top right).
Yet a grand plan of Corfu published in the mid-eighteenth century demonstrates
the strategic importance of even relatively small Mediterranean islands (see
bottom right). Topographical views executed by military officers convey their
isolation and boredom, but also their drawing skill and genuine interest in their

'VIEW OF ATHENS'
Hand-coloured aquatint
Height 340 mm, width 487 mm
Designed by Robert Dodwell and engraved by
Robert Havell; published in London in 1821
(PAI 0153).

This aquatint of Athens, with people dressed in
Greek costumes in the foreground and the
Acropolis and sea beyond, provides a romantic
view of the Aegean port. Such a view seems in
sympathy with the contemporary Greek campaign
for independence from Turkey.

'CITY OF ROSETTA'
Hand-coloured aquatint
Height 310 mm, width 388 mm
Designed by L. (?Louis) Mayer and engraved by
Thomas Milton; published in the early nineteenth
century (PAH 2856).

Engravings such as this exquisitely-coloured
aquatint of Rosetta (Rashid) in Egypt convey
Western artists' fascination with local dress and
sailing vessels.

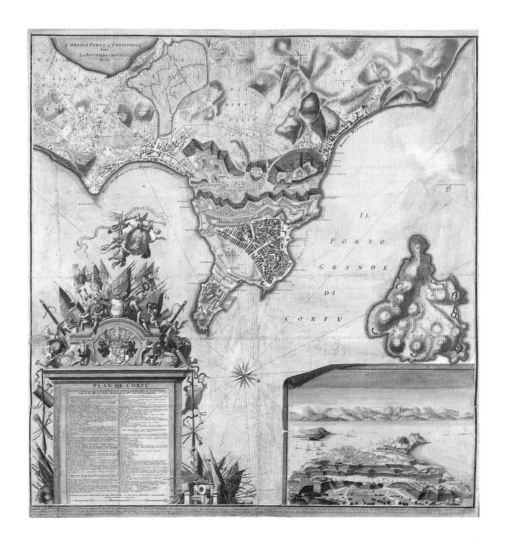

'PLAN DE CORFU'
Plan of Corfu
Hand-coloured etching
Height 777 mm, width 742 mm
Engraved by Johann-Baptista Homann; published in
1735 (PAI 0148).

This lavish plan of the Greek island of Corfu
includes many references to war. Fortifications
are prominently displayed in a cartouche, while a
description of Corfu is embellished with an
impressive array of weapons.

93

surroundings. Such works are often useful sources of contemporary social history. Thus, details depicting the daily routine of British soldiers on and off duty in Alexandria are beautifully recorded in a serious of colour aquatints after amateur drawings published in 1804 (see above).

'TRANSPORTING SUPPLIES, ALEXANDRIA, CA. 1804'
Colour aquatint and etching
Height 248 mm, width 911 mm
Designed by Captain (?C. M.) Walker, etched by J.(?John) Powell and engraved by Frederick Christian Lewis; published by Thompson in London in June 1804 (PAH 2865).

While many ports were sketched by British military and naval officers, Captain Walker's view of the port of Alexandria in Egypt is unusual in focusing on the activities of soldiers in camp. This may be the same Captain Walker whose miniature, on ivory, is in the collection of the National Maritime Museum.

Engraved by F.C. Lewis

Conclusion

Southern European and Mediterranean ports struck visitors as deliciously unfamiliar. Their sunny climate, ancient culture and strategic location heightened their fascination for Northern European viewers. These differences also influenced the visual representation of the ports. While Northern European artists delighted in the colours and customs of these foreign ports, commercial and strategic concerns also informed their views. Prints of Mediterranean ports reflect growing awareness of foreign cultures, and of the points of contact (and conflict) between nations. These contacts would continue to develop. Indeed, from the eastern Mediterranean, travellers and artists looked eastward towards Asia and Africa, the subject of the next chapter.

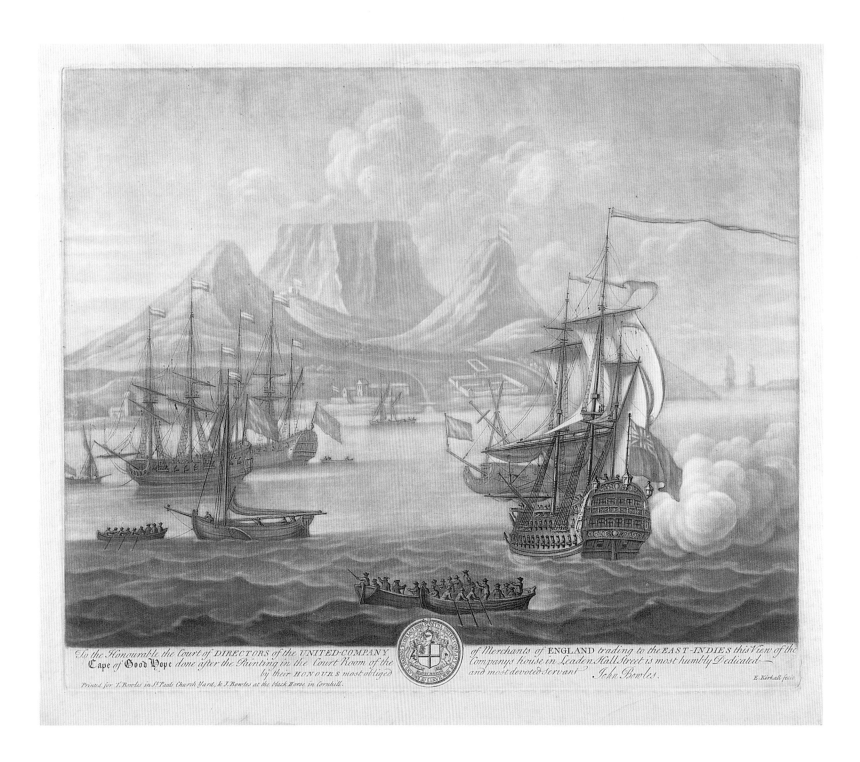

To the Honourable the Court of DIRECTORS of the UNITED-COMPANY of Merchants of ENGLAND trading to the EAST-INDIES this View of the Cape of Good Hope done after the Painting in the Court Room of the Companys house in Leaden Hall Street is most humbly Dedicated by their HONOURS most obliged and most devoted servant John Bowles.

Printed for T. Bowles in St Pauls Church Yard, & J. Bowles at the black Horse in Cornhill. E. Kirkall fecit

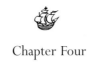

Chapter Four

Eastern Visions

Asian and African Ports

From the ports of Europe and the Mediterranean, navigators and traders moved eastwards, eager to find sea routes to Asia, the home of spices highly prized in Europe. After the pioneering exploratory voyages of Portuguese and Dutch navigators in the fifteenth and sixteenth centuries, several European governments, most notably the British and Dutch, authorised the establishment of joint stock companies to finance regular trading voyages to the East. It was within ports along these trade routes that Europeans first encountered Asian and African peoples and cultures. Drawings, paintings and engravings of these ports in turn informed other Europeans about these cultures, and, perhaps as importantly for contemporaries, the nature and degree of European involvement in the wider world. As this involvement expanded in the eighteenth and nineteenth centuries from a primarily trading to a military and eventually political role, the visual representation of Asian and African ports adapted to reflect these changing priorities.

In contrast to British, Irish, European and Mediterranean ports, where local as well as foreign artists produced engravings, most eighteenth- and nineteenth-century prints of Asian and African ports were created by European artists. Works by British artists predominate, particularly views of those ports which fell under British commercial, military or political influence. Yet prints by Dutch, French, Spanish and other European artists, usually of areas with links to these European nations, also appear. Inevitably, these eastern views must be understood in terms of western values and preconceptions, indeed misconceptions.

Cape Town

Before the opening of the Suez Canal in the mid-nineteenth century, the most direct route for European ships to the East was to sail down along the west coast of Africa, round the Cape of Good Hope, up along the east coast and then across the Indian Ocean to India, Malaysia and Indonesia. One of the first and most important stops en route was Table Bay, near the Cape of Good Hope at the tip of southern Africa. Initially established as a victualling base by the Dutch East India Company (VOC), the fertility of the land and the utility of the harbour encouraged the area's further development by Europeans. In time, the economy of the settlement of Cape Town was based as much on the export of the agricultural products of the interior as on servicing the needs of sailors and ships in port.

In the seventeenth and eighteenth centuries, however, such developments were still in the future, and many of the early engravings make explicit the anchorage's dependence on the great European trading companies. These close ties are described in an elegant green mezzotint '…View of the Cape of Good Hope…' by the renowned British engraver Elisha Kirkhall, published by the London printsellers Thomas Bowles and his brother John Bowles. The print depicts ships and boats in the bay with Table Mountain behind them (see page 96). The caption notes that the view is engraved after a painting in the Court Room of the East India Company's headquarters in Leadenhall Street in London, and the print is correspondingly dedicated to the 'Honourable the Court of Directors of the United-Company of Merchants of England trading to the East-Indies'. A similar view of Bombay links this port even more closely with the trading company, describing it as 'Bombay on the Malabar Coast Belonging to the East India Company of England'. Here, as in many prints of Asian and African ports, the description of native inhabitants and cultures is made secondary to the account of European activity. While many engravings claim to have been done 'on the spot', most rely upon sketches made by European visitors such as naval officers or artists, or upon paintings which may have been completed years before publication of the engraving. Such engravings were often expensive items intended for wealthy merchants, yet many inexpensive views were also produced. A good example is Robert Sayer's mid-eighteenth-century 'View of the Cape of Good Hope', whose title is published in both French and English, indicating that it was designed for both British and foreign audiences.

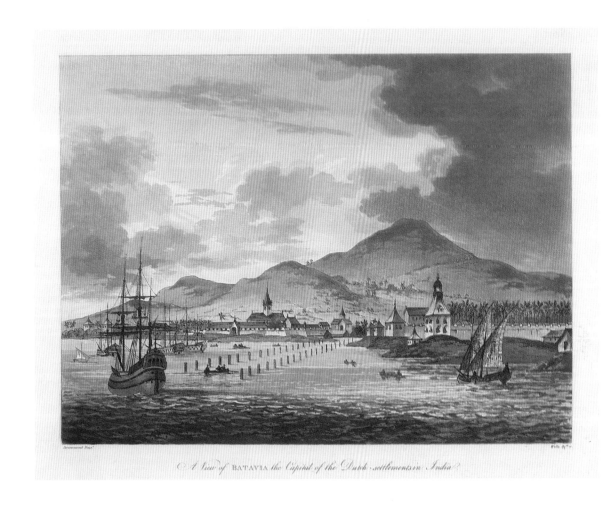

A View of BATAVIA the Capital of the Dutch-settlements in India

'A VIEW OF BATAVIA THE CAPITAL OF THE DUTCH-
SETTLEMENTS IN INDIA'
Brown aquatint and etching
Height 398 mm, width 546 mm
Designed by Drummond; engraved and published
by J. Wells in London on 25 February 1796
(PAI 0233).

Batavia (Jakarta), in Indonesia, was the centre of
the Dutch trading empire in Asia. Dutch influence
is evident in the steeply roofed buildings and
wide-bottomed ships visible in this design.

Batavia and Malacca

Whether expensive or not, what is striking about most seventeenth- and eigh-teenth-, and even some nineteenth-century prints is the emphasis on Asian ports' commercial value for European traders. Numerous views of Batavia, Malacca and other ports in the East Indies focus on their utility rather than their beauty. Prints often point out infrastructure linked with European trade and settlement, thus a series of prints of Batavia (Jakarta) in Indonesia designed to accompany a text includes views of the 'Fish Market', 'Spinhouse' and 'Slaughter House'. Even a tasteful brown aquatint view describes the port purely in terms of Dutch trading interests: 'A View of Batavia the Capital of the Dutch-settlements in India' (see above). Likewise a 'View of a House, Manufactory, and Bazar [sic] in Calcutta...' is

Engraved for Middleton's Complete System of Geography.

The CITY *of* MALACCA *in the East Indies.*

dedicated to 'the Chairman, Deputy Chairman, and Directors of the Honble. the United East India Company' of Britain. Prints serve as much to introduce the commercial aspect of Asian ports to Western audiences as to display their aesthetic features. Several engravings offer views of ports as part of a set of images of the region, for instance; 'The City of Malacca in the East Indies, Engraved for Middleton's Complete System of Geography' (see above). Designs such as these often focus more closely on Western shipping than on the layout and atmosphere of the town itself.

'THE CITY OF MALACCA IN THE EAST INDIES. ENGRAVED FOR MIDDLETON'S COMPLETE SYSTEM OF GEOGRAPHY'
Engraving
Height 191 mm, width 291 mm
Published in London *c.*1777–78 (PAD 0005).

Like many strategically located ports in Asia, Malacca was ruled by various European powers in turn, namely the Portuguese, Dutch and British. Engravings such as this one drew attention to the Malaysian port's importance as a trade centre.

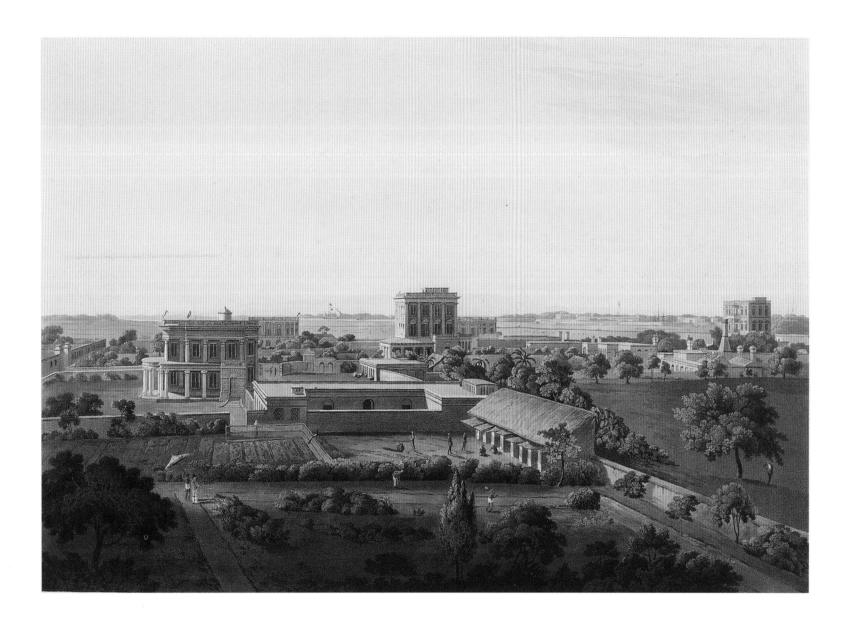

By the early nineteenth century, British trade with
India was growing rapidly. The substantial buildings
depicted in this view of Calcutta reflect Britain's
considerable commercial investment in the port.

India

Over time, though, European artists began to pay more attention to the aesthetic
qualities of the Asian landscape. Artists prepared many beautiful, often rather
empty topographical views which mention ports only tangentially. There is an air
of tranquillity about many views of India, as Daniel Havell's hand-coloured
aquatint of Henry Salt's 'Calcutta' demonstrates (see above). Salt has depicted a
peaceful scene of stately buildings set in gardens with ships in a distant channel.

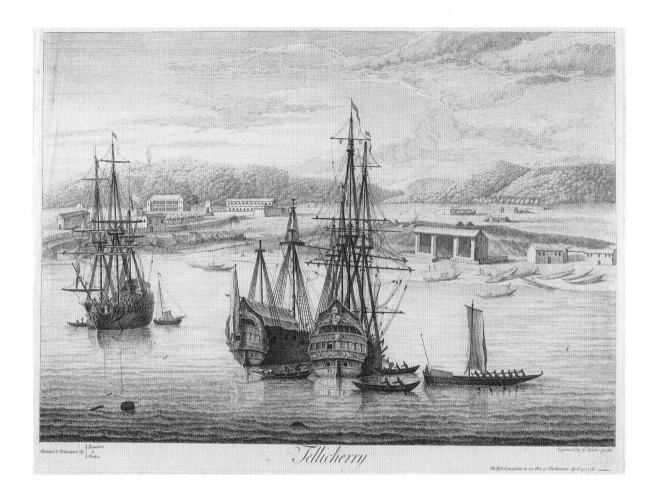

Tellicherry

Except for the tropical foliage and native figures, there is little to indicate that the scene is an Indian rather than a sleepy European river port. Such views are deliberately selective, and often focus on new western buildings, and developments directly connected with European trading companies. Thus forts, factories, wharves and docks feature more prominently in engravings than native traders, boats and markets. A mid-nineteenth-century print details a 'Hydraulic Graving Dock' intended for Bombay, indicating the application of new British technology to the growth and development of the Empire. Yet native vessels and, on occasions, native buildings, are included within some designs to emphasise the foreignness of the scenes to European viewers. Examples include an etching of Western ships towering over native boats in the little harbour at Tellicherry in India (1736) (see above), and a view of the 'Fishing Cove at Columbo [sic]' in Sri Lanka.

'Tellicherry'
Etching
Height 443 mm, width 597 mm
Painted and delineated by (?George) Lambert and (?Samuel) Scott and engraved by G.(?Gerard) Vandergucht; published on 19 April 1736
(PAI 0226).

This early view of the Indian port of Tellicherry reflects European pride in their trading ships, which dominate the foreground. Native boats, and, in the background, buildings, appear small by comparison.

Often a single port, such as Bombay or Calcutta, is depicted from several vantage points in a series of prints. An early nineteenth-century set of views of Calcutta includes scenes such as: 'A View of Writers Buildings from the Monument at the West End', 'A View of the Botanic Garden House and Reach', 'A View of the Opposite or Sulkhea Side. From the Respond[en]tia Walk with a North-wester coming on.' In addition to providing an aesthetically pleasing set of engravings, these designs gave European viewers a panoramic overview of this Asian port, and the opportunity to see western progress in developing the area. Such prints may well have been intended to encourage more Europeans to try the commercial opportunities in India.

The European perspective of most engravings of Asian ports is understandable, given that most of the artists and viewers were European. Many of the designers, engravers and publishers of prints of Asian and African ports also produced views of European and American ports. Indeed, British artists and publishers like William and Thomas Daniell, Daniel Havell, Francis Jukes, Edward Orme and Robert Sayer produced engravings of ports around the world. Although the details of the prints vary by port and individual sketch (which were often drawn by amateur artists such as military and naval officers), the stylistic approach is fairly standard, based on contemporary European topographic conventions. Moreover, as publishers sold views of foreign ports alongside views of European ports, their aim seems to have been to achieve a consistent style that would attract as many customers as possible. Widespread appeal rather than innovation was their aim. Most views of ports continued to be framed from the outside looking in, or alternatively from within looking out at the roads which brought trading vessels into the port. The few images which depict ports themselves from within usually focus on European buildings and houses.

Such views may indicate the limited extent of contact between Europeans and native peoples. Indeed most views of Asian ports show only a few natives, usually grouped separately from European figures, or depicted as servants, as in the case of a 'View from Malabar Hill', published in 1800. There were some exceptions to this rule, however, particularly in later prints. In a pair of comic prints of passengers landing and embarking at Madras, dated 1837, native people are well-represented. Nevertheless they are still depicted as subservient to the rather foolish-looking Europeans they carry ashore (see page 104).

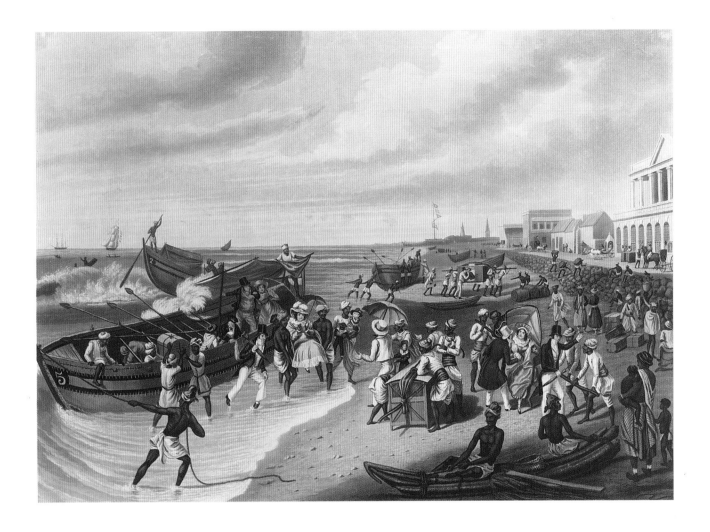

While most of the engravings discussed so far were of ports trading with Britain and/or the Netherlands, other European nations maintained links with Asian ports. A view of Macao, a port located on a peninsula in southeastern China, reflects Portugal's longstanding commercial and political influence in that community (see top right). Such prints remind us of Spain and Portugal's ties with specific Asian ports, including the Philippines, Macao, China and Japan. Yet as a late eighteenth-century etching of the British-controlled island of Bombay published in Paris with a Spanish title confirms (see bottom right), Europeans' interest in Asia was not confined to their own spheres of influence. Rather, artists recognised that viewers were curious about Asian ports in general, and about the activities of other European nations in opening these markets to the West.

'MADRAS. LANDING'
Hand-coloured aquatint
Height 368 mm, width 526 mm
Drawn by J. B. East and engraved by C.(?Charles) Hunt; published by Ackermann & Co. in London on 15 May 1837 (PAI 0219).

By the mid-nineteenth century, passenger travel to India was well established. In this humorous design, plump western tourists land awkwardly on the beach in Madras.

VIEW OF THE CITY OF MACAO
WITH SHIPPING
Gouache
Height 423mm, width 735 mm
Produced in the (?)early nineteenth
century (PAI 7196).

Macao, on the Pearl River delta,
was an important port and the
centre of Portuguese trade with
China. Chinese cultural influence is
evident in the sampans and other
local craft anchored in the fore-
ground, and in the design of many
of the buildings in the background.

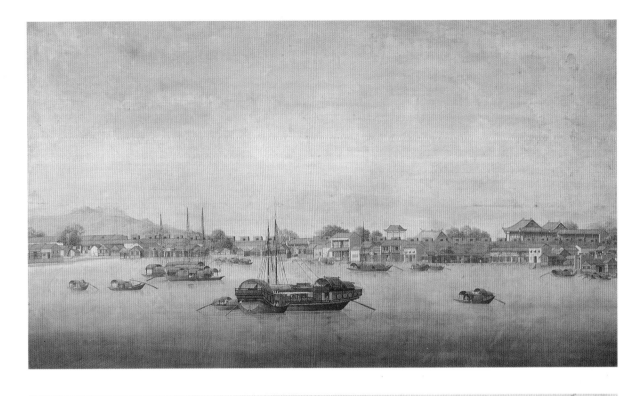

'VISTA EN PRESPECTIVA [SIC] DE LA
ISLA DE BOMBAY...'
Perspective View of the Island of
Bombay...
Hand-coloured etching
Height 267 mm, width 430 mm
Published by J.(?Jacques) Chéreau in
Paris, c.1780 (PAH 2690).

Bombay (now known as Mumbai),
an island off the West coast of India,
was developed by the Portuguese
and then the British as a major
trading port. In this view, the
depiction of numerous ships in
the harbour signals Bombay's
commercial importance.

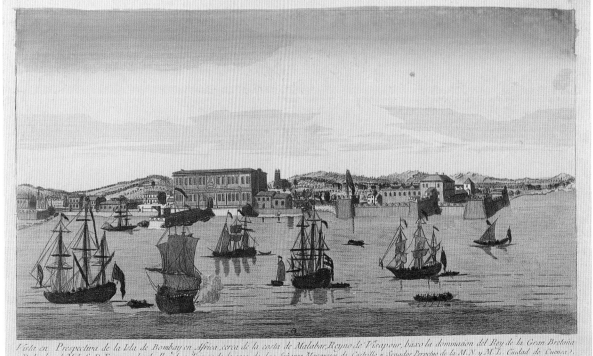

Vietnam, China and Japan

Perhaps the most mysterious and intriguing of Asian culture for western viewers was that of China. While interest in trade continued to dominate representations of Asian ports, fascination with the local culture was reflected in several views of China and Indochina. A series of prints describes views along the Yangtse River,

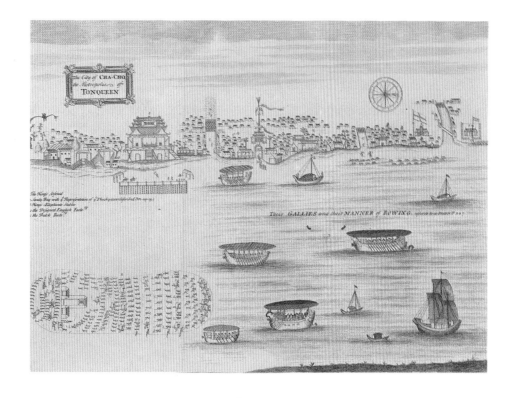

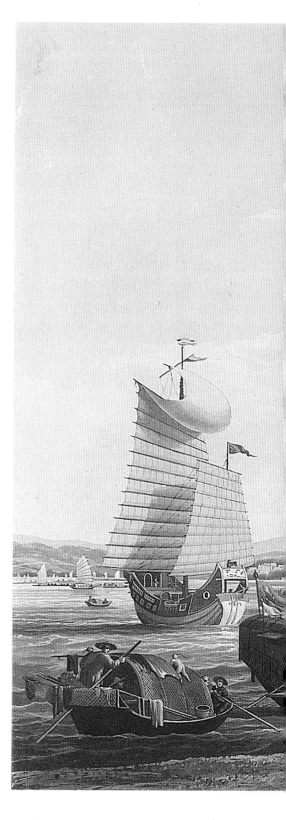

'THE CITY OF CHA-CHO. THE METROPOLIS OF TONQUEEN. THEIR GALLIES AND THEIR MANNER OF ROWING…'
Vol. 6, plate 2&3, page 122
Etching
Height 304 mm, width 405 mm
Published *c.*1704 (PAH 2722).

This early view of the Vietnamese port of Hanoi reflects the Western artist's fascination with the local architecture and canopied rowing vessels in the foreground. The crude manner of the design suggests an amateur artist, probably a visitor to the port.

'WHAMPOA, IN CHINA, TAKEN ON THE SPOT…'
Hand-coloured aquatint
Height 404 mm, width 610 mm
Painted by William John Huggins and engraved by Edward Duncan; published by William John Huggins in London on 9 August 1835 (PAI 0239).

By the mid-nineteenth century, Britain's growing trade with China inspired the production of numerous engravings of Chinese ports. This view of Whampoa depicts the colourful mix of Western and Eastern vessels in its harbour.

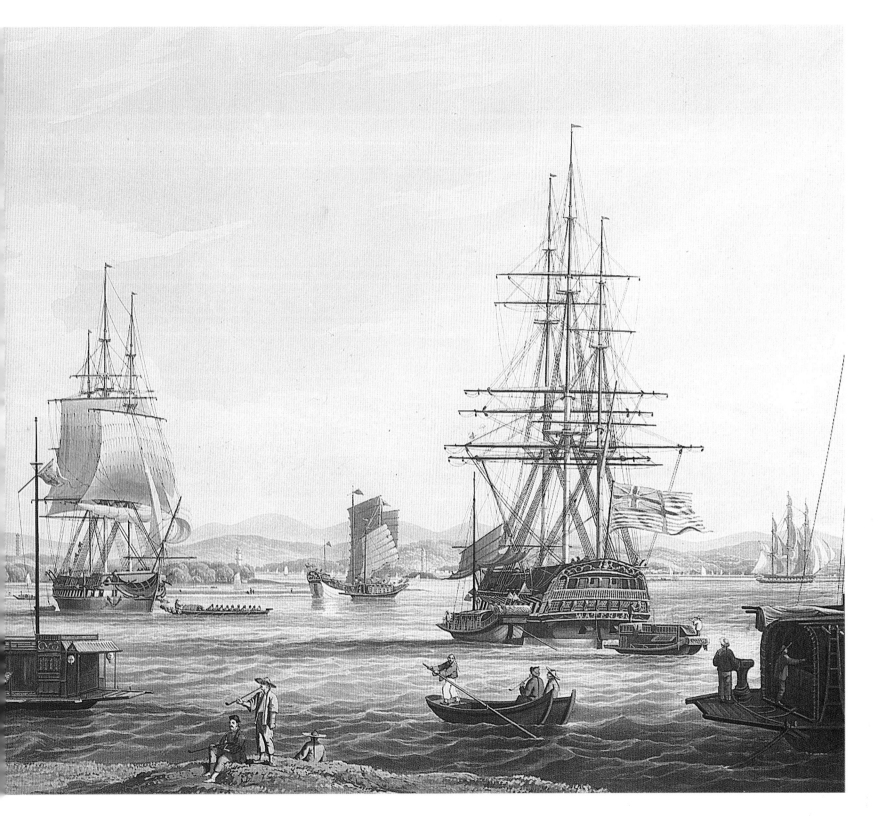

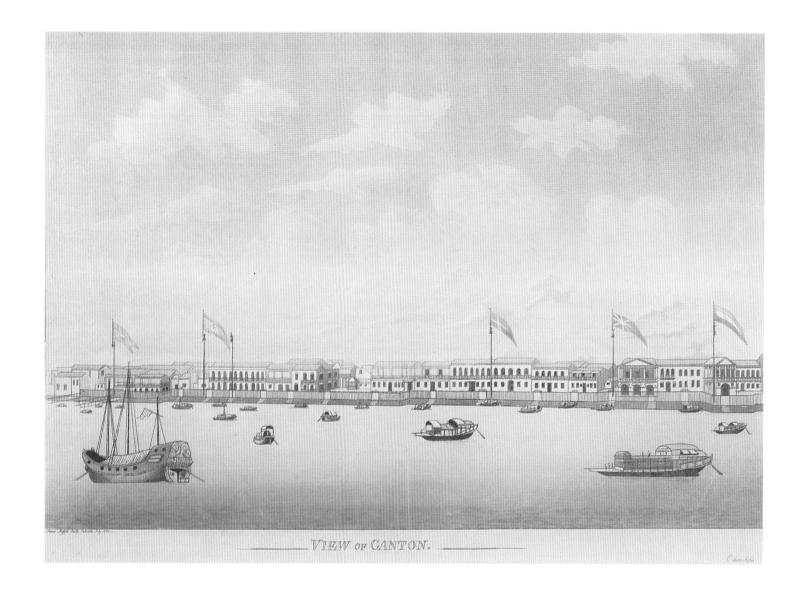

VIEW OF CANTON.

pointing out striking rock formations and temples, including: 'View of the Tchin-Shan, or Golden Island in the Yang-Tse-Kiang or Great River of China'. This combination of Western interest in topography and curiosity about Chinese culture is demonstrated further in a schematic view of present-day Hanoi in Vietnam, whose culture was heavily influenced by that of China. 'Cha-Cho. The Metropolis of Tonqueen. Their Gallies and their Manner of Rowing...' was published c.1704 as 'Plate 3' within a book or periodical (see page 106). In

'VIEW OF CANTON'
Aquatint and etching
Height 350mm, width 310mm
Engraved by James Moffat; published in
Calcutta in July 1802 (PAI 0237).

This view of Canton reflects the importance of international trade to this port. Rows of commercial warehouses with the flags of European trading nations line the shore.

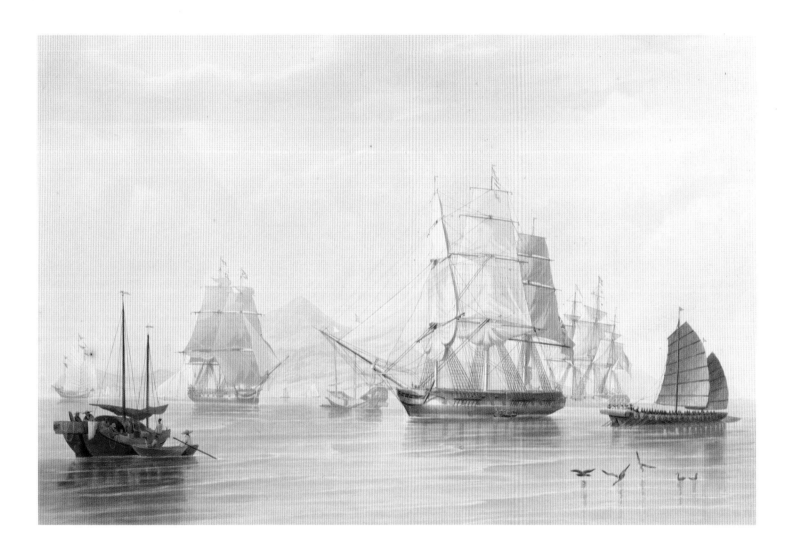

'THE OPIUM SHIPS AT LINTIN IN CHINA, 1824.
FROM A PAINTING IN THE POSSESSION OF JOHN
GOVER, ESQRE...'
Hand-coloured aquatint
Height 465 mm, width 653 mm
Painted by William John Huggins and engraved by
Edward Duncan; published by William John
Huggins in London in 1838 (PAI 0240).

Britain's lucrative trade in opium to China inspired
much commentary, including this lovely aquatint
of ships at the Chinese port of Lintin. The design
was taken from an oil painting, one of many
views of shipping made in the eighteenth and
nineteenth centuries.

general, views of China stress its foreign nature even more than contemporary views of other Asian ports. This is understandable, as European contact with China was patchier than with India and Indonesia. While the latter were well-established components of the late eighteenth-century European trade network, the former did not come under European influence till the early nineteenth century, and only after concerted Chinese resistance was overcome by European 'gunboat diplomacy'.

Several early nineteenth-century views of China focus on the exotic landscape and appearance of ports such as Canton, Whampoa and Lintin. Some attention is given to native cultural practices, thus a view of 'Whampoa, in China, Taken on the

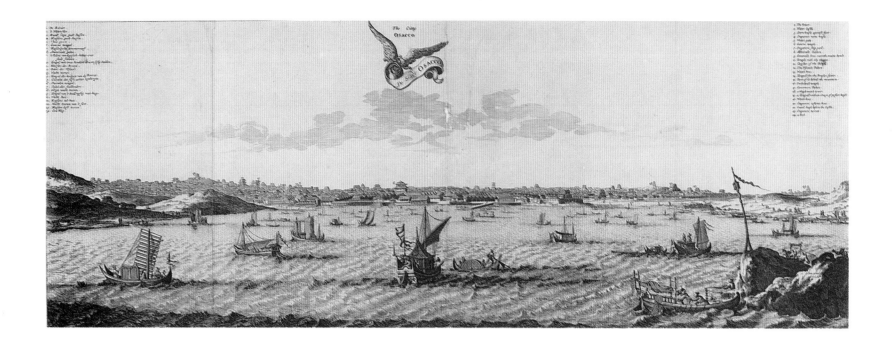

Spot…' includes 'Whampoa Pagoda, & those near to Canton' as well as views of Western and Asian shipping (see pages 106-107). Nevertheless the European presence is usually acknowledged in images of China. As early as 1802 a view of Canton refers to British involvement in this port (see page 108). This print was published in Calcutta, which in turn reminds us of the considerable number of British artists working in India at this time. India's links with China grew stronger through the lucrative British trade in tea, china and opium. A print published from William John Huggins's painting in 1838 depicts Britain's notorious involvement in the opium trade through a view of 'The Opium Ships at Lintin in China, 1824' (see page 109).

Engraved images of Japanese ports are comparatively rare before 1854. Japan was only really opened to trade with the West after U.S. Commodore Matthew Perry's negotiation of the Treaty of Kanagawa in that year. Seventeenth-century prints, including an engraving of Osaka *c.*1670, tend to present distant views of ports from the sea which provide limited information about the architecture and atmosphere of Japanese ports. Such remote views reveal both the actual and the cultural distance between Western artist and Japanese port (see above). There is little precise detail, only a general overview which does little to distinguish this

'DE STADT OSCACCO. THE CITY OSACCO'
View of Osaka
Etching
Height 267 mm, width 700 mm
Published in 1670 (PAI 0243).

This Dutch view of Osaka is one of the few Western engravings of the Japanese port made before the nineteenth century. Beyond the harbour with its variety of small craft, the skyline of the city is visible.

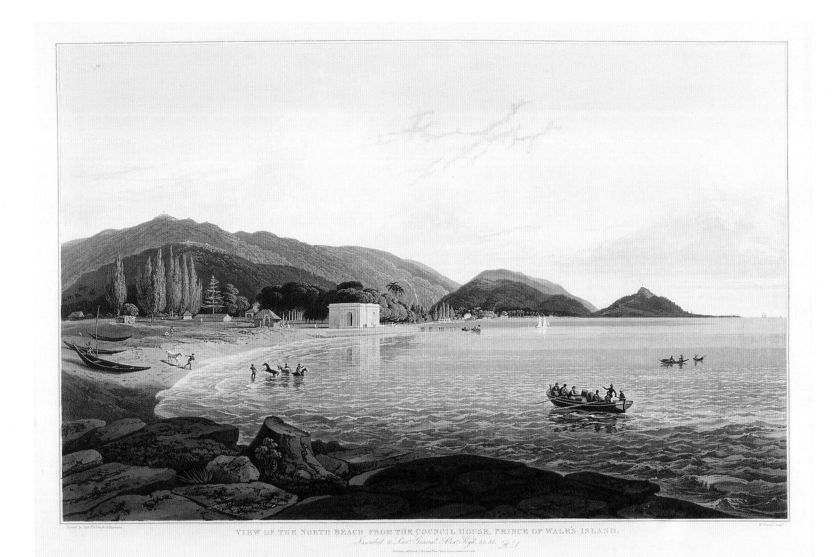

VIEW OF THE NORTH BEACH FROM THE COUNCIL HOUSE, PRINCE OF WALE'S ISLAND.

'View of the North Beach from the Council House, Prince of Wale's (sic) Island ...'
Hand-coloured aquatint
Height 454 mm, width 710 mm
Designed by Captain Robert Smith; engraved and published by William Daniell in London on 1 January 1821 (PAI 7178).

This delightful image of the Malaysian island of Penang depicts the buildings and activities of the British colonisers. A rowboat approaches a quiet beach where horses are being bathed in the water.

city from other Japanese ports. Prints thus reflect Western curiosity about the East, but also the considerable limitations of Western knowledge and understanding.

Political and Military Involvement

While commerce motivated much of the initial European activity in the East, gradually, although by no means uniformly, the perceived need for direct military and political involvement grew. This was in part a result of the high commercial

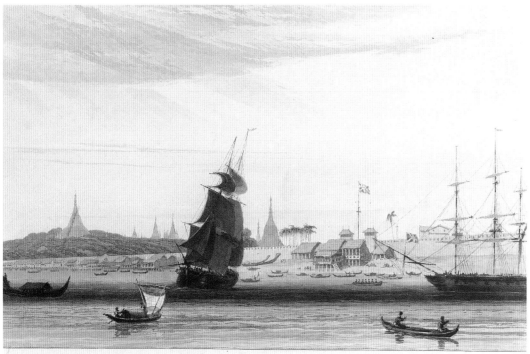

Rangoon from the Anchorage.

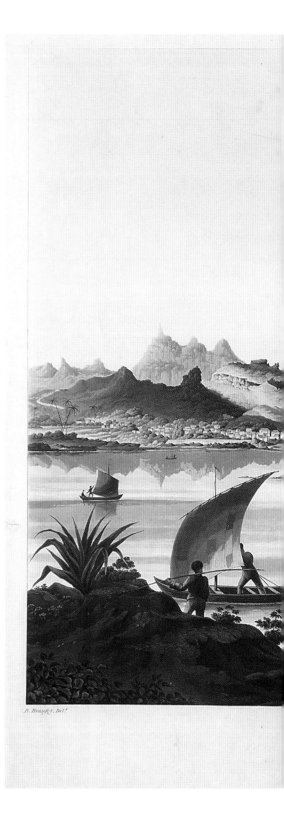

'RANGOON FROM THE ANCHORAGE...'
Hand-coloured aquatint and etching
Height 352mm, width 477mm
Drawn by Captain Kershaw in the early to mid-
nineteenth century (PAI 0212).

As the nineteenth century progressed, the British
established further trading and military links with
Asian ports. In this design flags and ships mark
the British presence in Rangoon (Yangon), while
conical buildings in the background reveal the
native Burmese culture.

'VIEW OF PORT LOUIS, MAURITIUS...'
Hand-coloured aquatint and etching
Height 478 mm, width 870 mm
Designed by (?Captain) B. Beaufoy and engraved
by Charles Rosenberg; published in the early
nineteenth century (PAI 7175).

The Napoleonic Wars inspired engravings of many
ports unfamiliar to British viewers. This lovely
view by a member of the 29th Regiment depicts
Port Louis on the island of Mauritius and
commemorates the military achievements of
the British army. Two soldiers admire the view in
the right foreground, while ships are visible in
the harbour beyond.

VIEW of PORT LOUIS, MAURITIUS.

Dedicated to Lieut. General the Right Honorable Sir G. Edeon, G.C.B. G.C.H. and the Officers of His Majesty's 29th Regiment. BY B. BEAUFOY. H.P. 29th Regiment.

C. Rosenberg, Sculp.

value of trade with Asian ports, and in part the extension of domestic European political rivalries to Asia. Prints began to depict permanent European settlements, protected not by the quasi-private armies of the joint stock companies but by the armies and navies of Europe, and in particular Britain. Cultural influence even more than just ownership became part of the colonial ethos. This is reflected in prints such as the 1821 set of views of the Prince of Wales's island (Penang) off the west coast of Malaysia. The series is a testament to British military and political interest in the area. It was painted by Captain Robert Smith, 'of Engineers', and engraved and published by the well-known London printseller William Daniell. The individual plates were dedicated to a variety of military and colonial figures; for instance a 'View of the North Beach from the Council House, Prince of Wale's [sic] Island…' was 'inscribed to Lieut. General Alexr. Kyd…' (see page 111). 'Capt. Kershaw, 13th Light Infantry' produced a similar series of early mid-nineteenth-century colour aquatints of Rangoon (Yangon). In 'Rangoon from the Anchorage…', for example, Kershaw presents an idyllic view of the British presence in the Burmese port (see page 112). British ships share a bay with native boats, and a fort flying the Union Jack keeps watch over the town.

As the above examples demonstrate, prints of Asian and African ports became well-established ways of honouring a patron as well as publicizing an artist. Often the person so honoured was an officer, or even a group of officers of a British regiment, as in (?Captain) B. Beaufoy's dedication of a 'View of Port Louis, Mauritius' to 'Lieut. General the Right Honorable Sir J. Byng, G.C.B. & G.C.H. and the Officers of his Majesty's 29th. Regiment' (see pages 112-113). Mauritius, a small island off the southeast coast of Africa, was a former French colony ceded to the British in 1814 after their victory in the Napoleonic Wars. It was thus particularly appropriate to dedicate contemporary views of Mauritius to British military officers. Many prints were dedicated to the local colonial governor, for instance a 'View of Cape Town, and its Environs' was dedicated to 'His Excellency Major General Sir Benjamin D'Urban, K.C.B. &c Governor and Commander in Chief of the Colony of the Cape of Good Hope, in South Africa…'. As men with influence and contacts in Britain as well as the local scene, colonial governors were useful patrons for artists developing careers, whether in the colony or at home. Thus Warren Hastings, the controversial Governor-General of Bengal, promoted the career of William Hodges in India.

'PORT ELIZABETH IN 1862...'
Hand-coloured lithograph
Height 495 mm, width 947 mm
Designed by Thomas William Bowler and
lithographed by Thomas Picken and Day & Son;
published by Messrs. Richards Impey & Co. in
Port Elizabeth, c.1862 (PAI 7198).

Civic pride and commercial confidence is
expressed in this view of well-dressed colonists
strolling on the hills above Port Elizabeth, South
Africa. Numerous ships are anchored in the
harbour below.

African Ports

Even more than prints of Asian ports, those of African ports reveal rather more
about the local European presence than native culture. Africans seem largely
hidden, even invisible in many prints of African ports and coastal settlements. This
may be partly a reflection of the differences in African and European maritime
activity, and in particular the lack of many substantial African ports in the
European sense, but it is also partly a reflection of European priorities. Trade was
the primary interest of most Europeans in Africa, and where there were few

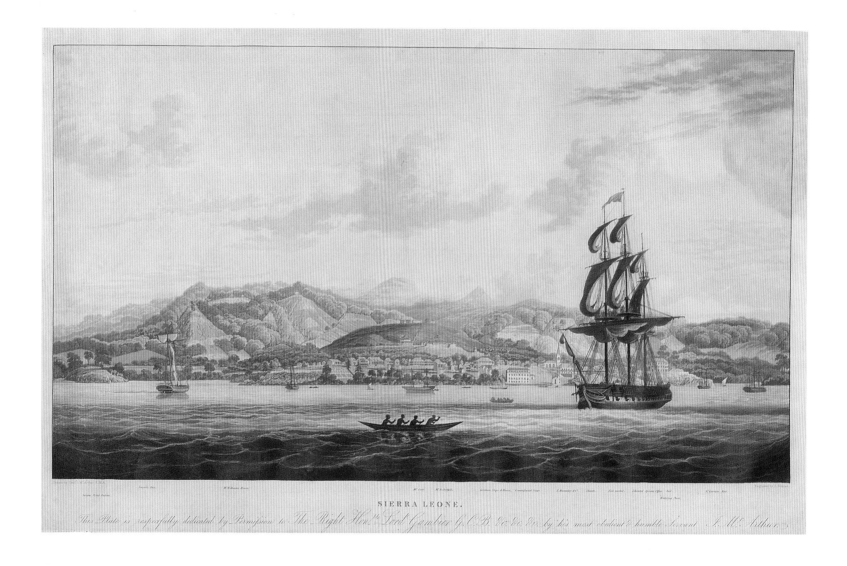

SIERRA LEONE.

This Plate is respectfully dedicated by Permission to The Right Honᵇˡᵉ Lord Gambier G.C.B. &c. &c. &c. by his most obedient & humble Servant J. McᵗʰArthur

opportunities for representing trade there was little incentive to represent details of the local culture. Representations of African ports and of people may also have been discouraged by increasing moral repugnance in Europe at what was long the most profitable and well-established form of commerce with Africa – the slave trade. By the mid-nineteenth century European involvement in the slave trade had ended, and the discovery of gold, diamonds and apparently plentiful pastoral land had revived European interest in parts of Africa. Nothing indicates this better than the many prints made of ports established during the gold rushes and other speculative ventures of the nineteenth century.

'SIERRA LEONE...'
Hand-coloured aquatint
Height 396 mm, width 623 mm
Designed by Lieutenant S. McArthur and engraved by Edward Duncan; published in the early nineteenth century (PAI 0265).

Sierra Leone's recent history as a centre of the slave trade with Britain is ignored in most nineteenth-century engravings. This aquatint focusses instead on the exotic beauty of the African coast and the ships and native craft off the port.

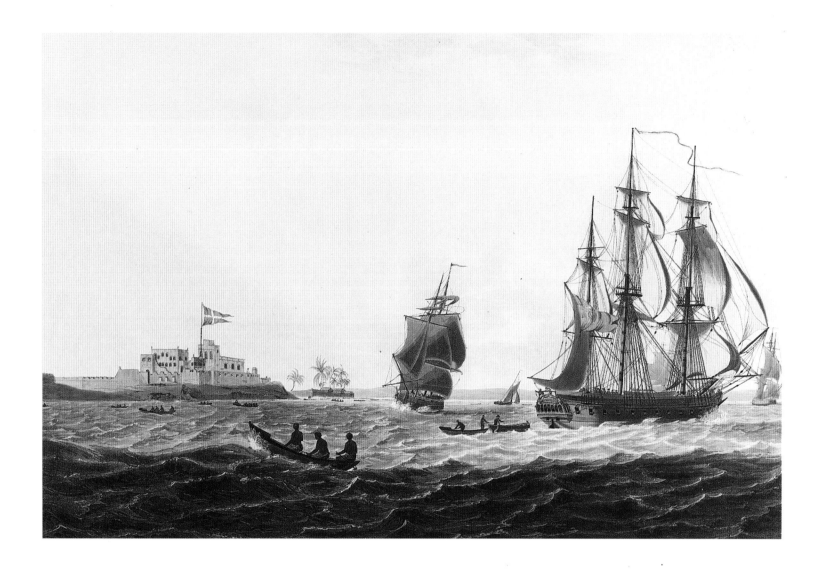

'CHRISTIANSBORG, A DANISH SETTLEMENT ON THE
GOLD COAST, AFRICA...'
Hand-coloured aquatint and etching
Height 460 mm, width 598 mm
Drawn by G. Webster and engraved by J. (?John)
Hill; published by J. Barrow in London on 26
October 1806 (PAI 0274).

Britain was not the only European nation to
establish port communities along the African
coast, as this view of ships and native boats off a
Danish settlement in Ghana demonstrates.

African, and as will be discussed in later chapters, American and Australian
ports, feature heavily in these representations. Port Elizabeth provides a useful
case study of a South African port booming in the mid- to late nineteenth
century. Numerous engravings were produced, including an 1862 hand-coloured
lithograph dedicated to 'the Mayor and Town Council' (see pages 114-115).
Significantly, this print was published in Port Elizabeth itself, indicating the
existence of a level of economic prosperity and population growth sufficient to
support a printing industry. Such views, with their emphasis on the aesthetically
pleasing sight of a prosperous port town, demonstrate mid-nineteenth-century

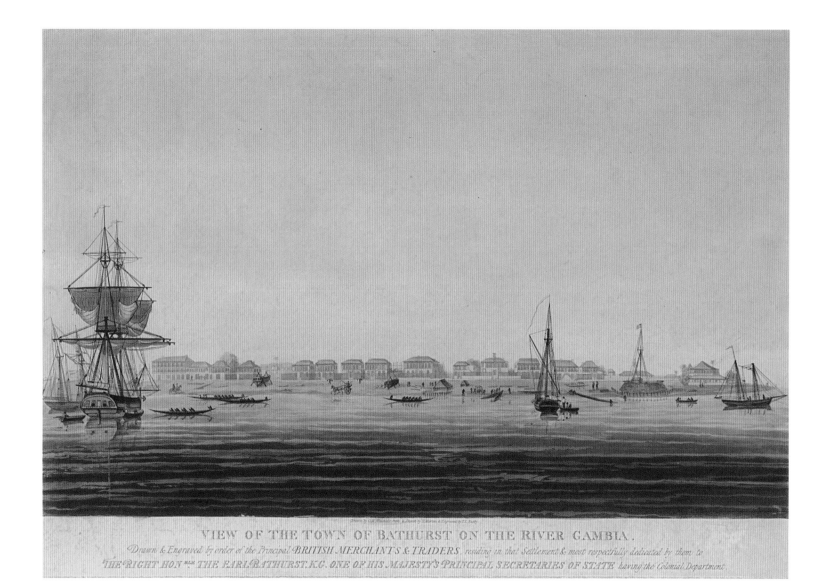

VIEW OF THE TOWN OF BATHURST ON THE RIVER GAMBIA.
Drawn & Engraved by order of the Principal BRITISH MERCHANTS & TRADERS, residing in that Settlement & most respectfully dedicated by them to
THE RIGHT HON.BLE THE EARL BATHURST. K.G. ONE OF HIS MAJESTY'S PRINCIPAL SECRETARIES OF STATE having the Colonial Department.

confidence in the social and economic future of white colonies in South Africa and elsewhere. The future seemed very bright indeed.

The search for profit, sometimes combined with Christian missionary zeal and humanitarian projects to resettle freed slaves, inspired the establishment of new settlements on the Gold Coast (Ghana) and elsewhere in West Africa. Attractive colour aquatints were produced of several port communities, for example Sierra Leone (see page 116); 'Christiansborg, a Danish Settlement on the

'VIEW OF THE TOWN OF BATHURST ON THE RIVER GAMBIA...'
Hand-coloured aquatint and etching
Height 385 mm, width 557 mm
Drawn by C. (John) M. Whichelo from a sketch by H. Martin, engraved by T. L. (?Thomas Lord) Busby, c. 1832 (PAI 0258).

The rows of warehouses on the shore, ships and native boats in this view of Bathurst attest to the importance of European trade with Africa.

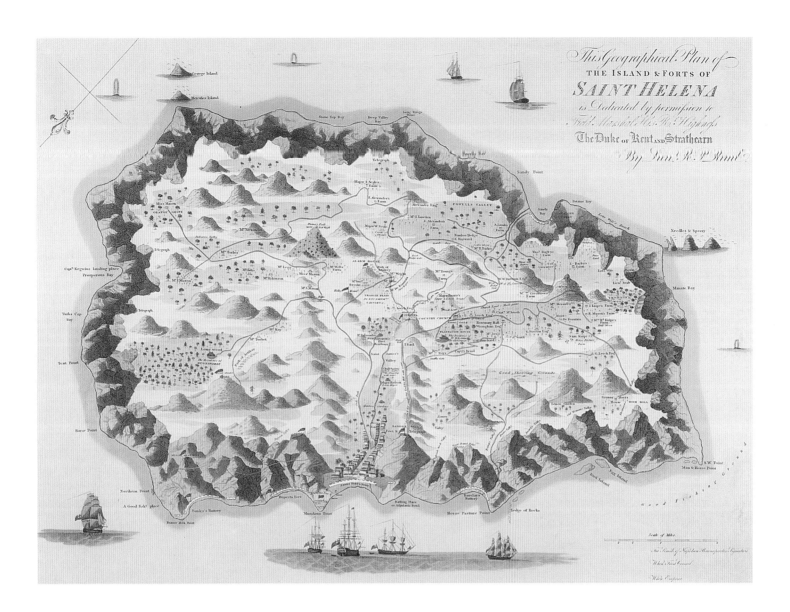

'...GEOGRAPHICAL PLAN OF THE ISLAND & FORTS
OF SAINT HELENA...'
Hand-coloured etching
Height 455mm, width 592 mm
Designed by Lieutenant R. P. Read and engraved
by R. Kirkwood; published by J. & M. Rippin in
London on 4 June 1817 (PAI 0413).

By the nineteenth century even tiny, remote
ports could attract engravers' attention. Views
of the island of St Helena such as this coloured
map were inspired by its role as a prison for
Napoleon Bonaparte.

Gold Coast' (see page 117) and the British settlement of Bathurst on the River
Gambia (see left). While interesting as historical records of European experiments
in colonisation, prints of these communities focus almost exclusively on European
trade rather than African culture. The dedication to the view of Bathurst reveals
the links between trade and politics: 'Drawn & Engraved by order of the Principal
British Merchants & Traders, residing in that Settlement & most respectfully
dedicated by them to the Right Hon.ble The Earl Bathurst, K.G. One of His

Majesty's Principal Secretaries of State having the Colonial Department.' Several prints of Sierra Leone were dedicated to colonial figures, and political ambition is evident in the dedication of a colour aquatint of Freetown, Sierra Leone: 'by permission to the Right Hon.ble Lord Glenelg her Majesty's Principal Secretary of State for Colonies by Patrick Leigh Strachan Esqr. Private Secretary to His Excellency Richd. Doherty, Governor in Chief of the Western Coast of Africa…'.

Political, military and commercial concerns combined to draw considerable European attention to the small island of St Helena in the nineteenth century. Located 1200 miles off the southwest coast of Africa, St Helena was a convenient stopping off place on the route to Cape Town and had been annexed by the Dutch and the British East India Companies respectively. Yet the island only achieved international attention after it was selected as the site of Napoleon Bonaparte's final exile, following his capture after his defeat at the Battle of Waterloo. The choice of such an isolated spot for a statesman's prison itself reflects the enormous success of European efforts in opening up the ports of the world. By 1815, a small island in the South Atlantic was deemed both sufficiently remote to make escape unlikely and sufficiently convenient to permit regular monitoring by the British government.

It was in St Helena that Bonaparte spent the last six years of his life, and numerous engravings were made of the island's steep St James's valley and the town of St Helena. A good example is an 1817 'Geographical Plan of the Island & Forts of Saint Helena', dedicated to 'Field Marshal His Rl. Highness The Duke of Kent and Strathearn By Lieut. R. P. Read', which includes details of Bonaparte's residence and even a facsimile of his signature (see page 119). Bonaparte's stay raised the island's profile and plans were made to establish St Helena as a coaling station for the British fleet, although this never materialised. The number and variety of extant engravings of St Helena indicate just how widespread European interest in foreign ports was, and to what extent optimism could overcome the daunting geographical and economic gaps separating Europe and its far-flung trading areas. While St Helena never succeeded as a self-sustaining colony, and today remains dependent on external support for economic survival, it maintained a firm hold on the European imagination, as the many beautiful and evocative prints of the island indicate.

Conclusion

Trade motivated early European voyages to Asia and Africa, and trade dominates the majority of eighteenth- and nineteenth-century European engravings of Asian and African ports. European ships, trading posts and officials are often described in great detail. Preconceptions of the East as a land of vast riches limited European perceptions of the variations between local cultures, and may explain the rather formulaic representation of many Asian and African ports in engravings. However, some prints do provide important information about the appearance and function of these ports and local society. By the late eighteenth and early nineteenth centuries, Asian and African ports were regarded as representing more than just access to valuable foreign goods. They provided sites for political and cultural influence over foreign people and territory. European imperial policies were initiated in the ports of Asia and Africa before moving inland. A variety of military, political and cultural projects are recorded in contemporary engravings. European imperial ambition was not limited to Asia and Africa, and indeed had an important role in the development of North and South American ports, which will be explored in the next chapter.

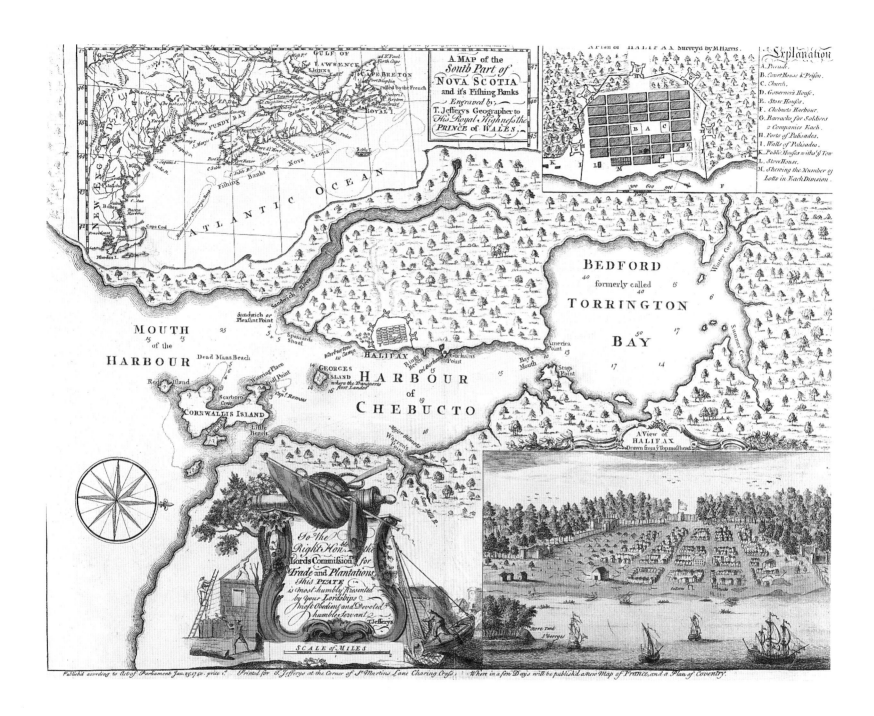

A MAP of the
South Part of
NOVA SCOTIA
and it's Fishing Banks
Engraved by
T. Jeffery's Geographer to
His Royal Highness the
PRINCE of WALES

A Plan of HALIFAX Surveyd by M. Harris.

Explanation

A. Roads.
B. Court House & Prison.
C. Church.
D. Governor's House.
E. Store House.
F. Chebucto Harbour.
G. Barracks for Soldiers
2 Companies Each.
H. Forts or Palisades.
I. Walls of Palisades.
K. Public Houses with the Town
L. Store House.
M. Shewing the Number of
Lotts in Each Division.

GULF OF
St. LAWRENCE

CAPE BRETON
called by the French

ROYAL I.

NEW ENGLAND

PUNDY BAY

ATLANTIC OCEAN

Fishing Banks of Nova Scotia

Cape Cod

Rhodes I.

MOUTH
of the
HARBOUR

Sandwich or
Pleasant Point

Dead Mans Beach

Red Island

Watering Place
Gull Point

Scarboro
Cove

CORNWALLIS ISLAND

Little
Beach

Sandwich River

Spaniards
Shoal

Warburton Camp

HALIFAX

GEORGES
ISLAND
where the Transports
first Landed

HARBOUR
of
CHEBUCTO

Ring
Bishops
Col Gorham
Gorhams Point

BEDFORD
formerly called
TORRINGTON
BAY

Winter Cove

Summer Cove

America
Point

Bays
Mouth

Stags
Point

A View of
HALIFAX
Drawn from ye Topmasthead &c.

Major Gilman's
Warren's
Point

To The
Right Hon.ble the
Lords Commission for
Trade and Plantations.
This PLATE
is most humbly Presented
by your Lordships
Most Obedient and Devoted
humble Servant
T. Jefferys

SCALE of MILES

Store Tent
St Georges

Published according to Act of Parliament Jan. 25. 1750. price 1.ª Printed for T. Jefferys at the Corner of St Martins Lane Charing Cross Where in a few Days will be publish'd a new Map of France, and a Plan of Coventry.

122

Looking West

North and South American Ports

While some prints of North and South American ports were published before 1700, it was in the eighteenth and nineteenth centuries that European and colonial artists began to produce substantial numbers of engravings. From views of well-established cities on the Eastern seaboard such as Halifax and Boston to smaller ports such as New Orleans on the Mississippi River and Victoria and San Francisco on the west coast, prints reflect growing North American political and commercial confidence. Many beautiful copper-plate engravings and lithographs were likewise produced of South American ports such as Rio de Janeiro and Montevideo, which shed light on both the development of individual ports, and on the cultural and political factors behind South American independence movements in the nineteenth century.

Prints of North and South American ports provide windows onto imperial expansion, colonial development and the evolution of colonial identity. In addition to the history of individual ports, prints express the symbolic importance of this region celebrated as a land of liberty, free enterprise and social equality. This 'New World' alternative to the prejudices, restrictions and hierarchies of the Old World continues to appeal to immigrants today. However, in spite of this connections with the Old World remained strong, as the practice of naming new ports after existing European towns ('Boston', 'Cartagena' and 'Liverpool') or monarchs and saints ('Charleston', 'Victoria' and 'San Francisco') indicates. The idea of combining the best of old and new is implicit in the practice of seeing

American ports as new versions of their European namesakes: thus 'New Amsterdam', 'New York' and 'New Orleans'.

North America: the Eastern Seaboard

CANADA

European settlement of North America was prompted by a range of motives: commercial, political and religious. It was along the Eastern seaboard that European colonies were first established. Even more than in Europe, North American ports often remained the most important and prosperous towns in the region, maintaining sea links to other colonial and Old World ports by sea, and access to the developing hinterland through river and overland routes. Today, ports such as Boston, Montreal and New York continue to serve as gateways to the continent.

One of the initial reasons for the development of North American settlements was to gain better access to lucrative commercial fishing sites. Indeed, controlling access to the Grand Banks, southeast of Newfoundland, became a politically sensitive issue, and one of the causes of the Seven Years War (1757–1763) fought between Britain and France. The importance of fishing is demonstrated in many contemporary engravings and charts, including Thomas Jefferys's engraved 'Map of the South Part of Nova Scotia and it's [sic] Fishing Banks...' (see page 122). This hand-coloured etching, published in 1750, was dedicated to 'the Right Hon.ble the Lords Commission.rs for Trade and Plantations', and is a powerful representation of British claims to the region. The design includes a coloured cartouche and inset plan and view of the port of Halifax. Such beautiful images confirm British authority, and suggest that this area is a natural part of Britain's political and commercial sphere.

In addition to operating as a political compliment to the Lords Commissioners for Trade and Plantations, this print's reasonable price (one shilling) would have made it accessible to a fairly wide audience. Indeed, the printseller's commercial acumen is further displayed in his advertisement below the design: 'Printed for T. Jefferys at the Corner of St Martins Lane Charing Cross, Where in a few Days will be publish'd a new Map of France, and a Plan of Coventry'. Clearly Jefferys hoped that this print of Nova Scotia would draw

'A VIEW OF THE CITY OF QUEBEC, THE CAPITAL OF CANADA, TAKEN PARTLY FROM POINTE DES PERES, AND PARTLY ON BOARD THE VANGUARD MAN OF WAR...'
Title also in French
Etching
Height 357 mm, width 508 mm
Drawn by Captain Hervey Smyth and engraved by Peter Benazech; published by Thomas Jefferys in London on 5 November 1760 (PAH 2889).

This view of Quebec is one of several engravings illustrating scenes from the Seven Years War. Such prints kept viewers informed of British progress in the war with France, and provided glimpses of Canadian ports.

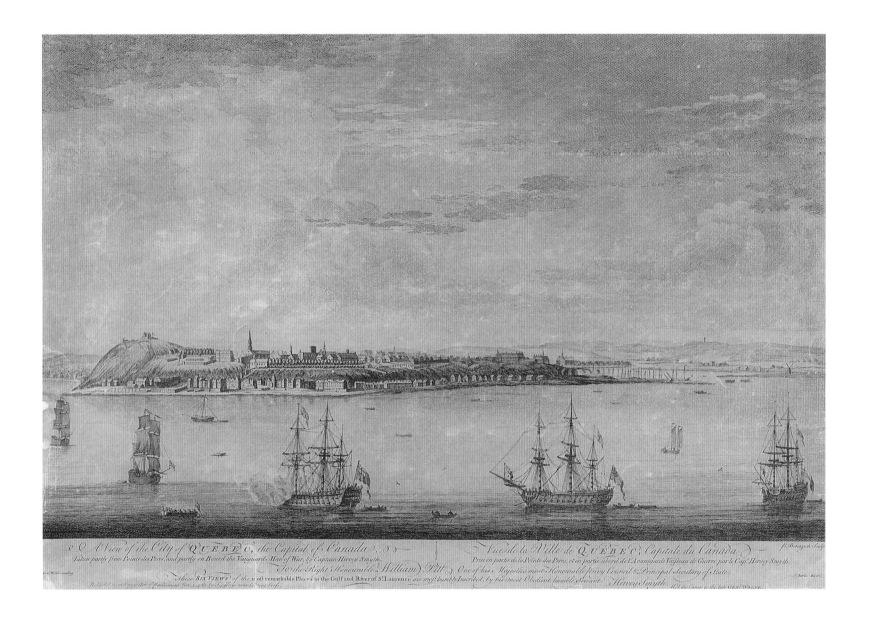

A View of the City of QUEBEC, the Capital of Canada.
Taken partly from Pointe des Peres, and partly on Board the Vanguard, Man of War, by Captain Hervey Smyth.
To the Right Honourable William Pitt, One of his Majestie's most Honourable Privy Council & Principal Secretary of State.
These SIX VIEWS of the most remarkable Places in the Golf and River of St. Laurence are most humbly Inscribed, by his most Obedient humble Servant Hervey Smyth.

Vue de la Ville de QUEBEC, Capitale du Canada.
Prise en partie de la Pointe des Peres, et en partie abord de l'Avantgarde Vaisseau de Guerre, par le Capt. Hervey Smyth.

viewers into his shop, where they might also purchase other prints. Successful or not, this ploy indicates how varied the print market was, and how images of North American ports were produced and sold alongside many other images, including topographical images of European subjects and other American maritime prints.

The outbreak of the Seven Years War between Britain and France in 1757 and the subsequent military struggle for control of North America inspired a series of engravings of ports. Many of the British prints combined views of North American

ports with dedications to prominent British political and military figures. Most frequently represented were William Pitt, the government minister who strongly supported the war in North America, and General James Wolfe, the talented military leader who died just as victory was secured at the battle for Quebec in 1759. This poignant moment was commemorated in Benjamin West's famous oil painting of 1770 and in many engraved copies, sold both in Britain and abroad, which publicised this event as one of the most heroic episodes of British military history.

Such views are overtly propagandistic, designed to promote the artist's or patron's career. Consider for example 'A View of the City of Quebec, the Capital of Canada, Taken partly from Pointe des Peres, and partly on Board the Vanguard Man of War, by Captain Hervey Smyth', and published in 1760 (see page 125). This print, which provides a beautiful and detailed view of General Wolfe landing at Quebec, and of the St Charles River, is dedicated to William Pitt. The reference to General Wolfe, who had died the previous year, underscores Smyth's military connections and, in turn, Smyth's continued availability for service to the British government. The fact that Smyth chose images of Canadian river ports to honour Pitt reflects both Pitt's interest in the progress of the Seven Years War, and the commercial and strategic importance of these settlements. The title appears in French as well as in English – indicating that the print was designed to appeal to the many Francophone viewers who would have been interested in engravings of French Canada. Another contemporary view of Canada published with both English and French titles was 'An East View of Montreal, in Canada', which appeared in 1762 (see right). Like other views published by Thomas Jefferys, the publication line emphasises that this is a true and accurate representation of the place depicted: 'Drawn on the Spot by Thomas Patten'. Montreal, like Quebec City, was a strategically important river port established by the French but coveted by the British.

As the nineteenth century progressed, prints focused more on the commercial than on the strategic importance of Canadian ports. Developments in trade and communications, such as the laying of the Atlantic telegraph cable, and newsworthy events such as major fires all inspired the production of engravings. The port of St John's in Newfoundland featured in several prints, including an 1831 colour aquatint. In the well-established tradition of British engravings of colonial

'AN EAST VIEW OF MONTREAL, IN CANADA'
Title also in French
Etching
Height 365 mm, width 537 mm
Drawn on the spot by Thomas Patten and engraved by Pierre-Charles Canot; published by Thomas Jefferys in London on 11 November 1762 (PAI 0309).

Eighteenth-century British engravings often included titles in both English and French to maximise sales. This image of the French Canadian port of Montreal, taken during the Seven Years War, would have appealed to both English and French viewers.

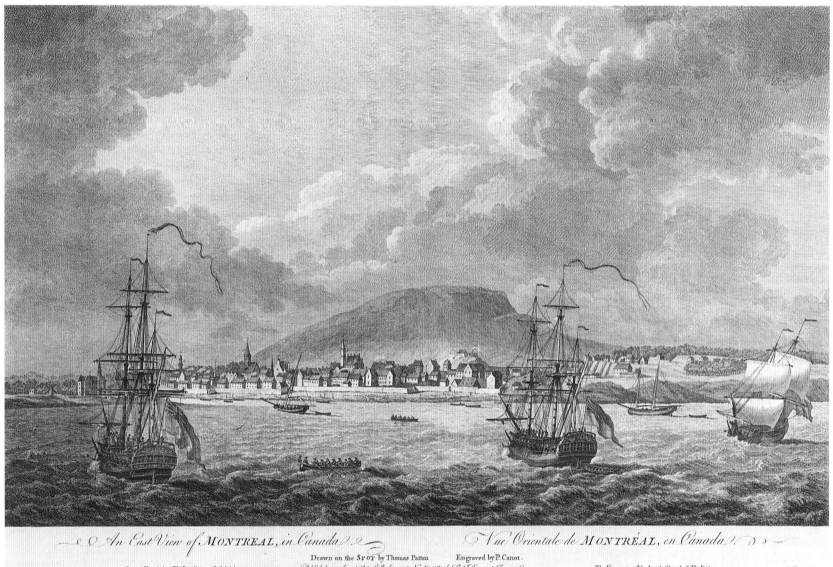

An East View of MONTREAL, in Canada. Vue Orientale de MONTRÉAL, en Canada.

Drawn on the SPOT by Thomas Patten Engraved by P. Canot.

1. General Hospital. 2. The Recollects. 3. S. Sulpicius. Published according to Act of Parliament Nov.20.1762. by Tho.º Jefferys at Charing Cross. 4. The Nunnery. 5. The Jesuits Church. 6. The Fort.

ports, it was dedicated to the local governor (see page 128). A few years later a hand-coloured lithograph of St John's commemorated 'the successful laying of the Atlantic Telegraph Cable'.

By the mid-nineteenth century, lithographs became the medium of choice for many port views. Lithography was a form of printing invented in 1798 which involved the reproduction of an image drawn in greasy ink on a stone or zinc plate.

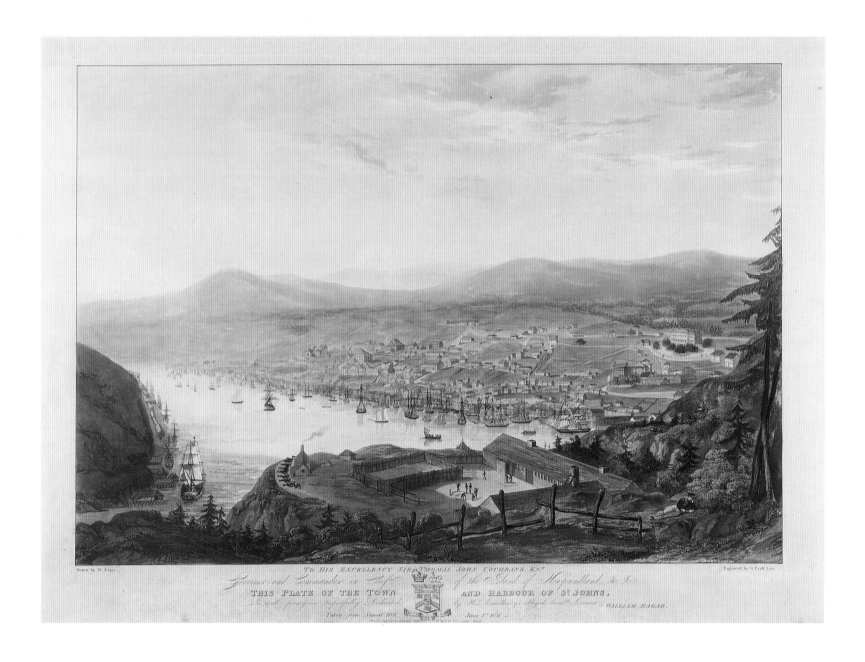

To His Excellency Sir Thomas John Cochrane, Knt.
Governor and Commander in Chief of the Island of Newfoundland, &c &c
THIS PLATE OF THE TOWN AND HARBOUR OF S.T JOHN'S,
Is with permission respectfully Dedicated by His Excellency's obliged humble Servant, WILLIAM EAGAR.
Taken from Signal Hill June 1.st 1831.

Lithographs, like aquatints, were well-suited for landscape subjects. As lithographs could be produced more quickly and cheaply they reached a wider market than aquatints, which remained a luxury item. By the mid-1800s the lithographic printing industry was well established in North America, and many port views were designed, published and sold there as well as in Europe. Such designs showed the

confidence and success of the North American enterprise, and Canada and the United States' commercial and political maturity.

One of several lithographic series produced was Edwin Whitefield's mid-century 'Original Views of North American Cities', published in Toronto and in New York. Over 30 plates depict views of regional ports, including Quebec, Toronto, Ottawa City, Montreal and Kingston. Undoubtedly the most famous producer of nineteenth-century lithographs was the New York-based firm of Currier & Ives. In addition to illustrations of current events, episodes from colonial American history and traditional English hunting scenes, Currier & Ives produced many designs documenting the growth of North American ports. These images provide a useful historical record of the construction of individual buildings, wharves and other landmarks. In turn, these prints demonstrate how the new nation's progress was in part measured through the appearance of its ports.

THE UNITED STATES

As might be expected, the port of New York was the subject of many engravings published from the seventeenth century onwards. Founded by the Dutch on land 'purchased' from Native Americans in 1614 and known as Nieuw Amsterdam, early engravings acknowledged its excellent harbour and commercial prospects. Such qualities made it a desirable acquisition for expansionist Britain, who seized control from the Dutch in 1664. An engraving of New York as it appeared in 1674, published in 1682, indicates the importance of the settlement's port to its commercial success.

During the eighteenth century, New York's commercial repute increased considerably, and many engravings promoted the thriving colonial town. A lovely example is the 'Plan of the City of New York' of 1776. This design highlights New York's commercial riches with a lavish display: a cartouche with a key to ten inset references, an image of a shield flanked by a settler and a Native American, barrels, ships and other symbols of trade. New York attracted considerable notice during the American War of Independence, and several engravings recorded the disembarkation of British troops in the loyalist port. But it was after the end of the war, and in the new republic rather than the British colony that prints fully drew attention to New York's status as the pre-eminent North American port. New York's commercial progress was recorded and promoted in a variety of engravings.

'...THE TOWN AND HARBOUR OF ST. JOHNS...TAKEN FROM SIGNAL-HILL, JUNE 1ST. 1831'
Hand-coloured aquatint
Height 485 mm, width 656 mm
Drawn by William Eagar; engraved and published by H. Pyall in London in 1831 (PAI 0296).

By the mid-nineteenth century Canadian ports such as St John's were thriving as centres of both local and international trade. Engravings such as this elevated view helped promote the port's commercial reputation.

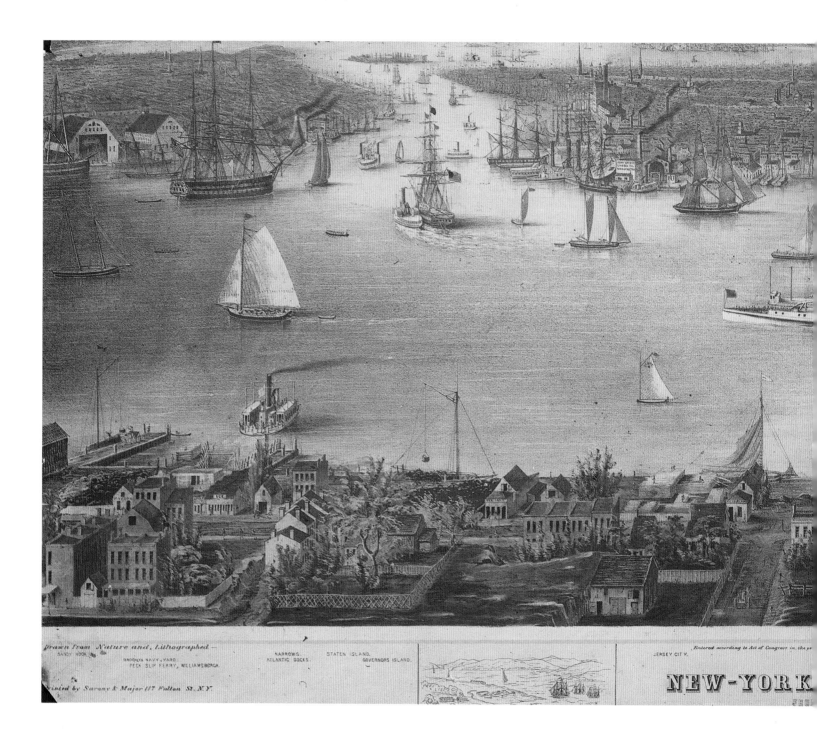

Drawn from Nature and Lithographed —
SANDY HOOK.
BROOKLYN NAVY YARD.
PECK SLIP FERRY, WILLIAMSBURGH.
NARROWS.
ATLANTIC DOCKS.
STATEN ISLAND.
GOVERNORS ISLAND.
JERSEY CITY.
Entered according to Act of Congress in the ye

Printed by Sarony & Major 117 Fulton St. N.Y.

NEW-YORK

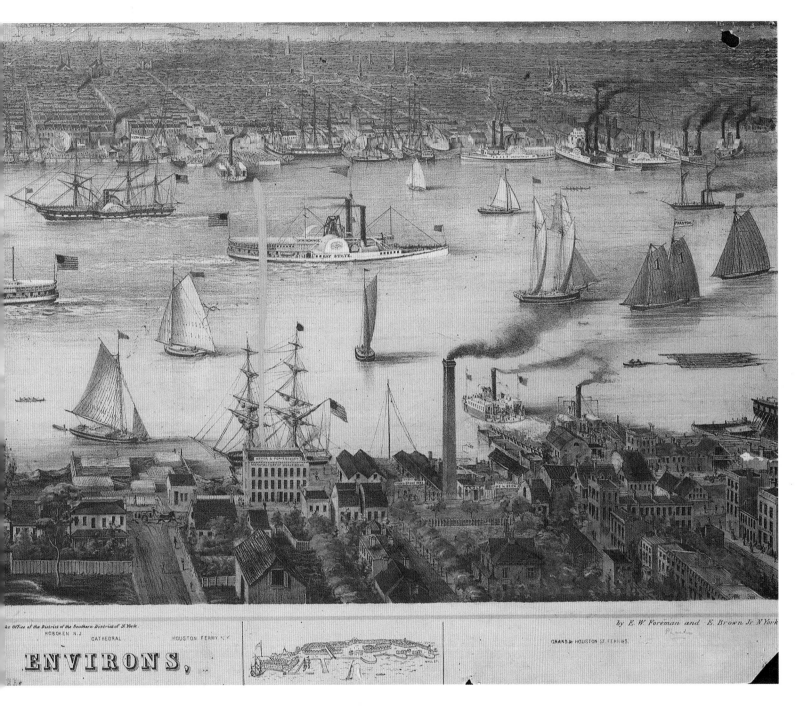

'NEW-YORK AND ENVIRONS, FROM
WILLIAMSBURGH…'
Hand-coloured lithograph
Height 291 mm, width 818 mm
Designed and lithographed by Edgar W. Foreman
and Eliphalet M. Brown Jr.; published by R. A.
Bachia in New York in 1848 (PAI 7226).

Nineteenth-century views of New York were taken
from many angles and for different purposes. This
design acknowledges New York's importance as a
port by drawing attention to its harbour, rivers and
the variety of shipping, including steam as well as
sail-powered vessels.

As well as being included within regional views, such as Laurie & Whittle's 1794 'New and Correct Chart of the Coast of New England and New York', prints of New York City itself were designed, and often published locally. In 1848, for example, Edgar W. Foreman and Eliphalet M. Brown Jr. published a colour lithograph of 'New-York and Environs, from Williamsburgh...' (see pages 130-131). New York's maritime dimension is highlighted through the depiction of ships and boats in the foreground, framing the city beyond. Such beautiful prints express immense pride in New York. This port city symbolised the vitality and industry of the region, and indeed the entire republic.

Even more than New York, the port of Boston was associated with the American War of Independence, albeit as a centre of rebel rather than loyalist activity. Through engravings such as 'A Plan of Boston, and its Environs shewing the situation of his Majesty's Army. And Also Those of the Rebels. Drawn by an Engineer at Boston' viewers could gain precise information about the progress of the rebellion. Other prints focussed more directly on Boston's role as a commercial port, thus a 'View of the Lighthouse' was dedicated to the merchants of Boston, who would be keen to promote favourable views of their home port.

Although most often created by British and French, and later American and Canadian artists, prints of North American ports were also produced elsewhere in Europe. Balthasar-Friedrich Leizelt's series of port prospects published in Augsburg, Germany includes several views of North American ports, including towns relatively little known outside the continent such as Salem, Massachusetts (see right). While ostensibly providing details of Salem, this engraving may reveal more about hasty contemporary printing practices. The title, 'Vuë de Salem', is printed backwards, an indication that it may have been copied from another source. Moreover, another print in the series, intended as a view of Philadelphia, is, as a handwritten note under the design explains, more reminiscent of Greenwich, England than the American city! Engravings were often copied and retitled, and this led to some very shoddy and misleading images. The existence of such views confirms the contemporary demand for cheap as well as expensive images of ports.

Interest in views of North American ports remained strong, to judge by their frequent appearance in eighteenth-century magazines. The *London Magazine* alone published several views of North American ports, including 'The South Prospect

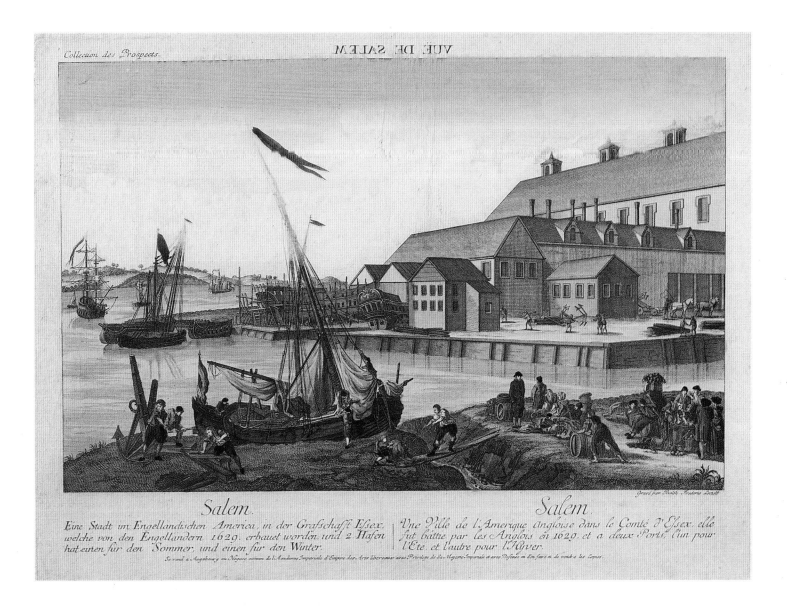

VUË DE SALEM

Salem.

Eine Stadt im Engellandischen America, in der Grafschaft Essex, welche von den Engellandern 1629. erbauet worden und 2 Hafen hat, einen für den Sommer, und einen für den Winter.

Salem.

Une Ville de l'Amerique Angloise dans le Comté d'Essex, elle fut bâtie par les Anglois en 1629. et a deux Ports, l'un pour l'Eté, et l'autre pour l'Hyver.

Se vend à Augsbourg, au Negoce commun de l'Academie Imperiale d'Empire des Arts libereaux, avec Privilege de Sa Majesté Imperiale et avec Defense en bien faire ni de vendre les Copies.

'VUË DE SALEM…'

VIEW OF SALEM…

Title also in German

Hand-coloured engraving and etching
Engraved by Balthasar-Friedrich Leizelt; published
in Augsburg in the late eighteenth century
(PAH 2900).

This supposed representation of Salem harbour
was one of several port views produced by a
German publisher and sold in Europe. The
brightly-coloured design shows men building and
repairing ships with warehouses and docks nearby.

of the City of New York'; 'The East Prospect of the City of Philadelphia, in the Province of Pennsylvania' and 'An Exact Prospect of Charlestown, the Metropolis of the Province of South Carolina'. Other European periodicals published similar views.

In addition to images of well-established ports such as New York, Boston and Philadelphia, nineteenth-century American artists produced views of prospective ports. The optimism of the age is evident in a colour lithograph view of a town with river and open land, with two couples and a dog in the foreground (see

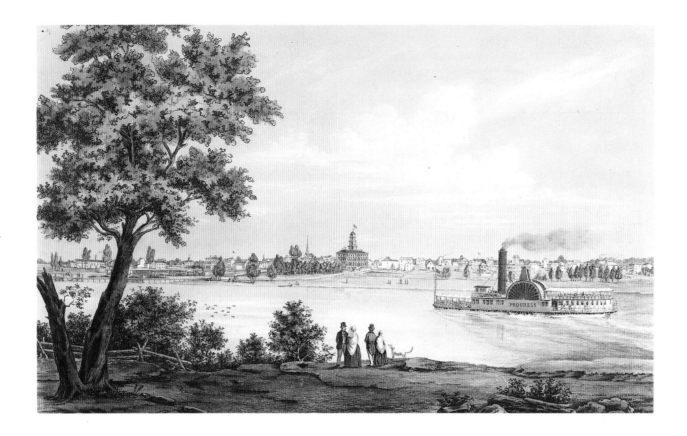

above). The caption below demonstrates the engraving's function as an advertisement for plots of land in a planned river town:

> View of the Town of Progress, Opposite the City of Philadelphia,
> 10 Miles from Camden, New Jersey. Accessible by Steam Boats
> and Rail Road Cars, every hour-Office no. 80, North 6th St. Lots
> selling from $40, and upwards: for Cash, with 10 per Cent discount,
> or in easy monthly Instalments. For plans and information,
> Apply at the office No. 80, North 6th St. Philada.

In this instance the developers' enthusiasm apparently exceeded that of potential customers, as a note, handwritten below the print suggests: 'Progress, so far as is known was never built'. Despite this individual failure, the pioneer spirit

'VIEW OF THE TOWN OF PROGRESS, OPPOSITE THE CITY OF PHILADELPHIA, 10 MILES FROM CAMDEN, NEW JERSEY...'
Hand-coloured lithograph
Height 441 mm, width 623 mm
Lithographed by Peter S. Duval & Co. in Philadelphia in the mid-nineteenth century
(PAI 0348).

Paddle-wheel steamers were often included in nineteenth-century prints of American river ports. In this lithograph, a paddle-wheel steamer emblazoned with the name 'Progress' advertises a prospective town near Philadelphia.

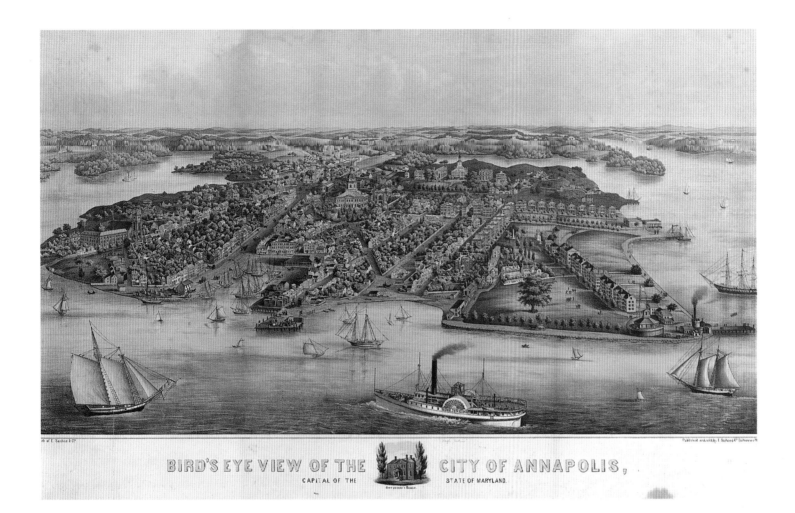

BIRD'S EYE VIEW OF THE CITY OF ANNAPOLIS,
CAPITAL OF THE STATE OF MARYLAND.

'BIRD'S EYE VIEW OF THE CITY OF ANNAPOLIS,
CAPITAL OF THE STATE OF MARYLAND...'
Chromolithograph
Height 475 mm, width 850 mm
Lithographed and published by Edward Sachse &
Co. in Baltimore in the mid-nineteenth century
(PAI 7235).

Rather than advertising the town behind it, the
paddle-wheel steamer in this view of Annapolis
was probably included in order to promote its
owner's business.

succeeded on a large scale, and numerous nineteenth-century engravings record
the development of new river towns and cities across North America.

Another historic eastern port was Annapolis, capital of the State of Maryland
and home of the United States Naval Academy. Edward Sachse & Co.'s chromo-
lithograph 'Bird's Eye View of the City of Annapolis...' presents an
informative as well as stylish view of a prosperous mid-nineteenth-century
American city (see above). While the format – a 'bird's eye view'– links this
engraving with other views of ports, the individual detail, such as the inclusion of
the paddle-wheel steamer 'Hugh Jenkins', reveals the artist's local knowledge.
Architectural historian John W. Reps has suggested that individual steamers may
have been included in such prints in exchange for payment, and certainly such

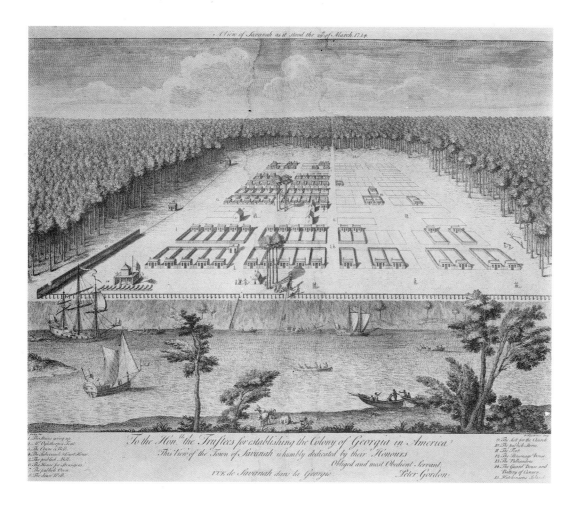

prints would have promoted the steamer's business – and by extension also that of the port. [1]

Many prints of Southern United States ports were also published. Peter Gordon produced a view of Savannah which was intended to inform and reassure the town's benefactors. 'A View of Savannah as it stood the 29th of March, 1734…' was dedicated to 'the Hon.ble the Trustees for establishing the Colony of Georgia in America' (see above). Although Savannah was still in its infancy in 1734, as can be gauged by the fact that the artist depicts a newly-laid out rather than a mature town, he has taken care to represent ships in the river channel. With this detail the artist acknowledges Savannah's commercial and communication links with the outside world, which will expand as the port itself develops. This etching is one of

'A VIEW OF SAVANNAH AS IT STOOD THE 29TH OF MARCH, 1734…'
Title also in French
Etching
Height 462 mm, width 584 mm
Designed by Peter Gordon and engraved by Paul Fourdrinier; published in the mid-eighteenth century (PAI 0313).

The port of Savannah in the British colony of Georgia was founded in 1733. One year on, this print depicts an orderly town in a forest clearing, with neat rows of houses on fenced plots.

several early engravings designed to convey favourable views of the newly fledged American colonies to benefactors back in Britain. Of course, as a commercial engraving the publisher also intended this print to appeal to a wider audience, and thus the title of this print appears in both English and French. Viewers may have been curious about the European settlement in North America in general, and about the fate of the colony of Georgia in particular. Anglicans would have been especially interested in views of Georgia, given their involvement in the establishment of the colony, and the missionary work conducted there by promising young preachers such as John Wesley and George Whitefield.

Moving West

From the Eastern seaboard pioneers looked inland to the settlement of the continent, and the establishment and subsequent penetration of the Western frontier. While much of this development was land-based, the discovery of navigable rivers such as the St Lawrence and the Mississippi in turn led to the establishment of river ports which would play a major role in the commercial and political development of both Canada and the United States.

One of the most important American ports in the nineteenth century, both in terms of commercial development and as a symbol of United States westward expansion, was New Orleans. Founded by the French and later ruled by Spain, New Orleans became part of the United States with the Louisiana Purchase of 1803. It was via river ports such as New Orleans that the American west was won. New Orleans was represented in numerous engravings, many published by American printsellers such as Currier & Ives for the domestic market. Unlike prints of other American ports, views of New Orleans often acknowledge the local black population. Antoine Mondelli and William James Bennett's hand-coloured aquatint of 'New Orleans, Taken from the opposite side a short distance above the middle or Picayune Ferry' provides a panoramic view of the town. Ships and boats dot the river, and both white and black people are visible on the shore in the foreground. This print was published in New York in 1841 and would have appealed to patriotic American as well as curious foreign viewers (see page 138).

Chicago was another port central to the development of the American nation. As with New York, numerous engravings of the lakeside hub were produced which

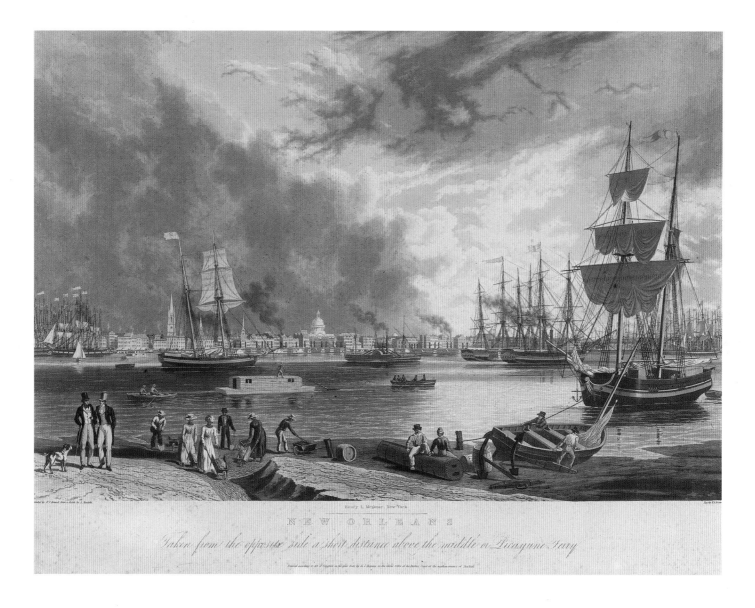

NEW ORLEANS

Taken from the opposite side a short distance above the middle or Picayune Ferry

emphasised its importance as a trade centre. In 1892 Currier & Ives re-published an 1874 colour lithograph view of the 'City of Chicago' which drew attention to Chicago's harbour area, with its many ships and boats.[2] The caption below the design points out the buildings of the 1892 World's Columbia Exhibition, further highlighting Chicago's prominence as a world-class city (see right). Smaller mid-western ports acquired regional prominence as links within the internal river and lake network. Although their fame has not survived the nineteenth century, ports such as Saginaw City, Michigan inspired engravings bursting with civic pride.

'NEW ORLEANS, TAKEN FROM THE OPPOSITE SIDE A SHORT DISTANCE ABOVE THE MIDDLE OR PICAYUNE FERRY'
Hand-coloured aquatint
Height 563 mm, width 741 mm
Painted and engraved by William James Bennett from a sketch by Antoine Mondelli; published by Henry J. Megarey in New York in 1841 (PAI 0328).

New Orleans was booming in the mid-nineteenth century, and this contemporary view captures the optimism and bustle of the river port. Beyond the river with its many vessels, churches and other major buildings are visible.

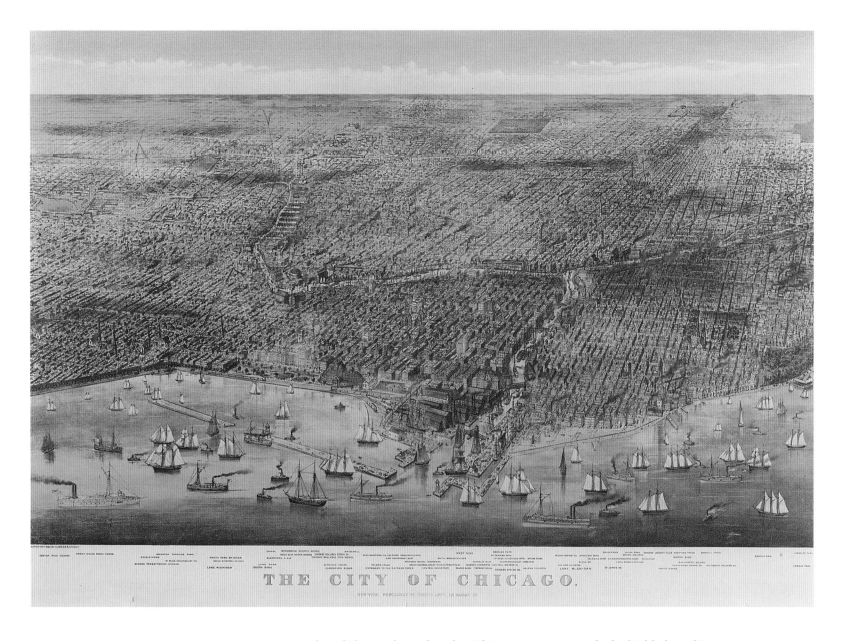

'THE CITY OF CHICAGO'
Colour lithograph
Height 525 mm, width 825 mm
Published by Currier & Ives in New York in 1892
(PAI 7219).

This 1892 view of Chicago is a late example of a
lithographic portrayal of a major American port
city. The expansive view includes individual ships
in the foreground, and rows of buildings stretching
almost as far as the horizon.

A colour lithograph produced in Chicago in 1867 reveals the highlights of Saginaw
City. Below the main view of a city riverfront with ships are several vignettes of
local mansions and commercial buildings. These vignettes were probably paid for
by the residents to promote themselves and their enterprises (see page 140).

By the mid- to late nineteenth century, greater attention was being focussed
on the development of the western states and territories, and the
commercial and political opportunities provided by their access to the Pacific

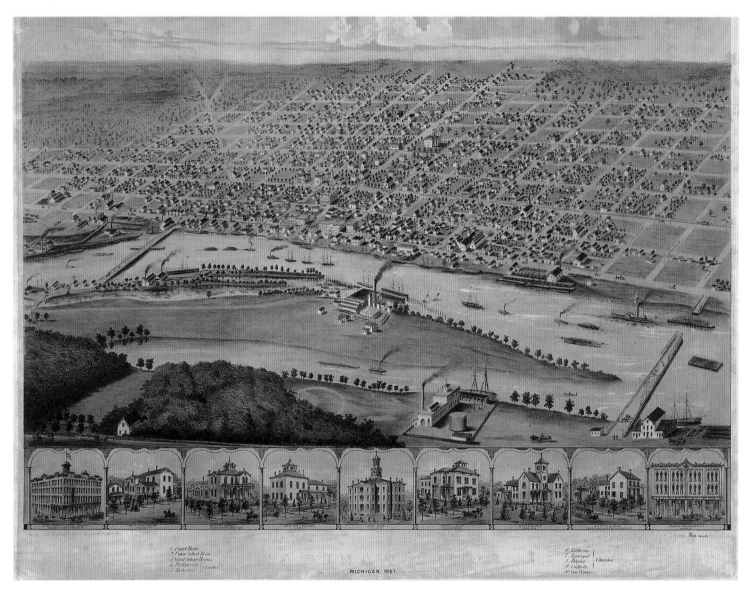

'Saginaw City. Michigan. 1867'
Colour lithograph
Height 545 mm, width 725 mm
Drawn from nature by Albert Ruger; published by the Chicago Lithographing Co. in Chicago in the mid-nineteenth century (PAI 7237).

In the mid-nineteenth century artists such as Albert Ruger travelled throughout the United States sketching river ports. The resulting lithographs, including this view of Saginaw City, were intended to promote the reputation of the towns and their prominent citizens.

Ocean. San Francisco, boosted by immigration during the mid-century California gold rushes and by increased Pacific and Asian trade, was a favourite subject of artists. One of many views to portray the city's maritime identity was Currier & Ives's 'The City of San Francisco. Birds Eye View from the Bay Looking South-West'. This hand-coloured lithograph provided an appealing view of one of America's fastest growing ports. Although many of the buildings depicted here in 1878 would not survive the catastrophic earthquake and fire of 1906, San Francisco's port infrastructure would continue to grow in size and national

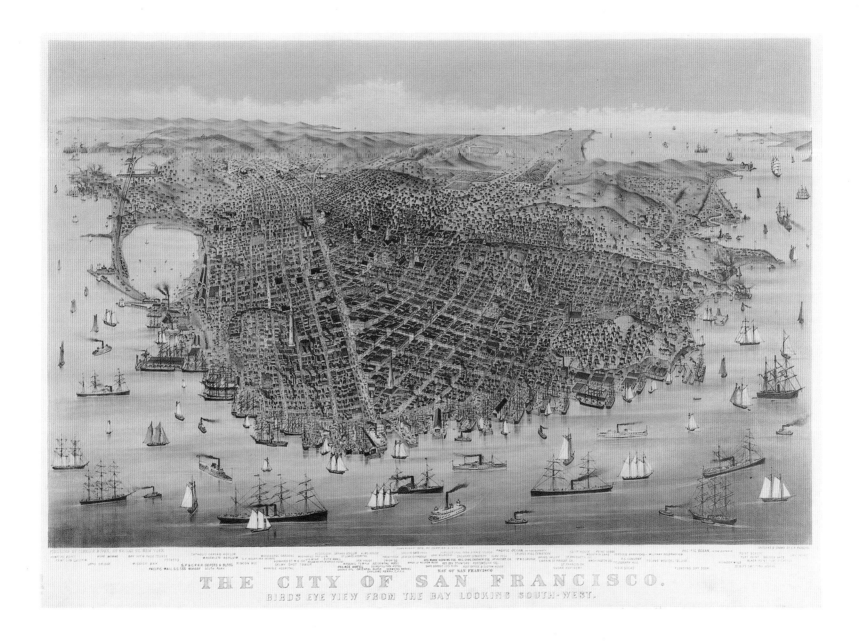

'THE CITY OF SAN FRANCISCO. BIRDS EYE VIEW FROM THE BAY LOOKING SOUTH-WEST'
Hand-coloured lithograph
Height 533 mm, width 833 mm
Sketched and drawn by Charles R. Parsons; published by Currier & Ives in New York in 1878 (PAI 7223).

This detailed and colourful view of San Francisco reveals a large and bustling port. Through such engravings the Californian city announced its coming of age to the world.

significance, providing an American gateway to Asia and the Pacific (see above).

While San Francisco represents the large, dynamic Pacific port, smaller regional ports also played an important role in the development of the Pacific Northwest. In addition to ties with the New World, ports such as Victoria in Canada demonstrated their European heritage. Thus an 1860 coloured lithograph 'View of Victoria, Vancouver Island' depicts European-style 'civilization' – a town

141

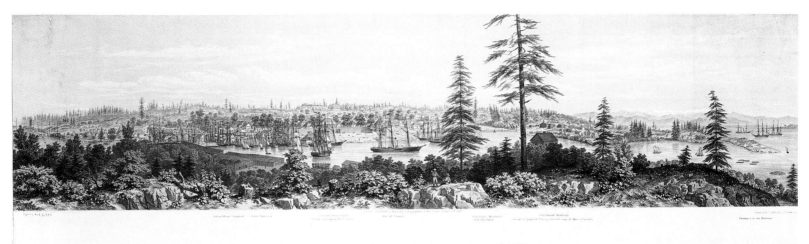

VIEW OF VICTORIA, VANCOUVER ISLAND.

with ships and boats — amidst the wilderness of the forest which surrounds the town and separates it from the viewer. Such views are useful reminders that for all the emphasis on western development and trade with Asia and the Pacific, North American ports could still be relatively isolated even in the mid- to late nineteenth century. And despite emphasis on opportunities across the Pacific, many ports still maintained strong commercial and cultural ties with Europe (see above).

South America

As with many early prints of North American ports, contemporary views of South American ports often focus on their status as colonial settlements established for commercial or strategic advantage. European rivalry is evident in many such engravings, including 'An Exact Prospect of the Town of Carthagena in the Spanish West Indies', published in 1740 (see right). Below this view is a map of Cartagena's strategic sites: 'A New & exact Plan of the Harbour Town & Forts of Carthagena in the West Indies from a Spanish Draught taken by the Sr. Danville Geographer to the King of Spain'. As if to confirm the anti-Spanish sentiment of this print, it advertises the sale of another print likely to appeal to viewers: 'ye Prospect of ye taking Porto Bello by Admiral Vernon'. Admiral Vernon's attack on Porto Bello in 1739 had become a symbol of both British naval might and a warning of Britain's growing appetite for commercial control of the region.

'VIEW OF VICTORIA, VANCOUVER ISLAND'
Coloured lithograph
Height 203 mm, width 850 mm
Drawn by H. O. Tiedemann and lithographed by Thomas Picken; published by Day & Son in London on 13 June 1860 (PAI 7216).

Although it depicts a new and relatively undeveloped port, this print of Victoria in western Canada would have appealed to viewers who wished to keep up with the development of Britain's colonies.

'An Exact Prospect of the Town of
Carthagena in the Spanish West Indies
and A New & exact Plan of the
Harbour Town & Forts of Carthagena
in the West Indies…'
Two plates printed on one sheet
Etching
Height 500mm, width 404mm
Designed by Danville and engraved by
J. Blundell; published by Henry Overton
in London on 29 April and 1 May 1740
(PAI 0417).

British interest in Spain's West Indian ports
prompted designs such as this mid-eigh-
teenth-century view of Cartagena and
accompanying town plan.

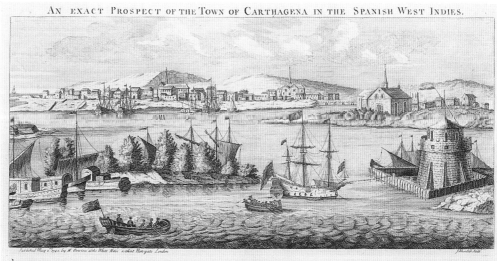

AN EXACT PROSPECT OF THE TOWN OF CARTHAGENA IN THE SPANISH WEST INDIES.

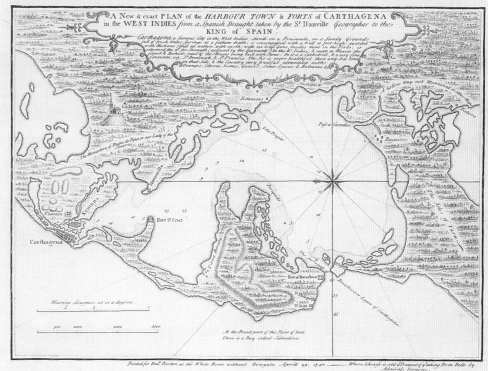

Over 50 years after this print was published, European colonial ambition was
still evident in engravings of South and Central American ports. At first sight, 'A
View of Truxillo Bay and City on the Coast of Honduras' may appear just
another attractive view of a bay with buildings, people and ships (see page 144).

143

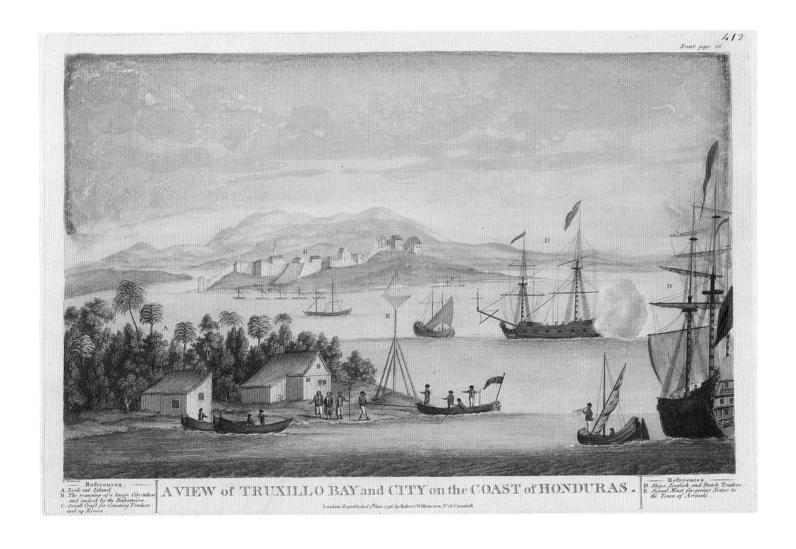

Yet the details of this brightly coloured print, which include references to 'small craft for Coasting Traders' and 'Ships, English and Dutch Traders' point to the continuing rivalry among European powers for access to the valuable Honduran hardwood log trade. Despite diplomatic and naval opposition, British, Dutch and other European powers continued to press for access to this and other Spanish colonial ports. Honduran hardwood was an excellent source of naval timber, and thus necessary fuel for continued colonial expansion.

Further south, European rivalries continued. In 1807 the London printsellers Colnaghi & Co. published an aquatint and etching, 'A View of the Town and Harbour of Monte Video', which underlines the Uruguayan port's strategic

'A VIEW OF TRUXILLO BAY AND CITY ON THE COAST OF HONDURAS'
Coloured engraving and etching
Height 248 mm, width 374 mm
Engraved by T. Bowen; published by Robert Wilkinson in London on 4 June 1796 (PAH 2959).

As a source of hardwood used in shipbuilding, the coast of Honduras attracted the attention of competing European navies in the eighteenth century. Prints such as this view of Truxillo helped explain the area's commercial importance to viewers at home.

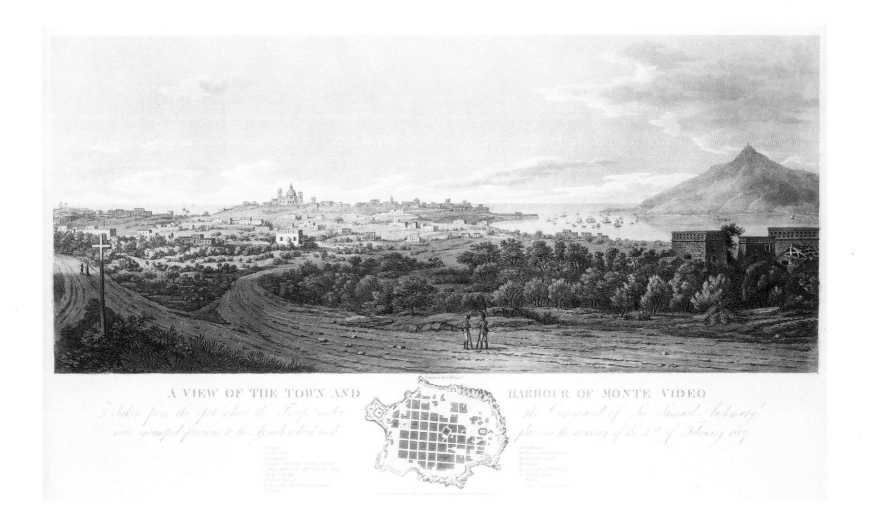

A VIEW OF THE TOWN AND HARBOUR OF MONTE VIDEO

'A View of the Town and Harbour of Monte Video Taken from the spot where…'
Aquatint and etching
Height 363 mm, width 599 mm
Engraved by J. Merigot; published by Colnaghi & Co. in London on 3 February 1807 (PAI 0423).

Although intended primarily to commemorate the site of a battle, this view of Montevideo in Uruguay also provides a glimpse of its port on the River Plate. A plan inset below the main design provides further details of the town.

importance: 'Taken from the spot where the Troops under the Command of Sir Samuel Auchmuty were encamped previous to the Assault which took place on the morning of the 3rd of February 1807' (see above). Although strategic concerns dominate this design, a key with references to fifteen major points of interest in the town acknowledges that Montevideo is important as a port in its own right, not just as a site of military conflict. Moreover, this view serves to introduce European viewers to the visual delights of this unfamiliar port.

Another port which was often presented in terms of its natural beauty was Rio de Janeiro in Brazil. Rio was an important port of call for ships en route to the West Coast, Pacific and Australia. With its tropical fruits and flowers and spectacular scenery, Rio refreshed and renewed weary European travellers. Their

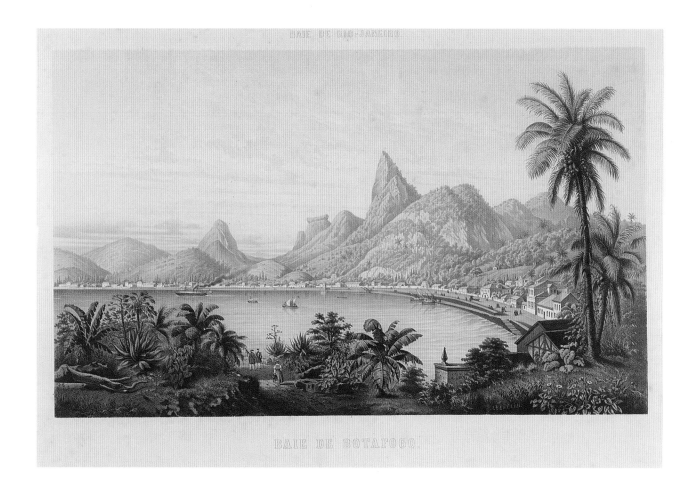

delight in the novel landscape and foliage is evident in the many engravings produced. But in addition to prints published in Europe, prints were published in Rio itself in the nineteenth century. Such engravings reflect the settlement's growing maturity and self-confidence, demonstrated further by Brazil's transition from Portuguese colony to independent nation in 1822. Typical of local views is a mid-nineteenth-century hand-coloured lithograph. It depicts a bay with town and mountains behind it, people in the foreground and lush tropical plants (see above). Rather than stressing Rio's commercial role, the design emphasises the port's exotic setting. Such images increased Rio's appeal for European travellers, and in particular would-be immigrants. As with prints of Asian and African ports, there is little reference to native peoples – well-dressed Europeans predominate.

Many designs seem intended to record the existence of South American ports

'BAIE DE RIO - JANEIRO BAIE DE BOTAFOGO'
Bay of Rio de Janeiro, Bay of Botafogo
Hand-coloured lithograph
Height 485 mm, width 704 mm
Designed by Louis Le Breton and printed by Auguste Bry; published by J. Youds in Rio in the mid-nineteenth century (PAI 0424).

This charming view of Rio de Janeiro in Brazil would have appealed to a variety of viewers – local residents, visitors and print collectors. The design depicts ships and boats in the harbour, with exotic plants in the foreground and steep mountains beyond.

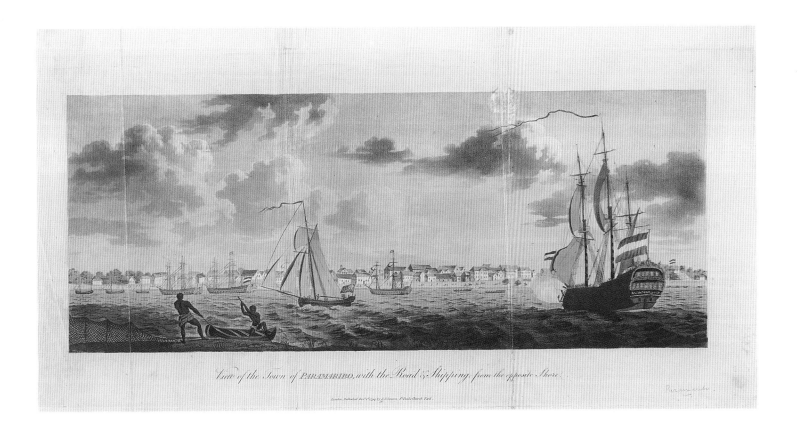

View of the Town of PARAMARIBO, with the Road & Shipping; from the opposite Shore.

London, Published Decr 1st 1794 by J. Johnson, St Pauls Church Yard.

'View of the Town of Paramaribo, with the Road & Shipping; from the opposite Shore'
Hand-coloured aquatint
Height 225 mm, width 471 mm
Published by J. Johnson in London on 1 December 1794 (PAH 3049).

This view of Paramaribo in Surinam shows a busy port, with ships flying Dutch flags and two native men landing a canoe in the foreground.

rather than to explore them in detail. Numerous small engravings were made of Surinam and French Guiana and were often printed two to a page. Some attempt was made to depict the life and customs of the local inhabitants, as we see in a 'View of the Town of Paramaribo, with the Road & Shipping; from the opposite Shore' (see above). This colour aquatint, published in London in 1794, includes a view of two native men on the shore with ships and a well-established town beyond. Paramaribo's interest for foreign viewers was certainly heightened by British and Dutch battles to possess Surinam. Five years after this engraving was published, for example, the British wrested control, and the Dutch were returned to power only in 1818. But Paramaribo's exotic landscape and remote location also would have appealed to Europeans' sense of adventure. Elegant prints like this aquatint would thus have attracted a wide audience.

Many more prints depict Spanish settlements in South America. The Mexican port of Acapulco featured in numerous prints, including the mid- to late eighteenth-century '…View of the Entrance of the Port of Acapulco…', comprising

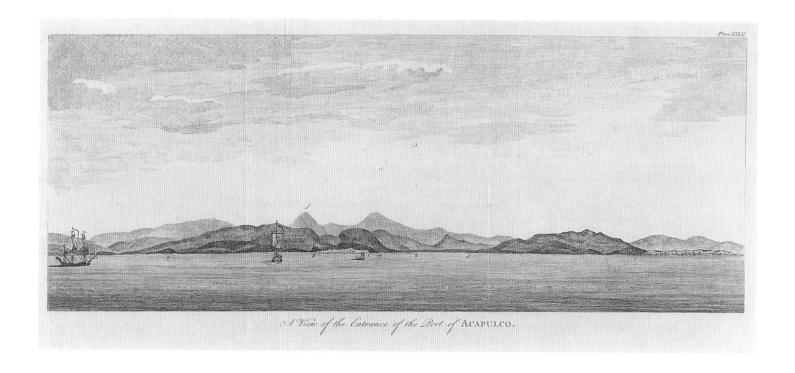

A View of the Entrance of the Port of ACAPULCO.

part of a series of engravings of international ports (see page 148). The panoramic view of the sea with land beyond conveys the singular beauty of the coast near Acapulco. Unlike many earlier views, no images of Spanish authority are visible in the design. By this date Spanish power in South America was in decline. Local movements for political independence were gaining strength, and would reach fruition in the nineteenth century.

Other South American ports were less well known to European travellers, and appear as small, remote settlements dependent on the sea for contact with the outside world. A 'View of Callao, and Distant view of Lima', for example, depicts ships at anchor beyond a town surrounded by mountains, with another town in the distance. The view of the mountains and the castle near the town conveys the isolation of the Peruvian port (see right). Lima was the chief city of Spanish South America, where precious metals were loaded for export, but a devastating earthquake in 1746 and Spain's declining trade had diminished its importance by the late eighteenth century. By the mid-nineteenth century, however, Lima, as capital of an independent Peru, was again a busy port, as was Callao. Yet now these ports looked to the developing Pacific Rim as much as to Europe for trading partners.

'A View of the Entrance of the Port of Acapulco, plate XXXII'
Engraving and etching
Height 224 mm, width 508 mm
Published in the mid- to late eighteenth century (PAH 2964).

Not all port views focussed on the central harbour area. Views of entrances to ports, such as this engraving of Acapulco in Mexico, provided useful information for mariners as well as attractive designs for tourists. Buildings are visible to the right, but the sea and mountains dominate this design.

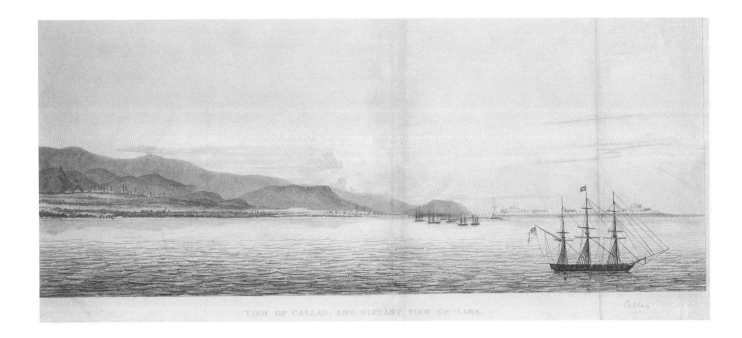

'VIEW OF CALLAO, AND DISTANT VIEW OF LIMA'
Engraving
Height 179 mm, width 395 mm
Published in the early nineteenth century
(PAD 2045).

Through engravings, European viewers discovered
the existence of ports on the other side of the
world. This view of the small port of Callao
provides a glimpse of the landscape of nineteenth-
century Peru.

Conclusion

Most early prints of North and South American ports reflect imperial priorities
and concerns: the establishment of trading posts, competition for raw materials
and markets and westward expansion. Prints reflect the strong links between Old
World and New World ports, visible in their names, layout and artistic represen-
tation. Although the New World continued to maintain important links with the
Old World, individual colonies began to develop along separate political and
economic lines, and ports played an important role in shaping this development.
Nineteenth-century prints thus often describe North and South American ports in
terms of their roles as local, regional and national centres. From the Americas,
European voyagers and artists turned to the ports of the Caribbean, Pacific and
Australia, the subject of the final chapter.

[1] John W. Reps, *Cities of the Mississippi: Nineteenth-Century Images of Urban
Development with Modern Photographs from the Air by Alex MacLean* (Columbia,
Missouri and London: University of Missouri Press, 1994), p. 59.

[2] John W. Reps, *Bird's Eye Views: Historic Lithographs of North American Cities* (New
York: Princeton Architectural Press, 1998), pp. 67, 69.

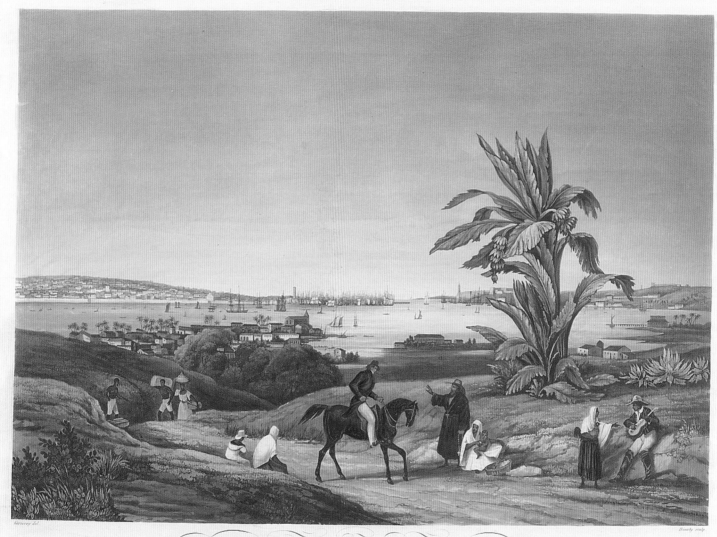

VUE DU PORT DE LA HAVANE

Vista del Puerto de la Havana

A Paris chez HOCQUART ainé S.^r de N.^r Bossel rue S.^t Jacques N.º 64.

150

Chapter Six

New Horizons

Caribbean, Pacific and
Australian Ports

Caribbean, Pacific and Australian ports fascinated eighteenth- and nineteenth-century European travellers with their unique flora and fauna and remote locations. Early views depict native coastal communities rather than developed European-style ports. Later prints record the establishment of European settlements, and, indirectly, the decline of native populations in these areas. While largely positive representations of these ports' economic and social potential, the prints do convey some of the conflict involved in the contact between vastly different cultures. Many views of Caribbean, Pacific and Australian ports were created by British and French artists. By the late eighteenth century these two nations possessed the most powerful navies in the world, and were keen to expand their commercial activities by establishing trade links abroad. In addition to North and South America, the Caribbean and the newly discovered islands of the Pacific and Australasia attracted British and French interest. Through engravings British and French explorers, scientists and later administrators and merchants displayed their supposed ability to develop these island communities along European lines, as orderly and profitable trading partners and colonies.

Caribbean ports

Long before European exploration of the Pacific came the establishment of colonies in the Caribbean. Spain was the first dominant European power in this

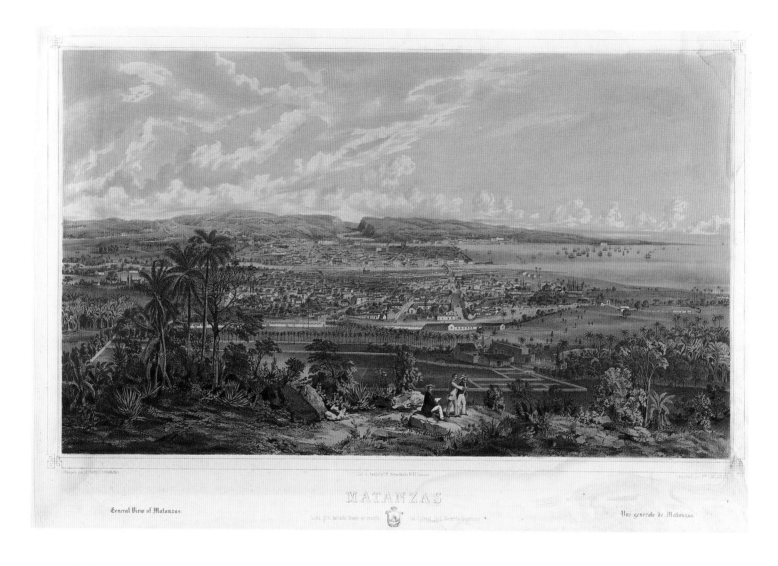

MATANZAS

General View of Matanzas. Vista gral tomada desde el monte ... del Cabezo ... á Vicente Guerrero. Vue generale de Matanzas.

area and, beginning in the sixteenth century, established bases on Caribbean islands as well as on the mainland of Central and South America. One of the most popular subjects for engravers was Cuba. The port of Havana was founded by the Spanish in 1519, and came to be represented as a symbol of Spanish hegemony in the region as a whole. Numerous engravings of Havana detail its impressive harbour and strongly fortified settlement. 'Vue du Port de la Havane' is a nine-teenth-century hand-coloured aquatint which shows the seaport's harbour and channel (see page 150). In addition to the port itself, this view depicts several people in the countryside near Havana. The repetition of the title in Spanish and the print's publication in France suggest the high European demand for engravings

'Matanzas Vista gral Fomada…General View of Matanzas'
Title also in French
Hand-coloured lithograph
Height 503 mm, width 737 mm
Designed by Leonardo Baranano and engraved by Edoardo Laplante and Fanjul y Cia; published in the mid-nineteenth century (PAI 0390).

While less well-known than Havana, the Cuban port of Matanzas also attracted the attention of artists from several European countries. In this elegant view, male spectators, including perhaps the artist, survey the port from a hillside.

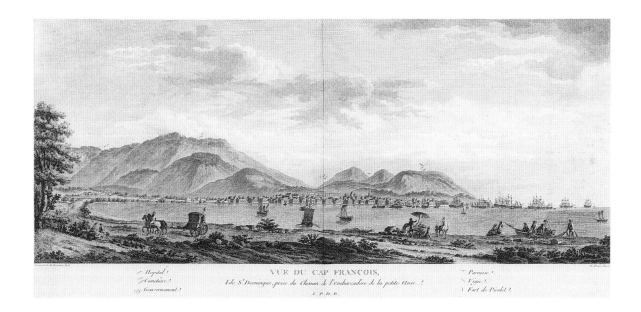

VUE DU CAP FRANCOIS,
Isle S.^t Domingue, prise du Chemin de l'embarcadere de la petite Anse.
J. P. D. R.

'Vue du Cap François, Isle St Domingue, prise du Chemin de l'embarcadère de la petite Anse'

View of Cape Francis, Island of St Domingue, taken from the Path leading from the pier in the little Cove

Etching and engraving

Height 316 mm, width 615 mm

Designed by Fernand de la Bruniere and etched by Nicolas Ponce; published *c*.1795 (PAI 0401).

French Caribbean settlements were the subject of several beautiful engravings. This etching of Cap François provides a sweeping view of a bay with ships and a town on the far side. In the right foreground a man with umbrella, stand and paper and drawing implements may represent the artist.

of Havana. Similarly a set of three prints of Havana with titles in English, French and Spanish was published in Britain in the mid-eighteenth century. Britain's military interest in Havana can also be gauged from the publication line of Elias Durnford's 1764 print: 'To the Right Honourable George Earl of Albemarle, Commander in Chief of His Majesty's Forces on the late Expedition to Cuba; these Six Views of the City, Harbour, & Country of the Havana, are most humbly Inscribed...'. By the mid-nineteenth century another Cuban port, Matanzas, was attracting attention. A detailed view describes this port's links with Spain. The title of this hand-coloured lithograph is in Spanish and French as well as English, revealing an international market for engraved views of this region (see left).

In addition to Spanish Caribbean ports, French artists published views of their own settlements in the region. N. Ponce's etching after Fernand de la Bruniere's drawing of 'Vue du Cap François, Isle St Domingue...', provides a panoramic view of the port and adjacent bay (see above). Famous French artists such as Claude-Joseph Vernet and Nicolas-Marie Ozanne also produced series of engravings of French Caribbean ports in the late eighteenth century. While often small in scale and repetitive in style, the sheer number of designs attests to France's continuing interest in, and commitment to Caribbean ports.

British settlements in the Caribbean also attracted considerable attention. Indeed, the large number of British views of Caribbean ports reflects Britain's

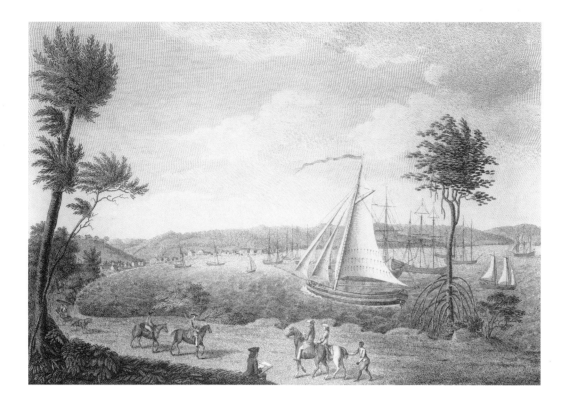

major naval and political presence in the area from the early eighteenth century onwards. While this presence was manifested through settlements on a number of islands, Jamaica was the jewel in Britain's Caribbean crown. Numerous engravings were produced of this wealthy sugar island, including a series of late eighteenth-century etchings of Jamaican ports and coastal communities. One of the most appealing prints from this series was 'A View of the Town and Harbour of Montego Bay, in the Parish of St James's, Jamaica, taken from the Road leading to St Anns', published in 1770 (see above). The design offers a detailed view of a bay with ships and boats, and people on shore. The artist is visible in the centre of the design, a feature common in landscapes where the artist is especially proud of his work. The identification of two tropical plants, the 'Bread Nut Tree' and the 'Mangrove Tree' indicates that this print was designed to satisfy European viewers' curiosity about Caribbean natural history, as well as to convey details of the local topography and Britain's commercial and political presence.

In the Caribbean as elsewhere, engravings were often created from sketches made by naval officers and passengers 'on the spot', and reworked by

'A View of the Town and Harbour of Montego Bay, in the Parish of St James's, Jamaica, taken from the Road leading to St Anns'
Etching
Height 430 mm, width 555 mm
Published by (?Jonathan) Spilsbury in London on 26 January 1770 (PAH 2984).

This etching depicts Montego Bay in Jamaica, Britain's most valuable Caribbean colony. The design lacks perspective (an oversized vessel sails dangerously close to the shore) but gives an excellent view of the local landscape.

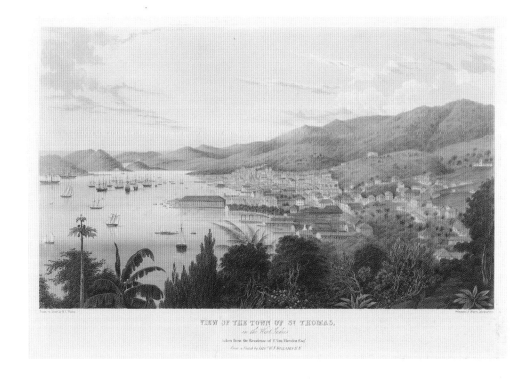

VIEW OF THE TOWN OF ST THOMAS,
in the West Indies.
taken from the Residence of P. Van Vlierden Esqr.
Drawn & Etched by Lieut. W. T. BELLAIRS R.N.

'VIEW OF THE TOWN OF ST THOMAS, IN THE WEST INDIES: TAKEN FROM THE RESIDENCE OF P. VAN VLIERDEN ESQR.'
Hand-coloured lithograph
Drawn on stone by W. L. Walton from a sketch by Lieutenant W. T. (? Walford Thomas) Bellairs and published by Hullmandel & Walton in London in the mid-nineteenth century (PAI 0392).

Through prints made from the sketches of visiting naval officers, small Caribbean ports such as St Thomas were introduced to European viewers. This elevated view depicts a town on a tranquil bay with ships, and tropical plants in the foreground.

professional artists in London. A pair of mid-nineteenth-century colour lithograph views of '…the Town of St Thomas, in the West Indies…' was published from sketches taken by Lieutenant W. T. (?Walford Thomas) Bellairs of the Royal Navy (see above). Although a small and somewhat remote port, these views present the town of St Thomas in the Virgin Islands, with its ships and boats in the harbour and mountains to the right, as a useful as well as aesthetically pleasing link in the British chain of Caribbean outposts.

The presence of the Royal Navy is also evident in a 'View of the Town and Harbour of Amsterdam, with Fort George in the Island of Curacoa [sic]' (see page 156). Above a panoramic scene of ships in a bay opposite a town, a fort on top of a mountain prominently flies the Union Jack. Handwritten on the design is a note that the view was sketched by Lieutenant Fores and copied by Lieutenant Rea of the HMS *San Pareil*. While Curacoa (Curaçao) was established as a Dutch colony in 1634, as this print indicates Caribbean islands moved in and out of different European powers' influence, sometimes within the space of a single decade.

Greater detail is provided in a pair of prints of the British colony of Bermuda. Bermuda's value to the British lay in its strategic position in the western Atlantic,

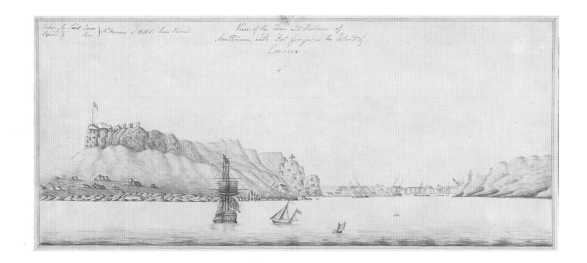

'View of the Town and Harbour of Amsterdam, with Fort George in the Island of Curacoa [SIC]'
Grey wash
Height 206 mm, width 442 mm
Drawn by Lieutenant Fores and copied by Lieutenant Rea, officers of HMS *Sans Pareil* in the (?)early nineteenth century (PAI 0387).

Naval officers' training in draughtsmanship enabled many of them to make sketches during their voyages. Drawings were often copied by other officers, as in the case of this view of the fort, town and ships at Amsterdam on the Caribbean island of Curaçao.

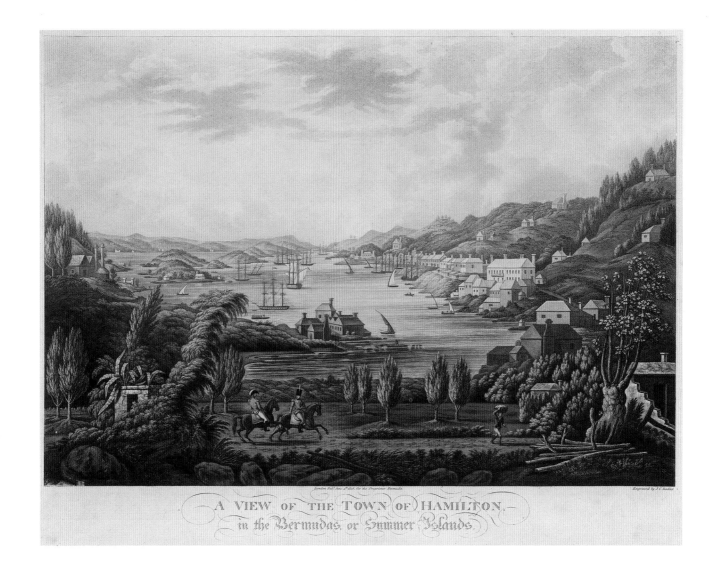

A VIEW OF THE TOWN OF HAMILTON, in the Bermudas, or Summer Islands.

'ENGLISH HARBOUR, ANTIGUA. FROM
GREAT GEORGE FORT, MONKS HILL'
Hand-coloured aquatint and etching
Height 355 mm, width 494 mm
Drawn by J. Johnson and engraved by
T. Fielding; published by T. & G.
Underwood in London on 1 May
1827 (PAI 0396).

This lovely view of the island of
Antigua provides a glimpse of the
production of the design. An artist,
watched by a British soldier, sketches
the harbour and town below.

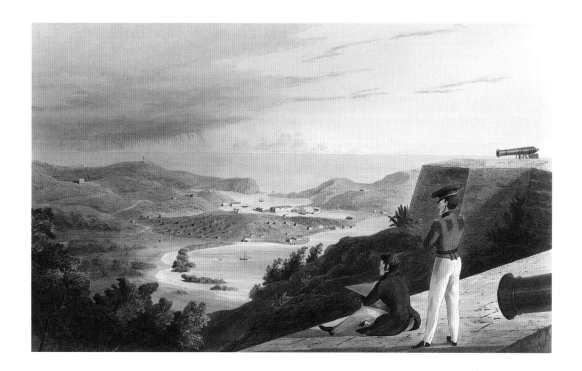

'A VIEW OF THE TOWN OF HAMILTON, IN THE
BERMUDAS, OR SUMMER ISLANDS'
Hand-coloured aquatint
Height 428 mm, width 557 mm
Engraved by Joseph Constantine Stadler and pub-
lished in London on 4 June 1816 (PAI 0286).

This prospect view of Bermuda reveals an orderly
and appealing scene. The port blends harmoniously
with the hilly landscape, and the two soldiers
on horseback in the foreground appear to be
enjoying themselves.

and a settlement was established there long before the British entered the
Caribbean. Yet even after Britain had established settlements on many lovely
Caribbean islands, British artists continued to represent Bermuda as a
particularly special place. 'A View of the Town of Hamilton in the Bermudas, or
Summer Islands', published in 1816, depicts the ships, buildings and people of
Hamilton from a slight elevation (see left). With its neat buildings and well-dressed
inhabitants, Hamilton appears an impressive example of colonial industriousness
and stability, and a model for the newer Caribbean settlements to follow.

Visual expression of British pride and confidence in its Caribbean colonies
reached a peak in views such as T. & G. Underwood's hand-coloured aquatint of
English Harbour, Antigua (see above). Published in 1827, after Britain's victory in
the Napoleonic Wars and during a period of growing enthusiasm for overseas
colonies, this design consists of an artist on a hill surveying the idyllic bay below.
Behind him stands a soldier who also contemplates the peaceful and beautiful
scene. These two men, the artist and the soldier, symbolise the mixture of
curiosity, pride and practicality with which British artists, explorers and adminis-
trators approached Britain's colonies in the Caribbean – and indeed the Pacific.

Exploration and Discovery of Pacific ports

Eighteenth-century voyages of exploration and discovery whetted European appetites for information about the lands and peoples of the South Seas. Artists and scientists, as well as military and naval officers, were well aware of the interest in these areas and produced sketches which were later engraved and published with written accounts of the voyages. Although not depicting conventional ports (i.e. European-style harbours with wharves and docks), images of Pacific 'ports' are useful for conveying European perceptions (and misperceptions) of native peoples' relationship with the sea. Such engravings attest to the great scientific and commercial interest in the Pacific and its development by European powers. In the nineteenth century this development would lead to the creation of European-style ports in the Pacific, for example at Honolulu and Lahaina in Hawaii.

On their way to the Pacific, European voyagers discovered new islands in the Indian Ocean. Several early views include details of European ships' visits to Indian Ocean ports and their encounters with new people and cultures. Thus for example 'A Perspective View of Cocos and Traitor's Islands discovered in the Voyages to the South Seas' depicts natives in canoes gathering around a European ship. This print, engraved by Francis Chesham for Charles Middleton's *A New and Complete System of Geography...* (1777–78), allowed readers to imagine what it would have been like to visit these remote islands (see right).

Several engravings of Pacific islands were likewise employed to illustrate books and periodicals. They often consisted of basic topographical views, which presented an accurate view of the landscape to the viewer but made no attempt to explore its historical or cultural significance. One of many similar engravings is 'A View of the NW Side of Saypan one of the Ladrones or Marian Islands' (see top, page 160). The design consists of a panoramic view of Saipan, the largest of the Northern Mariana Islands, which are located east of the Philippines in the Northwest Pacific. A lone ship in the right foreground breaks the monotony of sea, land and sky. The lack of detail suggests that the view was one of many similar topographical records made by the artist – who was probably a naval officer – during a long voyage.

Most prints naturally emphasised European explorers' successes rather than their setbacks. A theoretically significant moment in British exploration is recorded in a pair of prints. '...The arrival of the Discovery and Resolution, under

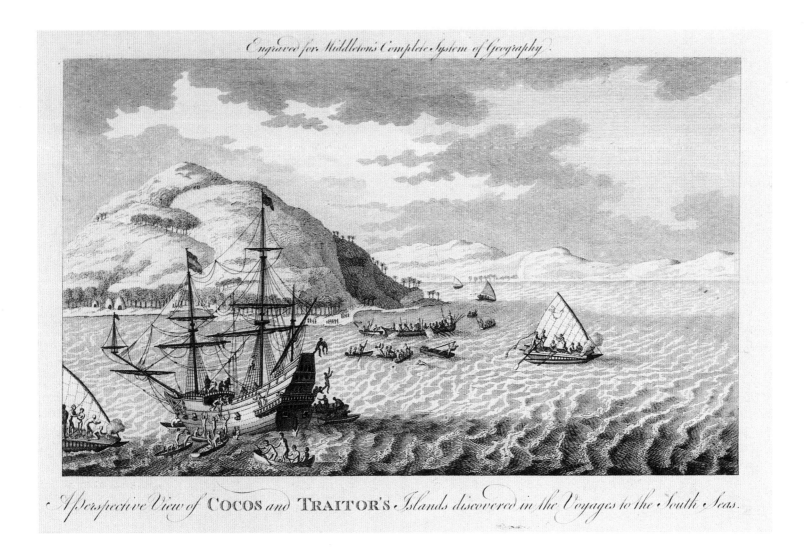

Engraved for Middleton's Complete System of Geography.

A perspective View of COCOS *and* TRAITOR'S *Islands discovered in the Voyages to the South Seas.*

'A PERSPECTIVE VIEW OF COCOS AND TRAITOR'S
ISLANDS DISCOVERED IN THE VOYAGES TO THE
SOUTH SEAS, ENGRAVED FOR MIDDLETON'S
COMPLETE SYSTEM OF GEOGRAPHY'
Engraving
Height 189 mm, width 288 mm
Engraved by Francis Chesham; published in
London *c.*1777–78 (PAD 2021).

This view of natives approaching, boarding and
jumping off a European ship conveys the enormous
cultural and technological differences between the
residents of the Cocos Islands and their visitors.
Such a scene was repeated many times throughout
the Pacific in the eighteenth century.

Captains Clerke and Gore…in Kamschatka, the 29th of April 1779' documents the
British explorers' visit to the Russian peninsula of Kamchatka after the death of
their commander, Captain James Cook, in Hawaii the previous February (see bot-
tom, page 160). This pair of designs is almost sentimental in tone. '…The depar-
ture…' describes the officers' tender leave taking, with the Governor, of the inhab-
itants and the Governor's wife. This bittersweet air seems appropriate – not only
had Cook recently died, but Captain Clerke was himself dying, and would not live
to complete the return voyage to Britain. These plates were intended to be read
alongside the account of Captain Cook's third voyage, and were dedicated to men
intimately involved with the expeditions. '…The arrival…' was dedicated to the

A view of the N.W. side of SAYPAN one of the LADRONES or Marian ISLANDS

'A View of the NW Side of Saypan one of the Ladrones or Marian Islands, Plate XXXVII'
Etching
Height 225 mm, width 515 mm
Published in the (?)mid-eighteenth century
(PAH 3116).

The necessity for accurate topographical views inspired simple designs such as this panoramic view of Saipan, an island in the Northwest Pacific. The ship on the far right-hand side of the design may have been accompanying the artist's ship.

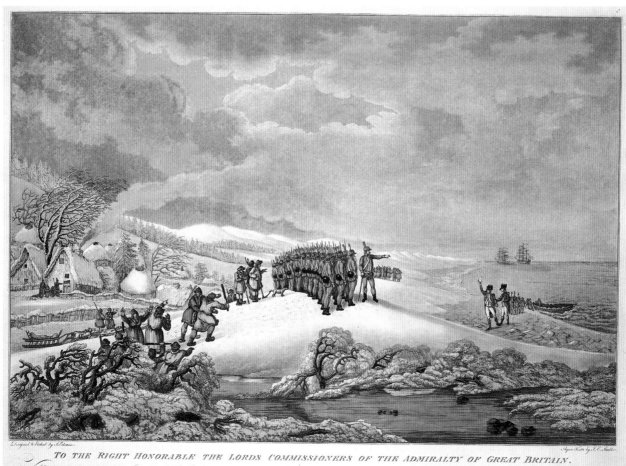

TO THE RIGHT HONORABLE THE LORDS COMMISSIONERS OF THE ADMIRALTY OF GREAT BRITAIN.
This PLATE, representing the arrival of the DISCOVERY and RESOLUTION, under CAPTAINS CLERKE and GORE, at S.t PETER and S.t PAUL, in KAMSCHATKA, the 29.th of April 1779, is respectfully dedicated by their most obliged and humble serv.t de la Garde.

'…VIEW OF HUAHEINE, ONE OF THE SOCIETY ISLANDS IN THE SOUTH SEAS'
Hand-coloured aquatint and etching
Height 484 mm, width 625 mm
Designed by John Cleveley the younger and engraved by Francis Jukes; published in London
c.1775 (PAI 0470).

This view of Huaheine was painted from sketches made by the artist's brother during Cook's second voyage to the Pacific. The ships depicted in the bay are probably HMS *Resolution* and HMS *Adventure*.

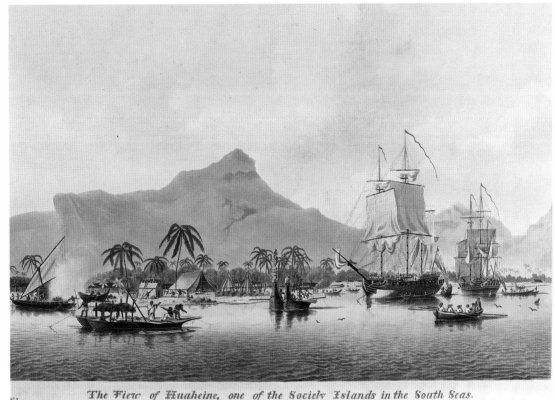

The View of Huaheine, one of the Society Islands in the South Seas.

'…THE ARRIVAL OF THE DISCOVERY AND RESOLUTION, UNDER CAPTAINS CLERKE AND GORE, AT ST. PETER AND ST. PAUL IN KAMSCHATKA [SIC], THE 29TH OF APRIL 1779'
Hand-coloured aquatint and etching
Height 495 mm, width 642 mm
Designed and etched by Johann Eckstein, aquatinted by Joseph Constantine Stadler; published in the late eighteenth century (PAI 0245).

This snowy, windswept scene provides one of the most unexpected images from the Pacific voyages of Captain Cook. Soldiers gather to greet the British explorers, whose ships are visible in the right background.

patrons of the voyage: 'the Right Honorable the Lords Commissioners of the Admiralty of Great Britain', while '…the departure…' was dedicated to the influential scientist who had accompanied Cook on his first voyage, 'the Right Honorable Joseph Banks, K. B.' While such representations would convince viewers that the visit to Kamchatka was part of a successful voyage, in fact the British explorers had been greatly hampered by ice, and they left the North Pacific with little to show for their efforts. But as print viewers were not interested in purchasing images of failure, images of progress were supplied instead.

Likewise, many representations of Pacific islands focus only on the harmonious side of European contact with native peoples. The widespread perception of these islands as an earthly paradise is illustrated in elegant engravings such as John Cleveley the younger and Francis Jukes's colour aquatint '…View of Huaheine, one of the Society Islands in the South Seas' (see above). This view, which like many other contemporary engravings depicts ships and boats in a bay

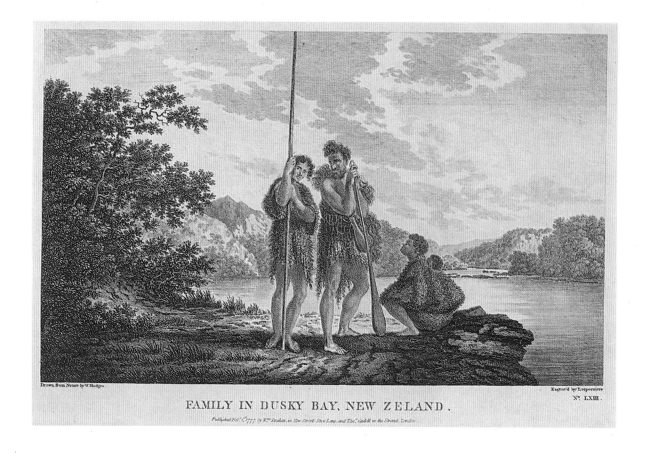

FAMILY IN DUSKY BAY, NEW ZELAND.

Drawn from Nature by W. Hodges. Engrav'd by Lerpernière

Nº. LXIII.

Published Novʳ.ᵗʰ 1777 by Wᵐ. Strahan, in New-Street, Shoe-Lane, and Thoˢ. Cadell in the Strand, London.

with mountains behind, may have been intended more to confirm European pre-conceptions than to present an accurate picture of Pacific societies as Europeans actually found them. In any case, these prints, designed for a home audience, helped publicise Cook's expeditions and may have encouraged further European involvement in the Pacific.

Some ethnographic detail is provided in the 1777 engraving 'Family in Dusky Bay, New Zeland…', which presents a close-up view of native people on a shore (see above). This engraving was made after a drawing by William Hodges, the artist who accompanied Captain Cook on his second voyage and who provided European viewers with some of the first images 'drawn from nature' of Pacific islands and islanders. While it does not describe an actual port, 'Family in Dusky Bay, New Zeland…' does acknowledge native communities' close relationship with the sea. By depicting native people living near natural harbours and mature forests, moreover, such designs could be used to demonstrate the feasibility of future

'FAMILY IN DUSKY BAY, NEW ZELAND, PLATE LXIII'
Engraving and etching
Height 254 mm, width 376 mm
Designed by William Hodges and engraved by Daniel Lerpernière; published by William Strahan and by Thomas Cadell in London on 1 February 1777 (PAH 3197).

In addition to harbours and landscapes, European artists made views of the people of the Pacific. This view of a family group in Dusky Bay is one of the earliest Western views of the native people of New Zealand.

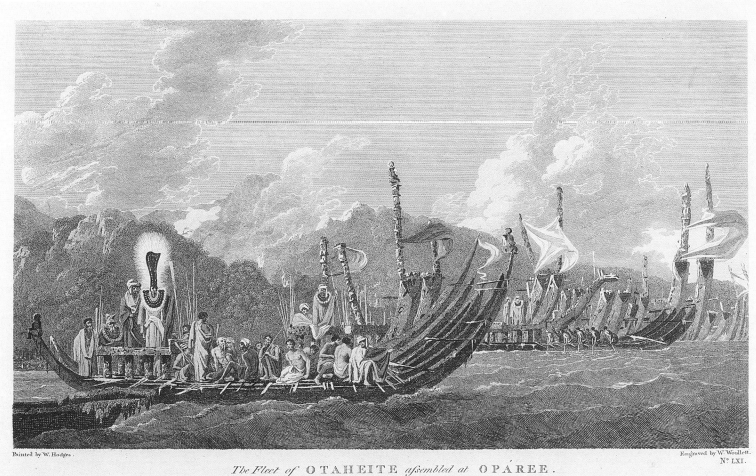

Painted by W. Hodges.

Engraved by W. Woollett.
Nᵒ LXI.

The Fleet of OTAHEITE *assembled at* OPÁREE.

Publifhed Feb.ʸ 1ˢᵗ 1777, by Wᵐ Strahan, New Street, Shoe Lane, & Thoˢ Cadell, in the Strand, London.

'THE FLEET OF OTAHEITE ASSEMBLED AT OPÁREE, No. LXI'

Engraving and etching

Height 234 mm, width 397 mm

Painted by William Hodges

Engraved by William Woollett; published by William Strahan and by Thomas Cadell in London on 1 February 1777 (PAH 3202).

Pacific islanders were skilled mariners, as this view of Tahitians sailing their magnificent war canoes demonstrates.

European settlement and commercial development. Engravings of the Pacific thus had political as well as educational applications.

Interest in native peoples' relationship with the sea is also demonstrated in Hodges's view of 'The Fleet of Otaheite assembled at Opáree...' (see above). This beautiful engraving, which is also based on sketches Hodges made while travelling with Cook, depicts the warriors of Tahiti in their war canoes with a mountainous landscape behind them. Such images indicated that Pacific peoples were not always peaceful, and that European encounters with Pacific islanders might one day turn violent, as Cook later learned to his cost.

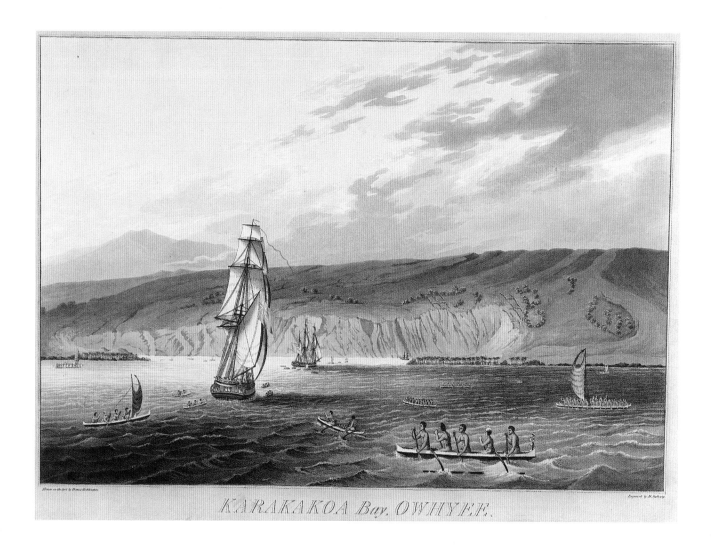

KARAKAKOA Bay. OWHYEE.

While not represented directly, native violence is alluded to in Captain Thomas Heddington's 1814 view of 'Karakakoa Bay, Owhyee' (Kealakekua Bay, Hawaii) which depicts ships and Hawaiian canoes off a cliff-lined coastline (see above). This bay was famous as the site of Captain Cook's death in February 1779, and numerous engravings were made of the event, which seemed to many observers to encapsulate the collision between Pacific, so-called 'savage' and European or 'civilized' cultures. Yet the beauty of the scenery and the favourable climate overcame Europeans' concerns, and they continued to visit the islands of the Pacific throughout the nineteenth century.

'Karakakoa Bay, Owhyee'
Kealakekua Bay, Hawaii
Hand-coloured aquatint
Height 453 mm, width 616 mm
Drawn on the spot by Captain Thomas Heddington
and engraved by M. Dubourg; published by
Captain Thomas Heddington in March 1814
(PAI 0469).

Long after Captain Cook's death, Kealakekua Bay in Hawaii continued to attract the attention of European artists. This view provides an excellent view of Hawaiian outrigger canoes.

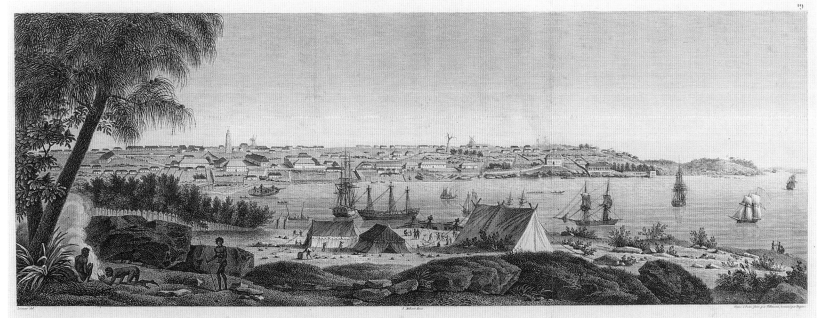

NOUVELLE - HOLLANDE : NOUVELLE GALLES DU SUD.

Vue de la partie méridionale de la Ville de SYDNEY Capitale des Colonies Anglaises aux Terres Australes, et de l'Embouchure de la rivière de Parramatta (1803.)

'…Vue…de la Ville de Sydney Capitale des Colonies Anglaises aux Terres Australes, et de l'Embouchure de la rivière de Parramatta (1803), Plate 19'

…View…of Sydney, Capital of the British Colonies in Australia, and of the mouth of the river from Paramatta (1803), Plate 19

Etching

Height 245 mm, width 494 mm

Designed by Charles-Alexandre Lesueur, etched by (?Jean-Baptiste) Pillement, finished by (?Marie-Alexandre) Duparc and published by J. (?Jacques) Milbert in 1807 (PAH 3148).

The arrival of a French scientific expedition in Australia led to the creation of many interesting engravings. This design of the British settlement at Sydney was included in an account of the expedition published in 1807.

Australian ports

Many of the Pacific voyages undertaken by British and French explorers were designed to solve the mystery of the great southern continent which was thought to exist somewhere below Asia. Although this continent was never found, the island continent of Australia was, and soon became the object of British and French commercial and political interest. With its excellent strategic position along the trade routes to Asia and its promise of fertile land to sustain free settlers as well as convicts, Australia seemed an ideal choice for a new colony. The British First Fleet created the first European settlement in Sydney in 1788. While the French never succeeded in establishing their own colony on the continent, French explorers and artists continued to maintain their interest in Australia. Numerous French as well as British engravings of Australia were produced, including the 1803 print '…Vue de…la Ville de Sydney…' (see above). This early view depicts the port of Sydney in its infancy. Aborigines with fire and spears appear as prominent as Europeans, but already the number and quality of buildings and ships in the

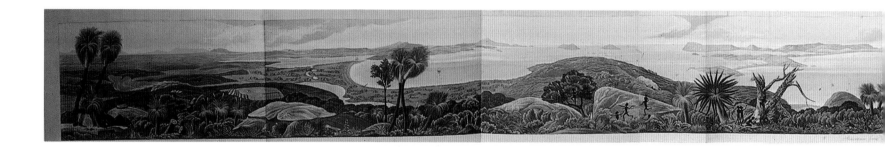

harbour suggest that Sydney is likely to survive, and indeed prosper – as a European settlement.

While many artists were later criticised for drawing Australian landscapes with European-style flora and fauna, some were both able and willing to depict the unique Australian scenery. One of the most powerful and dramatic views of early Australia was prepared by Lieutenant Robert Dale, who arrived in Western Australia in 1829 and was appointed temporary assistant surveyor. His hand-coloured aquatint and etching 'Panoramic View of King Georges Sound part of the colony of Swan River' was printed in four parts and published by the well-known publisher Robert Havell in London in 1834 (see above).

This stunning view combines topographical accuracy with details of the local aborigines and their encounter with British soldiers. The depiction of the temporary British settlement and ships in the distance conveys the impression that this wilderness will soon be developed into a viable port community. The desire to convince British viewers that settlement would succeed can be seen in representations of all the colonies. It is particularly noticeable in representations of Western Australia, whose colony was controversial even before its first settlers arrived, and subsequently encountered severe financial problems. Engravings of European settlements in Australia were therfore often explicitly designed to pro-mote the reputation of the new colony and that of its local administrators to the home government.

Other views seem to have been designed to attract as many purchasers as pos-sible. Major James Taylor's view of 'The Town of Sydney in New South Wales', is Plate Two of an exceptionally detailed four-part panorama of Sydney drawn c.1821. Three of the four parts were published in London in 1823 (see right). Plate Two depicts a neat, orderly and thriving town, with individual houses,

'PANORAMIC VIEW OF KING GEORGES SOUND PART OF THE COLONY OF SWAN RIVER'
Hand-coloured aquatint and etching
Height 216 mm, width 2.82 m
Drawn by Lieutenant Robert Dale; engraved and published by Robert Havell in London in October 1834 (PAI 0445).

This striking view of a sound in Western Australia provides details of the local aborigines, and of the local flora and fauna. Despite the remoteness of the landscape, the presence of British officers and ships beyond suggests that the area will soon be settled by Europeans.

'THE TOWN OF SYDNEY IN NEW SOUTH WALES, PLATE 2'
Hand-coloured aquatint and etching
Height 476 mm, width 652 mm
Drawn by Major James Taylor and engraved by Robert Havell & Son; published by Colnaghi & Co. in London in August 1823 (PAI 0452).

Orderly views of Australia were often created to impress British officials with the colony's progress. This detailed view of Sydney was dedicated by the artist to the Under Secretary of State for the Colonies.

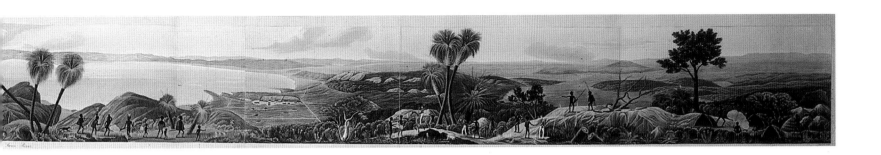

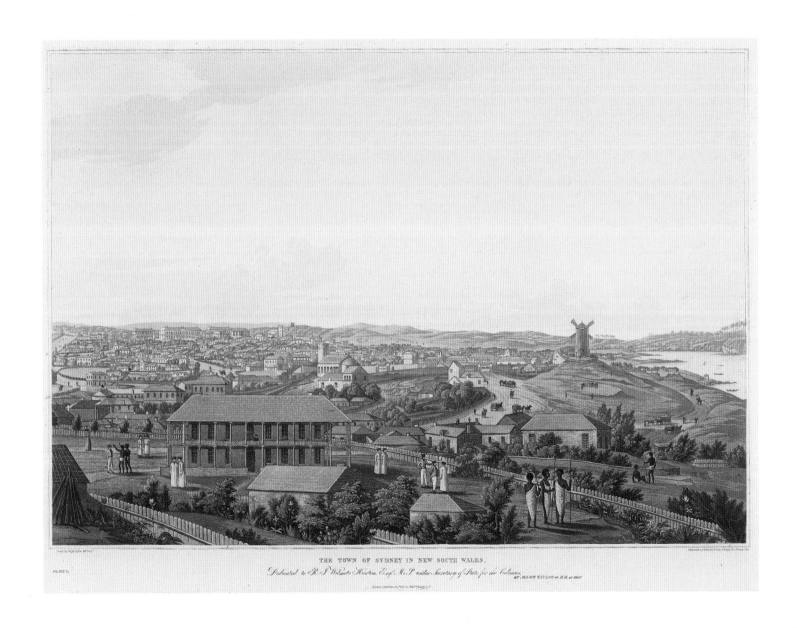

THE TOWN OF SYDNEY IN NEW SOUTH WALES.

Dedicated to R. J. Wilmot Horton, Esq'r. M. P. under Secretary of State for the Colonies.
BY MAJOR TAYLOR OF H.M. 48 REG'T.

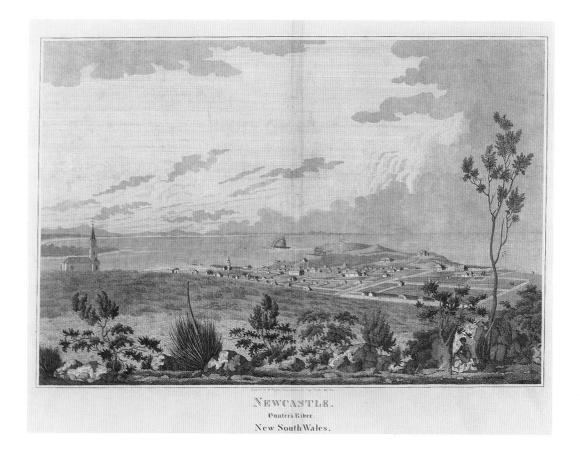

NEWCASTLE.
Hunter's River.
New South Wales.

warehouses, aborigines and Europeans clearly visible. British viewers of this design would have been in little doubt as to the colony's considerable recent progress. Yet despite this emphasis on construction and development, the topography of the unique landscape, and in particular the magnificent natural harbour dominate the scene. Such views may ignore the hardship faced by almost all early settlers as well as convicts, but they cannot disguise the tremendous geographical and cultural distance separating the colony from the mother country.

This isolation is evident in other early nineteenth-century views of Australian port settlements, including Newcastle, established first as a penal settlement and later developed as an important port for the coal trade. The convict Walter Preston's engraving after Captain James Wallis of 'Newcastle. Hunter's River. New South Wales' depicts the early years of European settlement (see above). Beyond the town is the sea, with a church to the left and, perhaps to deliberately contrast with these European features, a group of aborigines on the

'NEWCASTLE. HUNTER'S RIVER. NEW SOUTH WALES'
Etching
Height 395 mm, width 525 mm
Engraved by Walter Preston from a drawing by Captain James Wallis; published by Rudolph Ackermann in London on 1 September 1820 (PAI 0444).

The artist, who was also the commanding officer at Newcastle in Australia, probably intended this view to impress his superior officers. A neat church and town, with sea beyond, offer visible proof of his administrative tenure. Ironically – or perhaps appropriately – this orderly scene was engraved by a convict!

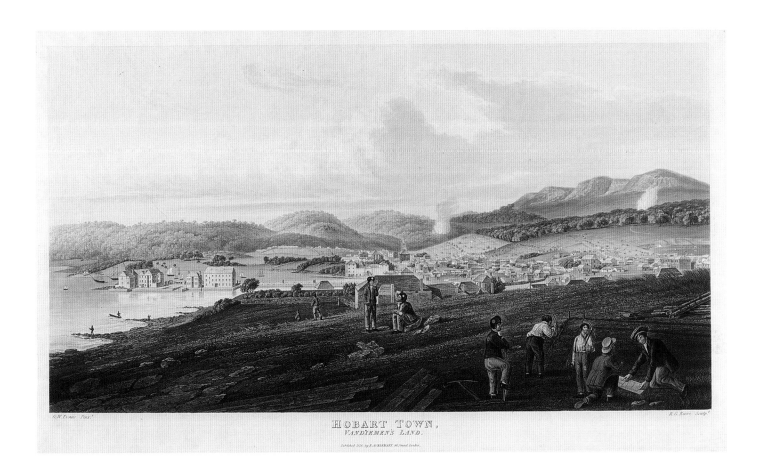

HOBART TOWN,
VANDIEMEN'S LAND.

'HOBART TOWN, VANDIEMEN'S LAND'
Hand-coloured aquatint and etching
Height 378 mm, width 646 mm
Painted by George William Evans and engraved by
R. G. Reeve; published by Rudolph Ackermann in
London in 1828 (PAI 0437).

This appealing view of the neat buildings and port
of Hobart in Tasmania may have been intended to
promote free emigration to Australia. The men
labouring in the foreground suggest that there is
still much work to be done in the colony.

right. Aborigines were often included in early engravings of Australian port
communities to satisfy European taste for the exotic. While aborigines lived in and
around port communities, they did not always resemble the quaint groups engaged
in hunting or ceremonial activities portrayed by European artists. This design is
noteworthy because it was made by the British officer who was in charge of the
penal settlement at Newcastle, and thus it may have be seen as a visual advertise-
ment of his administrative success. Captain Wallis had his set of twelve views of
New South Wales published first in Sydney and later in Britain. While such images
might have been primarily intended to impress the captain's superiors, they could
also be used to promote the idea of Britain's wise government of Australia to a
wider range of people.

Van Diemen's Land was the second British settlement established in Australia,
after Sydney in New South Wales. Named by the seventeenth-century Dutch

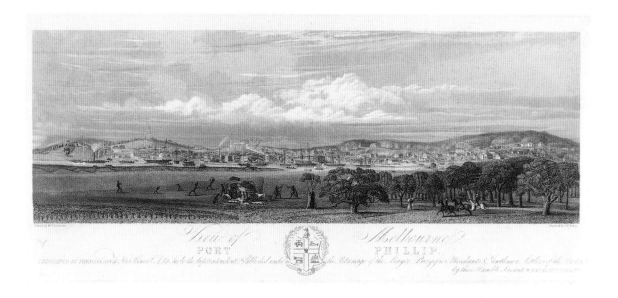

explorer Abel Tasman after the governor-general of the Dutch East Indies (and subsequently renamed Tasmania after the explorer), for much of the nineteenth century Van Diemen's Land seemed a more promising economic experiment than New South Wales. As an island, Tasmania was wholly dependent on the sea for its contact with the outside world. Ports were established to handle the export of wheat and import of manufactured goods (and convict labour) and to service the whaling and sealing fleets. Numerous engravings depict local ports and their surroundings, perhaps because, much more than 'New South Wales', the Tasmanian landscape reminded viewers of Britain. Hobart, with its impressive deep water harbour became Tasmania's largest and most important port. George William Evans's early nineteenth-century design of 'Hobart Town, Vandiemen's Land', conveys contemporary enthusiasm about Hobart's economic future (see page 169). A panoramic view includes the town with hills beyond, labourers (perhaps convicts) in the foreground and ships and boats to the left.

Melbourne was founded after both Sydney and Hobart, yet after a rocky start its population grew to exceed that of both those cities. The development of its port was spurred on by the growth of the wool trade and by the discovery of the Victorian goldfields in the mid-nineteenth century. Joseph William Lowry's 1844 proof etching after Wilbraham Frederick Evelyn Liardet's drawing 'View of

'VIEW OF MELBOURNE, PORT PHILIP'
Proof etching
Height 243 mm, width 567 mm
Designed by William Frederick Evelyn Liardet, etched by Joseph William Lowry and published by Wilbraham Frederick Evelyn Liardet in London in 1844 (PAI 0443).

Unlike many other views of Australian ports, this view of Melbourne was probably intended for a local audience. It was dedicated by the artist to 'His Honor C. J. La. Trobe the Superintendent' and published 'under the Patronage of the Mayor, Burgesses, Merchants & Gentlemen, Settlers of the District'.

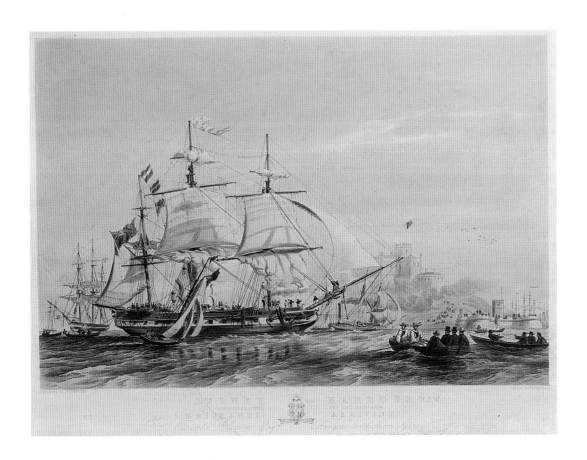

'SYDNEY HARBOUR, N. S. W. GOVERNMENT HOUSE
AND FORT MACQUARIE, EMIGRANTS ARRIVING'
Hand-coloured lithograph
Height 397 mm, width 523 mm
Watercolour painted by Sir Oswald Walters Brierly
and lithographed by Thomas Picken and Day &
Son; published by Ackermann & Co. in London on
1 June 1853 (PAI 0449).

This festive view of Sydney Harbour was taken
from a watercolour painted by one of the most
eminent British maritime artists of his day. The
scene conveys British pride in the development of
Sydney as a successful port, and in the emigration
schemes which aid Australia's continued growth.

Melbourne, Port Philip', expresses the optimism and pride of early settlers (see page 170). By including depictions of aborigines throwing spears as well as a higgledy-piggledy mass of buildings, ships and boats on the river, the engraving serves as a reminder that nineteenth-century Australian port communities, while aspiring to European elegance and commercial strength, remained part of the local landscape, and as such exotic curiosities to European viewers. In spite of this, the town's future lay with the European model, as the print's dedication to prominent European settlers clearly demonstrates.

By the mid-nineteenth century, engravings of Australian ports were focussing less on the contrast between European and aboriginal culture and more on the rapid commercial development of these cities. As local labour shortages grew more acute, and as attitudes to dealing with crime and poverty changed in Britain, campaigns to encourage voluntary emigration rather than convict transportation to Australia were launched. Several engravings promoted the

benefits of emigration to Australia. Thus the lithograph pair 'Sydney Harbour... Emigrants arriving' and 'Sydney Harbour...Emigrants Disembarking' depict healthy emigrants in handsome ships arriving (perhaps from Liverpool?) in a large and pleasant port (see page 171). These scenes were painted in watercolour by the British marine painter Sir Oswald Walters Brierly (he was Marine Painter in Ordinary to Queen Victoria) during a visit to Australia and were intended for publication in Britain. While these images were not commissioned to promote an emigration scheme, such positive representations would certainly have helped further Sydney's reputation as a newly desirable destination for British migrants.

Less than 70 years after the First Fleet arrived, engravings of Australian port communities emphasised the European appearance of these cities. While a few aborigines might still appear in some views, most nineteenth-century engravings accentuated the links between Australian and European ports and peoples. Rather than just places to view native peoples or send unwanted criminals, Australian ports were now represented as ideal sites for European immigration and commercial development.

Conclusion

Although considerably different from one another, Caribbean, Pacific and Australian ports fascinated European viewers with their exotic landscape, flora and fauna. Successive voyagers described these island societies as paradises on earth, and promoted the commercial and political development of their ports. Yet European maritime activity created conflict with many native people, and fuelled intense colonial rivalries for possession. While originally celebrated as unique environments, by the mid-nineteenth century many Caribbean, Pacific and Australian ports seemed more European than native. In particular, Pacific and Australian ports developed as important links in the new international trade network. The many beautiful and lively engravings of Caribbean, Pacific and Australian ports record and reflect these developments. They also point to the considerable contemporary demand for information about these ports. Eighteenth- and nine-teenth-century men and women used prints of ports to convey information about their home ports to others, and in turn to explore the increasingly complex world around them. Through prints, ports of the world became familiar.

Select Bibliography

Archibald, E. H. H. *Dictionary of Sea Painters.* Woodbridge, Suffolk: Antique Collectors' Club, 1980.

Bénézit, E. *Dictionnaire critique et documentaire des peintres, sculpteurs, dessinateurs et graveurs.* 8 vols. Paris, 1948-55.

Blainey, Geoffrey. *The Tyranny of Distance: How Distance Shaped Australia's History.* Revised Edition. Sydney: Pan Macmillan Australia, 1982.

Broeze, Frank, ed. *Brides of the sea: port cities of Asia from the 16th - 20th Centuries.* Kensington, N. S. W.: New South Wales University Press, 1989.

Broeze, Frank. *Island Nation: a history of Australians and the sea.* Sydney: Allen & Unwin, 1998. Chapman, Barbara. The Colonial Eye: A topographical and artistic record of the life and landscape of Western Australia 1798-1914. Perth: The Art Gallery of Western Australia, 1979.

Clayton, Timothy. *The English Print 1688-1802.* New Haven and London: Yale University Press, published for the Paul Mellon Centre for British Art, 1997.

Colley, Linda. *Britons: Forging the Nation 1707-1837.* New Haven and London: Yale University Press, 1992.

Corbin, Alain. *The Lure of the Sea: The Discovery of the Seaside in the Western World 1750-1840.* Originally published in France as *Le Territoire du vide* by Aubier, Paris, 1988. Translated by Jocelyn Phelps. London: Penguin Books, 1995.

Cordingly, David. *Painters of the Sea: A survey of Dutch and English marine paintings from British collections.* London: Lund Humphries in association with The Royal Pavilion, Art Gallery and Museums, Brighton, 1979.

Flower, Cedric. *The Antipodes Observed: Prints and Print Makers of Australia, 1788-1850.* South Melbourne, Vic.: Macmillan, 1975.

Griffiths, Antony. *The Print in Stuart Britain, 1603-1689,* with the collaboration of Robert A. Gerard. London: British Museum Press, 1998.

Kemp, Peter, and Richard Ormond. *The Great Age of Sail: Maritime Art and Photography.* Oxford: Phaidon, 1986.

Kemp, Peter, ed. *The Oxford Companion to Ships and the Sea.* Oxford: Oxford University Press, 1976, reissued with corrections as a paperback, 1988.

Keyes, George S. *Mirror of Empire: Dutch marine art of the seventeenth century.* With essays by George S. Keyes, Dirk de Vries, James A. Welu and Charles K. Wilson. Cambridge: The Minneapolis Institute of Arts in association with Cambridge University Press, 1990.

Langford, Paul. *A Polite and Commercial People: England, 1727-1783.* Oxford: Oxford University Press, 1989.

Mallalieu, H. L. *The Dictionary of British watercolour artists up to 1920.* Woodbridge, Suffolk: Antique Collectors' Club, 1976.

Neill, Peter. *On a Painted Ocean: Art of the Seven Seas.* In collaboration with James A. Randall and Suzanne Demisch. Ed. Gareth L. Steen. New York and London: New York University Press, 1996.

O'Byrne, William R. *A Naval Biographical Dictionary.* London, 1849.

Pratt, John Lowell, ed. *Currier & Ives: Chronicles of America,* with an introduction by A. K. Baragwanath. Maplewood, New Jersey: Hammond Incorporated, 1968.

Prentice, Rina. *A Celebration of the Sea: the Decorative Arts Collection of the National Maritime Museum.* London: HMSO, 1994.

Quarm, Roger and Scott Wilcox. *Masters of the Sea: British marine watercolours.* Oxford: Phaidon, 1987.

Rediker, Marcus. *Between the Devil and the Deep Blue Sea: Merchant Seamen, Pirates, and the Anglo-American Maritime World, 1700-1750.* Cambridge and New York: Cambridge University Press, 1987; Canto edition, 1993.

Reps, John W. *Bird's Eye Views: Historic Lithographs of North American Cities.* New York: Princeton Architectural Press, 1998.

Reps, John W. *Cities of the Mississippi, Nineteenth-Century Images of Urban Development with Modern Photographs from the Air by Alex MacLean.* Columbia and London: University of Missouri Press, 1994.

Robinson, C. N. *The British Tar in Fact and Fiction.* London and New York: Harper & Bros., 1909.

Robinson, M. S. *A Pageant of the Sea: The Macpherson Collection of Maritime Prints and Drawings in the National Maritime Museum Greenwich.* London and New York: Halton & Company Ltd, 1950.

Rodger, N. A. M. *The Wooden World: an Anatomy of the Georgian Navy.* London: Fontana Press, 1986.

Taylor, James. *Marine Painting: Images of Sail, Sea and Shore.* London: Studio Editions, published in association with the National Maritime Museum, Greenwich, 1995.

Terry, Martin. *Maritime Paintings of Early Australia, 1788-1900.* Melbourne: The Miegunyah Press, Melbourne University Press, 1998.

Index